fashion
illustration
next

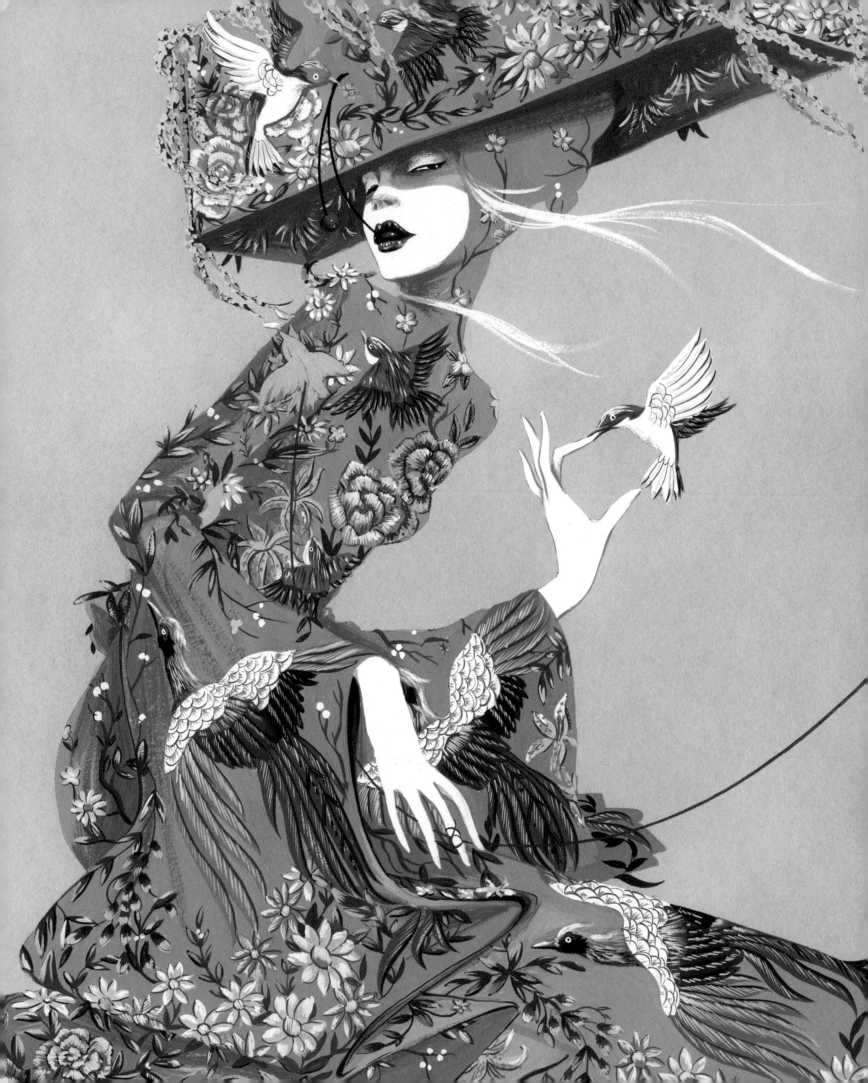

laird borrelli

fashion illustration next

![Thames & Hudson logo] **Thames & Hudson**

with 226 illustrations, 177 in colour

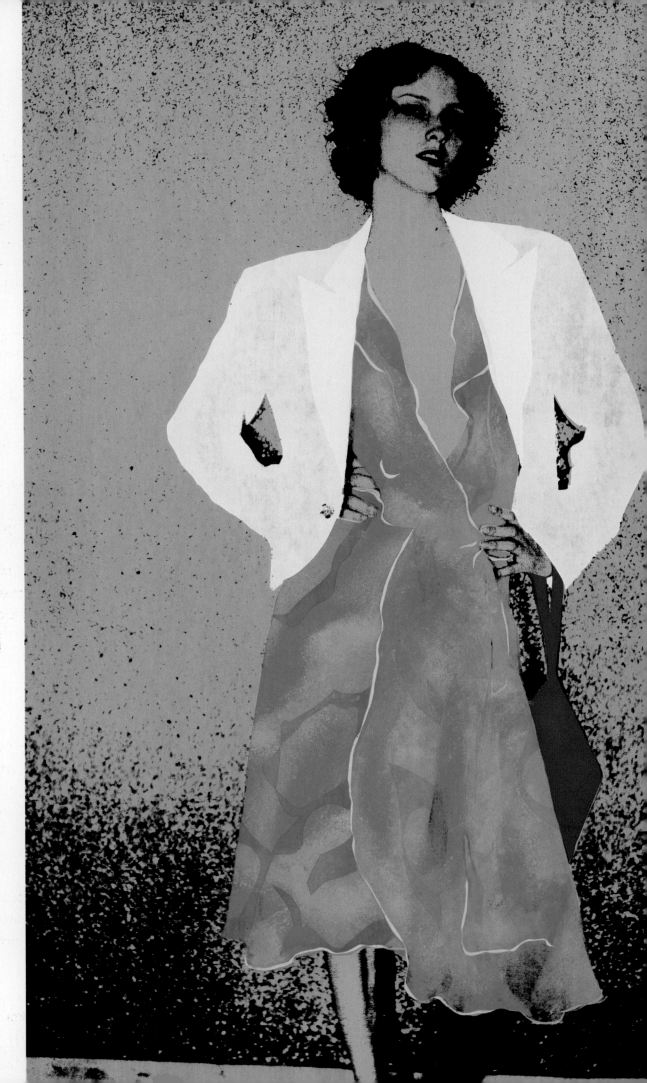

half-title page:
esdar maren
Mixed media collage
Created for *Fashion Illustration Next*, 2003

title page:
gray richard
Alexander McQueen
Gouache
Art Department promotion, 2001

▷
gibb kate
Dries Van Noten
Silkscreen print; photographer: Ellen Nolan
Spring/summer catalogue, 2001

First published in the United Kingdom in 2004
by Thames & Hudson Ltd,
181A High Holborn, London WC1V 7QX

www.thamesandhudson.com

British Library Cataloguing-in-Publication Data
A catalogue record for this book is available
from the British Library

ISBN 0-500-28499-7

Printed and bound in Hong Kong
by H & Y Printing Ltd

contents

Four years ago my book *Fashion Illustration Now* documented the beginnings of a renaissance in fashion illustration, now in efflorescence, which is currently the subject of much media crowing. *Fashion Illustration Next* presents the work of over forty international artists whose creativity has fuelled the current boom. Inevitably, these artists are connected to the fault lines of the collective psyche, for 'fashion', New York-based designer Miguel Adrover reminds us, 'says something about the moments in which we live.' Thus their work reflects our times. The often joyously satirical observations on fashion and its idiosyncratic milieu that filled the pages of *Fashion Illustration Now* have given way to more inward musings. As the spectre of terrorism and the reality of economic dislocation set the mood, it is not surprising that the resultant images are darker and more psychologically nuanced than what we have seen before. One is struck by the introspective quality of much of the art in *Fashion Illustration Next*. Thomas Barwick's inspiration comes, he tells me, 'from looking very carefully. From sitting on my bed in the dark and from staring at the sun.' And Charles Anastase admits: 'My work is wholly biographical and a bit obsessional.'

Obsession takes many forms in *Fashion Illustration Next*. One of the marked preoccupations of many of the artists in the book – among them David Remfry and Mode 2 – is a focus on the realistic rendering of the figure. Anastase, whose stated interest is in 'drawing people I like in clothes I find attractive', will only accept jobs where he has complete freedom in choice of model (and fashion). For his part, Mode 2, who is not only an accomplished illustrator but a revered graffiti artist, says: 'I think that my self-taught style, the importance of having painted with the spraycan for so many years, and my obsession with trying to get anatomy right, define what I do.'

The interest in realistic figurative drawing and the demand agents are seeing for other 'old school' styles is understood by some to be a reaction to the slick perfection of what Peter Jeroense describes with a quip as the 'suntanned girls with cocktails [and] astrobabes' school of computer-generated illustration. (The work of the pioneers of computer art – Jason Brooks, Kristian Russell and Ed Tsuwaki among them – which was first documented in *Fashion Illustration Now*, has launched thousands of mostly inferior imitators.)

The realistic figure-based work of Remfry and co. gives way to the 'hypernatural' in the slick, digitally

finished drawings of René Habermacher and Jannis Tsipoulanis. Their collaborative work is almost photographic in its fetishistic attention to surface and gloss. This concern with surface is shared by Tristan Galdos del Carpio, in his wholly different hand-drawn work, whose ambition is to make his drawings 'lively, neat and shiny like fruits'.

In contrast, artists such as Richard Gray, Kime Buzzelli and Nawel pursue the fruits of their fevered imaginations. Their work is full of the eerie distortions of surrealism and fairytales. Maren Esdar (whose aesthetic invites comparison with Hannah Höch) credits Peter Greenaway as a strong influence on her collages.

Collage is one of the most used techniques in *Fashion Illustration Next* and I believe that it can be understood, to some extent, as a reflection of the surrealist fascination with the found object and image. (It also calls to mind T. S. Eliot's line about shoring fragments against the ruins.) The reclamation of images is a significant feature of Kate Gibb's work. Her silkscreens, she says, are made from 'a mixture of

drawing, stencils [and] photographs that I take myself or find in junkshops'. Keiji Ito collects vintage graphics to work into his collages and Kime Buzzelli trims her drawings (which she has recently started to stuff, transforming them into soft sculptures) with sequins and bits of old fabric and lace.

Peter Jeroense's technique is to cut and paste by hand, pulling images from 'a huge archive with

photographs of body parts in all positions'. His forays into technology extend only so far as the black and white copier. 'Even colour copy machines think digital, I hate digital!' he opines. Jeroense's technophobia is very much the exception, in fact. Photoshop and scanners have totally transformed the art of illustration. Not only can images, colours and patterns be applied in layers, but also the paste-free juxtaposition of images and materials (virtual multimedia art) becomes possible, as is gloriously evident in the work of Kenzo Minami, Rebecca Antoniou and Elisabeth Arkhipoff.

The implications of digital technology for all aspects of fashion illustration are revolutionary. The Internet has vastly increased the sharing (as well as copying) of creative skills, and the pages of this book reveal an explosion of global talent. It has also provided new venues for publishing work. Koji Ota, Stina Persson and Clay Weiner have all contributed to such online magazines as tigermag.org and thisisamagazine.com, while projects by Julie Verhoeven, as well as Warren du Preez and Nick Thornton Jones in collaboration, have been featured on Nick Knight's SHOWstudio.com.

Almost all of the artists in *Fashion Illustration Next* have readily incorporated technology into their methods of working. 'I use the Mac', Jasper Goodall has said, 'as a technological way of silkscreening...the technique I used before I owned a Mac.' It is a strange irony that the fashion plate, an early form of fashion illustration, was mechanically produced and hand-coloured, whereas contemporary illustration usually starts with a hand-drawn sketch and is finished – and coloured – on the computer. Technology's greatest impact on artwork, though, is on the actual production process. The ramifications are so profound that our understanding of the final product, our assessment of it – even our definition of what fashion illustration is – requires reconsideration.

'I am curious about what is going to happen,' muses Habermacher, whose work with Tsipoulanis fully exploits digital processes. In recent years, he tells me, he has realized that the direction of their work is different from what can be described as classical fashion illustration. 'Continuing on that road will necessarily lead to a new definition. I believe that descriptions of creative processes as "illustration", "art" or "handcraft" have lost their essential meaning nowadays.'

The selling point of illustration for many journalists and art buyers is the 'hand' of the work (a quality that, to my great chagrin, is often given a 'made by loving hands at home' gloss by the press). But when we look at M/M's watercolour splashes and graphics in *Paris Vogue*, what do we see? These computer-drawn doodles are positively Saharan, examples of hi-tech *trompe l'oeil* created without a brush and with not one drop of water. This does not affect the impact of the art, but it alters our definition of it. Similarly, our understanding of what constitutes an original is evolving now that much final work exists only in the virtual realm – until ejaculated by a computer printer.

Not surprisingly, many of the artists included in this book (and some in its predecessor) find the moniker 'fashion illustrator' ill-fitting. 'I have the impression', says Elisabeth Arkhipoff, with diplomacy, 'that nowadays there aren't really fashion illustrators, but one can be an artist, a graphic designer, a photographer....' Arkhipoff's views are echoed by Nawel, whose images are created using a mixture of techniques, including oil painting. 'Fashion illustration is something I do, but I am not a fashion illustrator...I draw, I paint, I take photographs. Fashion is one means of

◁
weiner clay
'Blue Thoughts'
Marker pen and gouache on manila paper
Artist's collection, 2003

◁
nawel
Yves Saint Laurent Rive Gauche
Oil paint on paper
Io Donna (Italy), 2003

expression.' Carlos Aponte states with certainty: 'I don't believe in fashion illustration but art, maybe fashion art if you want to label it. The work you see around in the last decade doesn't much resemble that term. I hear the word fashion illustration as I visualize a long-lost era.'

So what is fashion illustration now? Next? The artists give us some eclectic clues. Bernie Reid: 'Depicting fashion by any method besides photography.' Beautifully broad and generous, Reid's definition acknowledges the essential catch-22 of fashion illus-

△

toulouse sophie
Photoshop, Illustrator, ink and watercolour
Artist's collection, 2003

▷▷

reid bernie
Amaya Arzuaga
Pencil, marker and photocopy on paper;
model: Lucy McKenzie
Dazed & Confused (UK), 2002

tration: that it exists in direct relation (opposition) to fashion photography. The relationship between the two, ever since photography became the dominant means of sartorial representation in the thirties, is inescapably symbiotic and unequal; there will always be seesaw proportions – favouring photography – in print. Yet, this imbalance guarantees a perpetual redis-covery of the art of drawing at regular intervals, for, like fashion itself, modes of representation are trend driven.

'Fashion is capable of greater ideas than sexy.'

Clay Weiner

One of the reasons for the resuscitation of fashion illustration at the turn of the (21st) century was that it offered a (palliative) alternative to the dreary, shock-seeking, sex-riddled though not-quite-porn photographic aesthetic of the time. 'The only fantasy in pornography, if there is one,' Jean Baudrillard writes in *Seduction*, 'is not a fantasy of sex, but of the real, and its absorption into something more than the real, the hyperreal.' Illustration, by contrast, offered fantasy, satire and humour. And, as most illustrators

are relatively unknown, it was free from model-worship and the cult of the photographer, leaving wiggle room (as in a boyfriend's sweater) for viewer participation (outside of titillation).

This is not to say that the art in *Fashion Illustration Next* is without grit, set apart from sexuality. Quite the contrary. There is a marked move in this book toward an engagement with desire. Julie Verhoeven's work, for example, is unabashedly erotic. Photography's albatross is that it is always associated with the real and

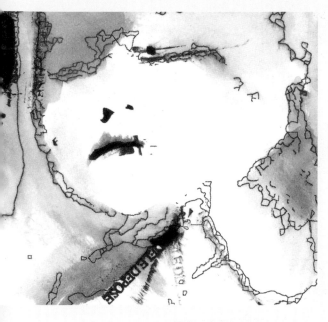

the known, no matter how altered, or how conscious the viewer is of its alteration. Photography and illustration engage the narrative in different ways, illustration being seductive, photography sexual.

'Fashion illustration is the art of seduction.'

Fábia Bercsek

Illustration is alluring because of its narrative qualities, by which I mean to say that it is visibly filtered through another person's (the artist's) sensibility. A pose, the set of a pouty lip, can speak volumes. Moreover, illustration is like couture; it is produced in limited quantities, with incredible skill (though technology might affect how quickly it is produced and distributed). Unlike couture, however, illustration's cost – relative to photography – is minimal, which, whether considered crass or not, is a factor in the art market.

The many column inches of press devoted to the 'Drawing Now' exhibition, shown at MoMA in Queens, New York in 2002, is a powerful witness to the repositioning of drawing in the art world. Once the Cinderella of the art world, considered the competent

but lesser product when compared with a 'finished' painting or sculpture, a process rather than an art, drawing now has credibility and cachet. Fashion illustration, however accomplished, is generally ignored by the arts establishment.

The work of John Currin, Elizabeth Peyton and Graham Little was included in a section of 'Drawing Now' titled 'fashion, likeness and allegory'. In the exhibition catalogue, curator Laura Hoptman writes about Peyton's 'partnership with fashion and fanzine pictures – sources outside fine art'. The implication is that outside equals populist and therefore commercial.

Many illustrators have exhibited their work in fine-art galleries. All, I venture to say, have been influenced by capital-A art. Some of the work that appears in *Fashion Illustration Next* has been commissioned and published in magazines. Some of it was made specifically for the book; and some of it is from the artists' collections (does this make it 'fine' art?). All of it, however, conforms to Warren du Preez and Nick Thornton Jones's proposition that 'fashion illustration is the collision between vision and fashion'.

'What you wear can get you sex or get you killed', asserts Miguel Adrover. The artists in *Fashion Illustration Next* spin sibylline stories about this power. Through their art the primitive power of clothing, art and identity – the story of all our lives – is told.

Laird Borrelli

akroe

Art is the means by which Akroe (aka Étienne Bardelli) 'elaborates on and embellishes' his 'own personal universe'. He is passionate about mixing drawing and graphic design, on the page, on the street – or in abandoned factories. The 'simplicity, clarity and logic' of industrial architecture and design is a continuing influence on him. 'Even more than in the past, my work is under this industrial influence – for purity of strokes and shapes, and for choosing colours and surfaces,' he says.

'Blumen', 2003
Illustrator and Bic pen

'Sewing Strokes', 2003
Drawing over photograph

(Photoshop and Bic pen);
photographer: Manuel Lagos Cid;
model: Lisa Aengel

anastase charles

'My work is uniquely autobiographical and a bit obsessional,' confesses Charles Anastase. The artist, who taught himself to draw as a child, says that 'today, drawing is like writing to me, because I have never stopped using pencils'. When making a drawing, Anastase (a designer) collaborates with the photographer Persephone Kessanidis. Following a shoot Anastase chooses the photos he wants to draw and then sets about it, spending three days to a week working on each illustration.

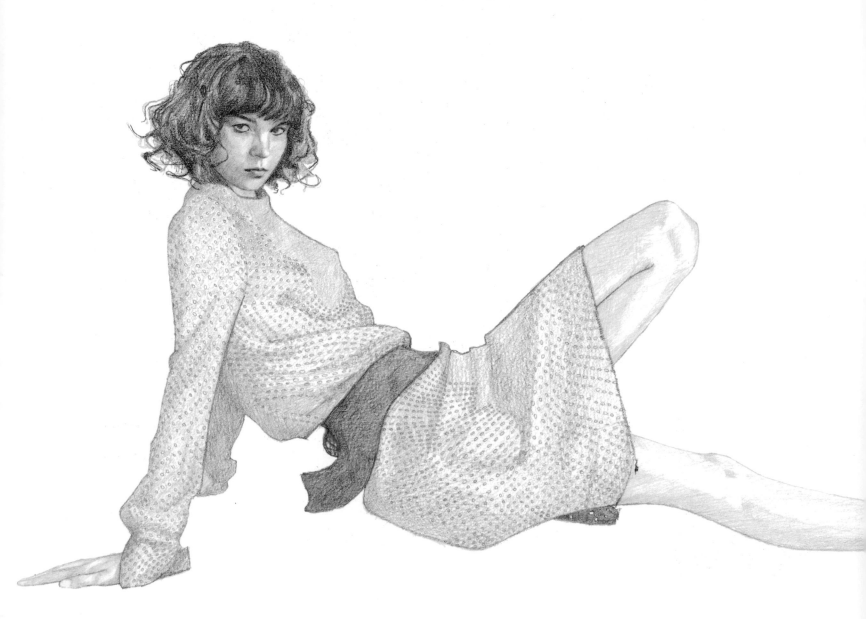

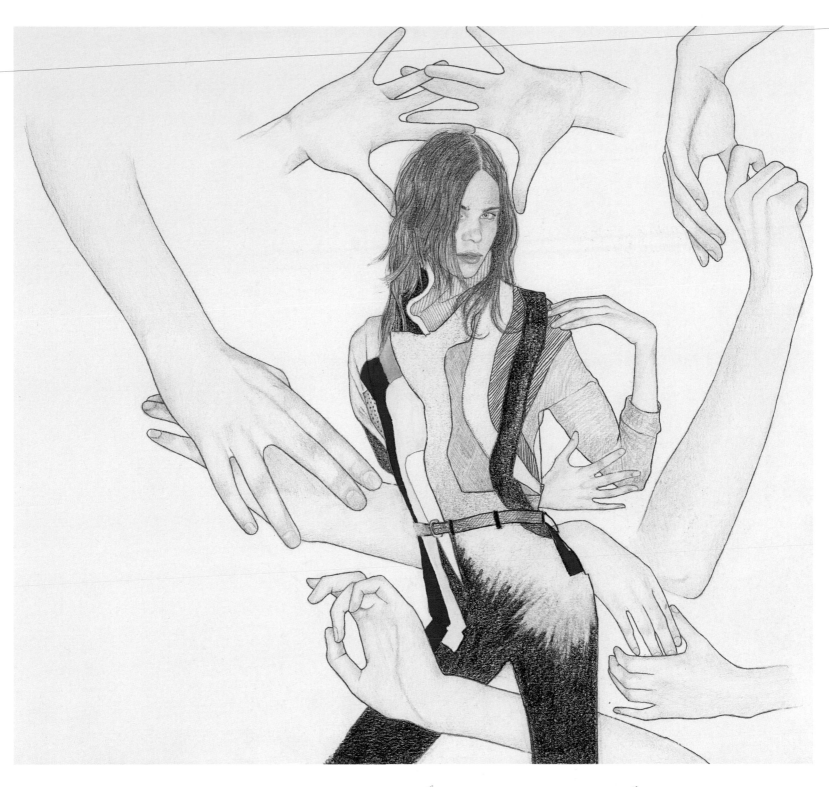

◁
'Non-finished Tribute to Martin
Margiela in Memory of My Grandfather'
Pencil on paper
Doing Bird (Australia), 2002

△
'The Hand People', Balenciaga
Pencil on paper
Dazed & Confused (UK), 2002

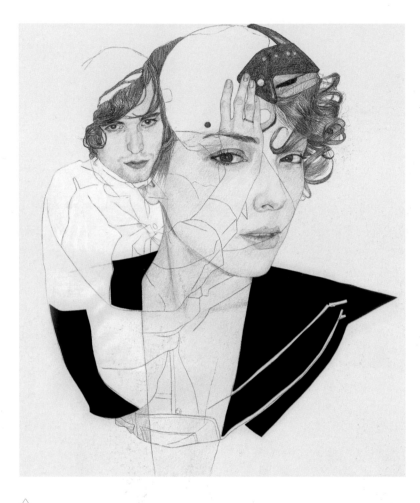

△
'Telepathy & Electricity', Wendy & Jim
Pencil on paper
Doing Bird (Australia), 2002

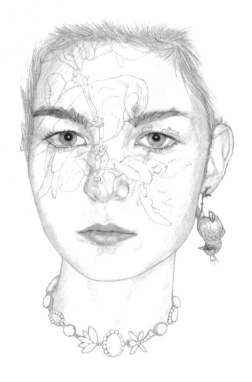

△
'Julie Morin – portrait'
Pencil on paper
Crash (France), 2002

Lundi 23 Avril I NEED FREEDOM 2002

△
'I Need Freedom, Non-finished
Tribute to Martin Margiela
in Memory of My Grandfather'
Pencil on paper
Doing Bird (Australia), 2002

'Telepathy & Electricity', Wendy & Jim
Mixed media, pencil and stickers
Doing Bird (Australia), 2002

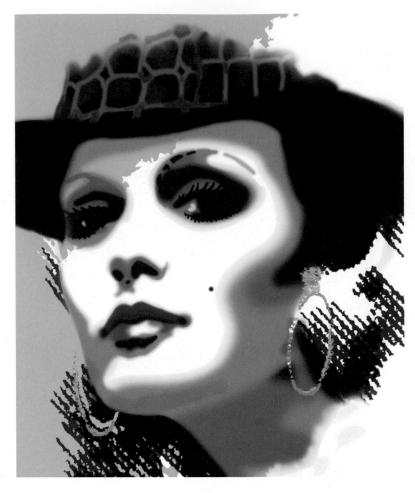

antoniou rebecca

'I love exaggerated postures and gestures,' says Antoniou. 'There's something very organic about the way a line can suggest something that isn't fully there, or a flowing movement.' An Art Nouveau aficionado with a penchant for the graphic stylings of the Constructivists, she works in Photoshop with scanned-in scraps of fabric, photographs, drawings and collage.

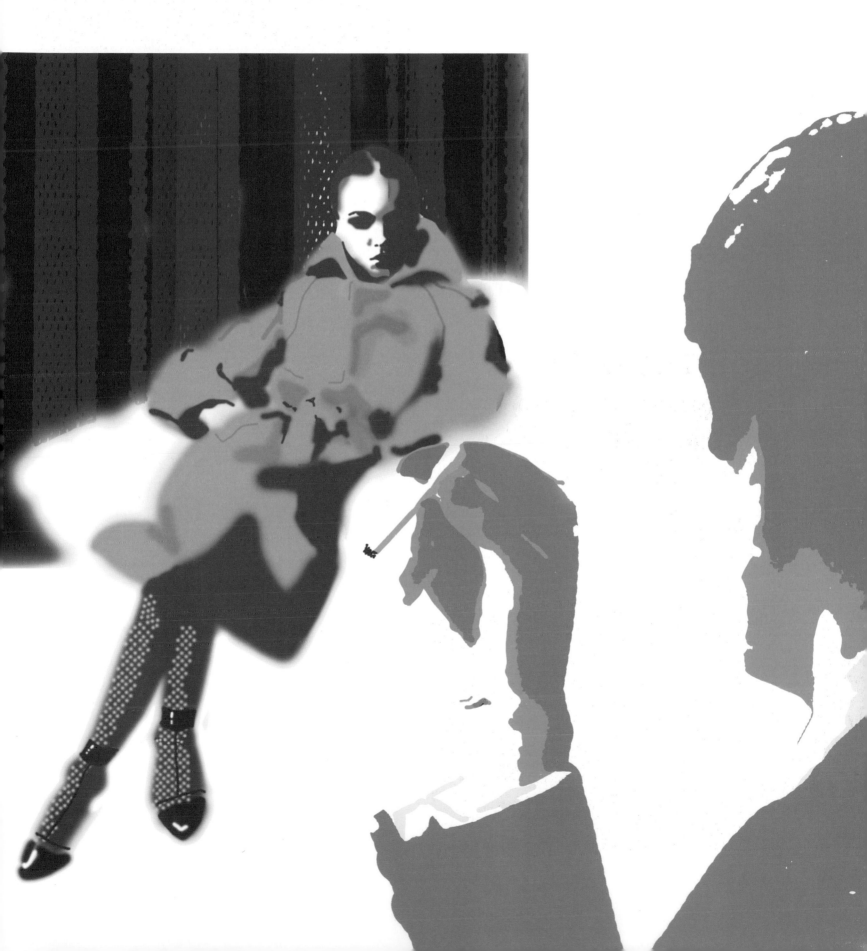

▷
Gucci
Photoshop over photograph;
photographer: Donna Francesca;
model: Andre at Premier
Loaded Fashion (UK), 2003

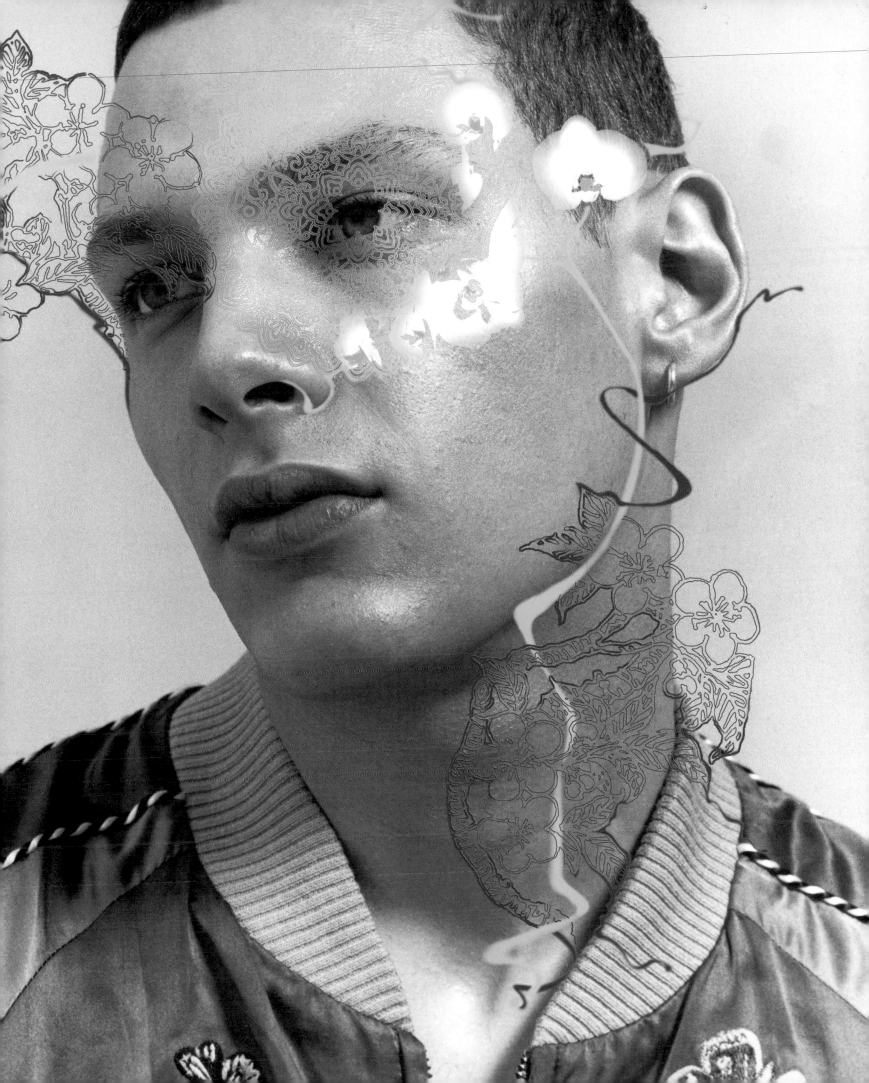

△ ▽ ▷▷

Paul Smith Christian Dior
Tape on board Tape on board
Created for *Fashion Illustration Next*, 2003 Created for *Fashion Illustration Next*, 2003

aponte carlos

'My style is not for the slick at heart, it's like going outdoors to a rough-and-tumble Jungle Gym playground,' says Aponte. Influenced by the teachings of Anna Ishikawa and the late Jack Potter, he uses many techniques, including digital, to produce a broad range of work. His masking-tape drawings/soft sculptures form a small, but important, part of this range. 'Few people know this side of me,' he admits.

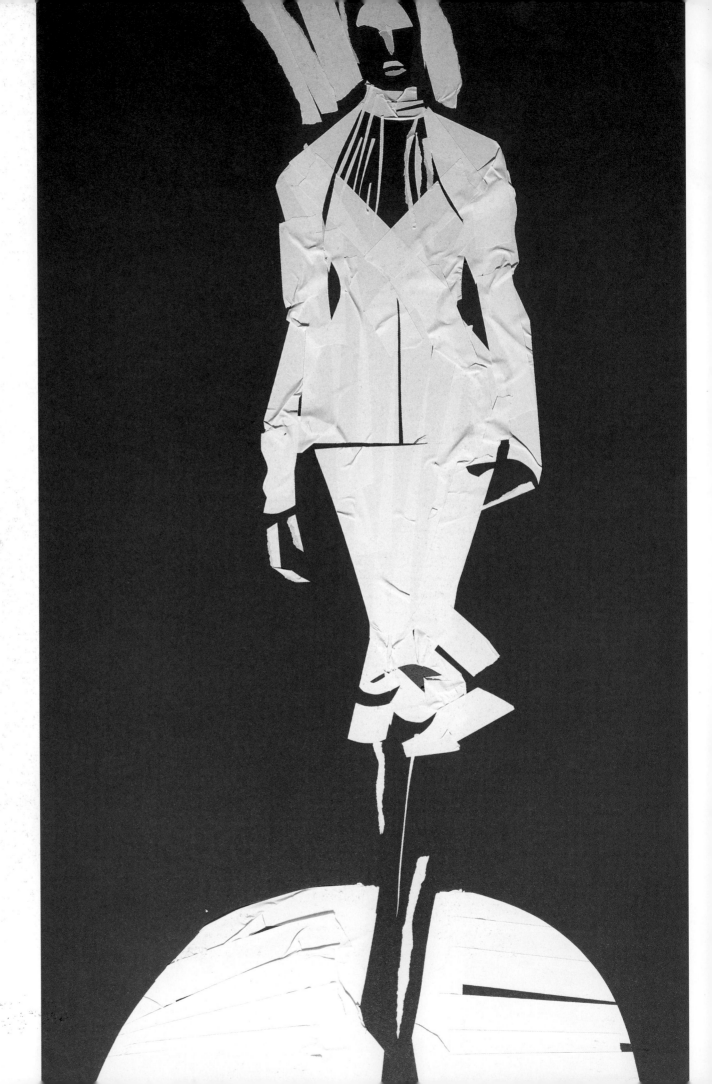

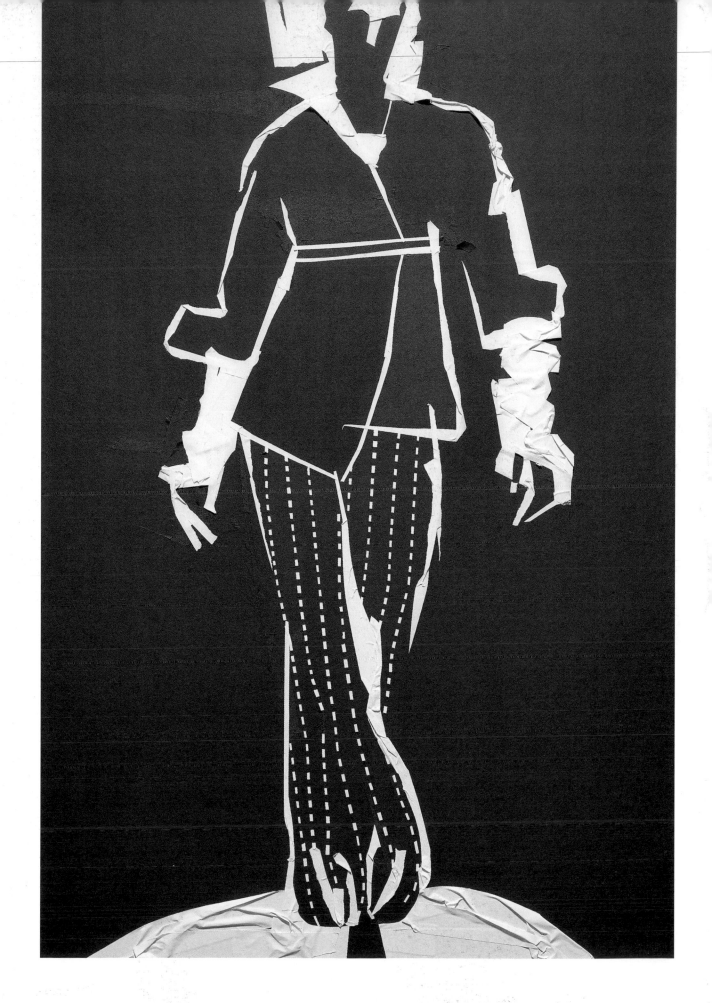

Gianfranco Ferré
Tape on board
Io Donna (Italy), 2003

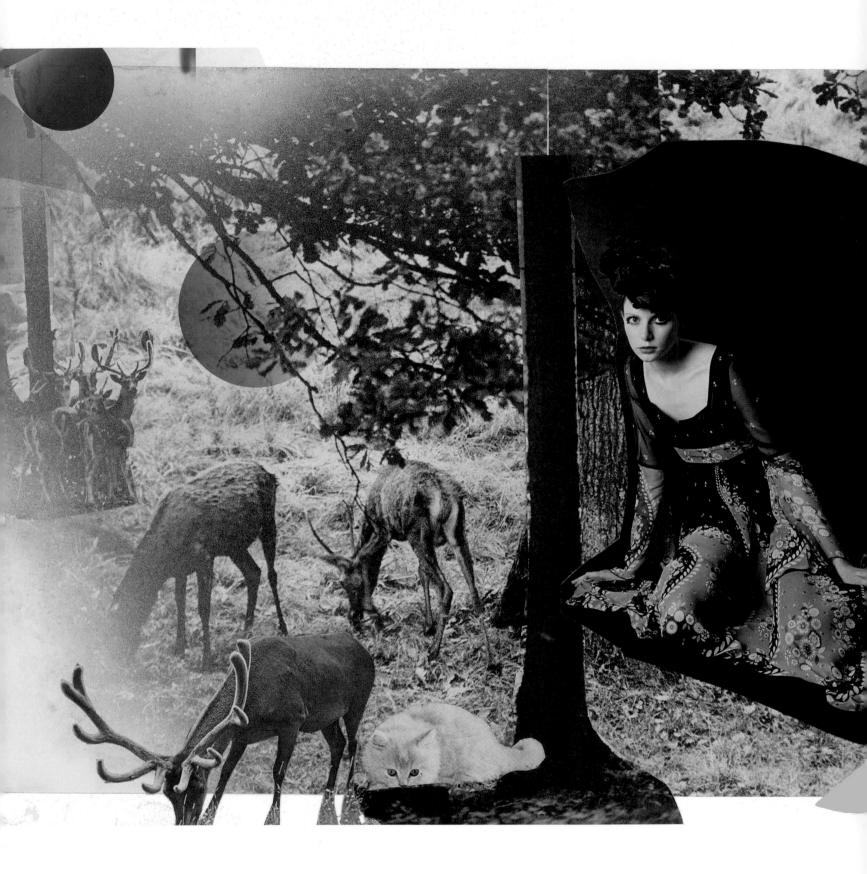

△ ▽
'Twilight Fantasy', Anna Sui
Collage; photographers: Elisabeth Arkhipoff
and Laurent Fétis
Vogue Nippon, September 2002

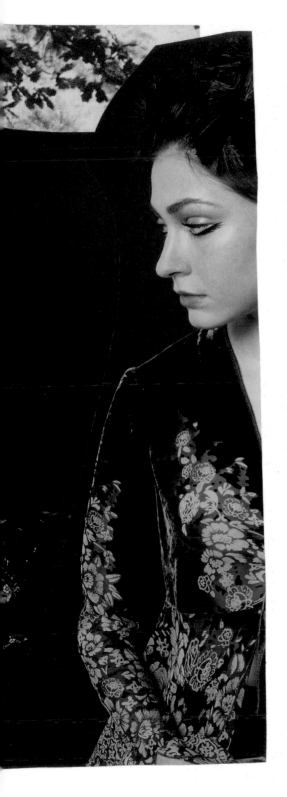

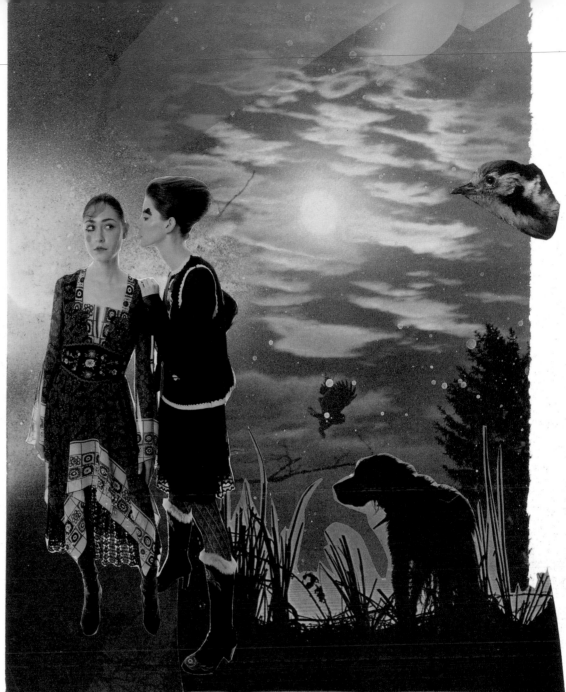

arkhipoff elisabeth

An artist and illustrator, Arkhipoff employs 'intuitive and anarchic' processes to create her work. The results of this approach are multimedia drawings, collages, installations and paintings that have been described as 'unexpected and twisted'. She says, 'my work is sincere and reflects my personality.'

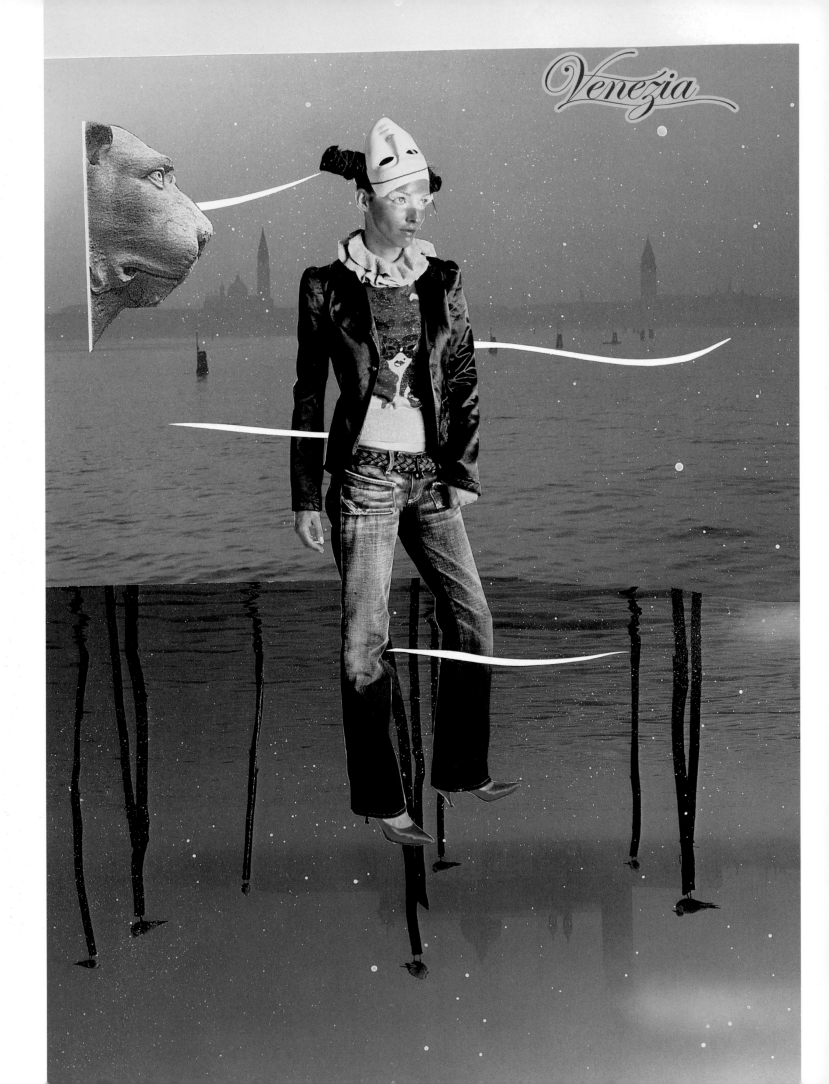

Venezia

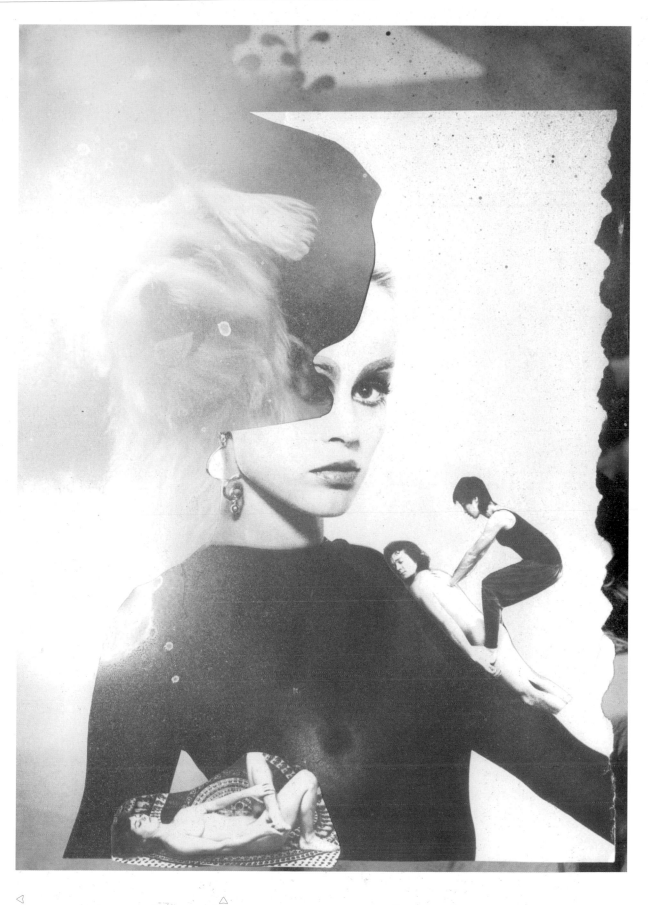

◁
'Diesel on Tour', Diesel
Collage; photographers: Elisabeth Arkhipott
and Laurent Fétis
Vogue Nippon, November 2002

△
Karine Arabian
Collage and paint on paper
Karine Arabian Campaign (France), 2003

barwick thomas

'I think you are always trying to catch something that you cannot really see,' muses Barwick. 'Women are not statues in a frozen moment and I am trying to capture this, not simply their grace but also animalistic movements, darting heads, piercing eyes... that hopefully gives the work a real psychological crunch.'

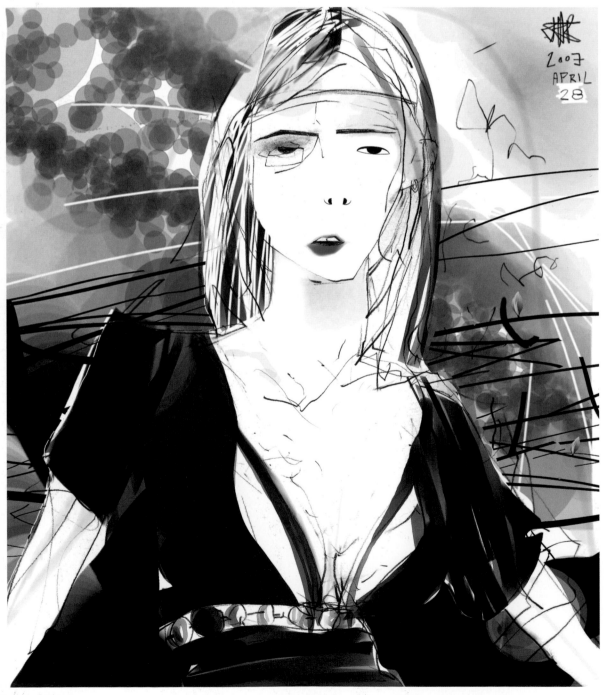

◁
Chloé
Pencil on paper, Photoshop,
Illustrator and Painter
Artist's collection, 2003

▷
Prada
Pencil on paper, Photoshop,
Illustrator and Painter
Artist's collection, 2003

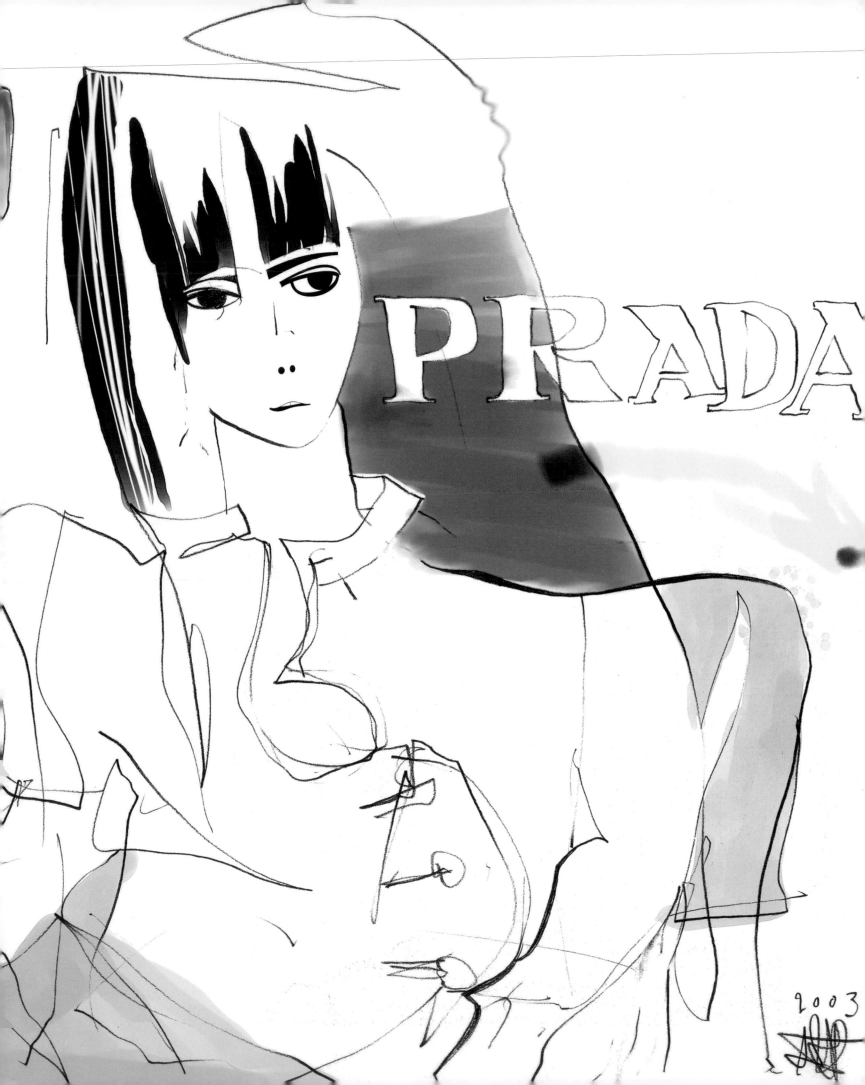

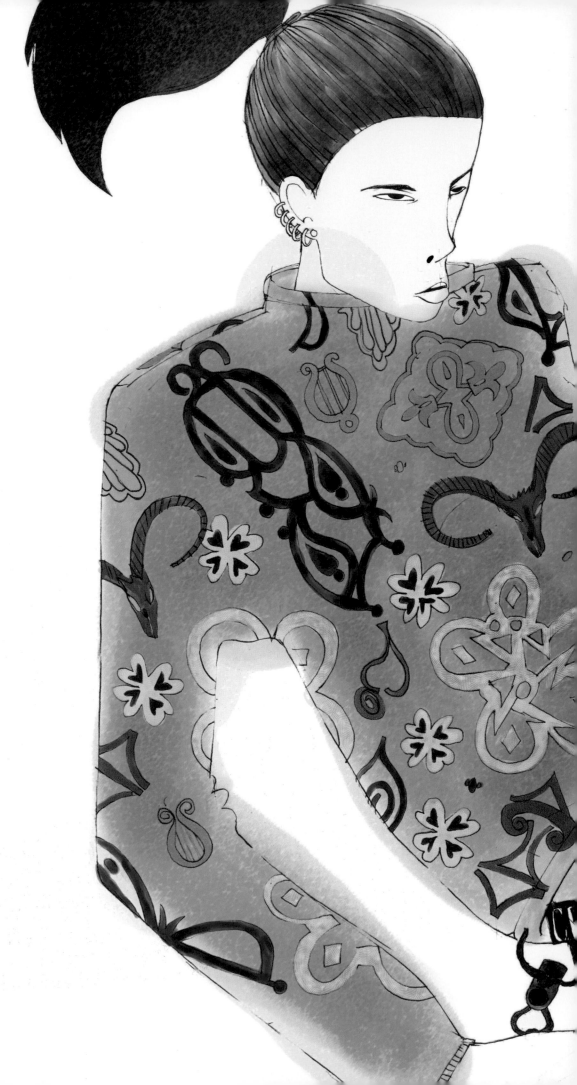

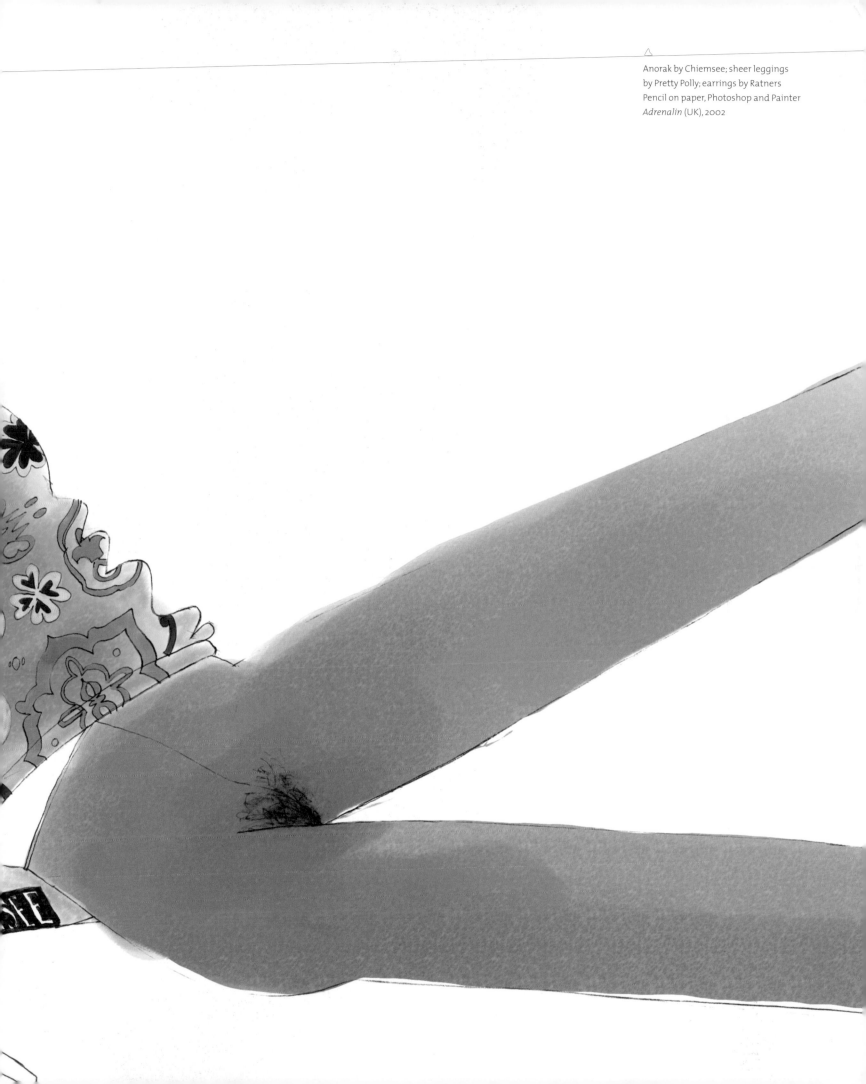

Anorak by Chiemsee; sheer leggings
by Pretty Polly; earrings by Ratners
Pencil on paper, Photoshop and Painter
Adrenalin (UK), 2002

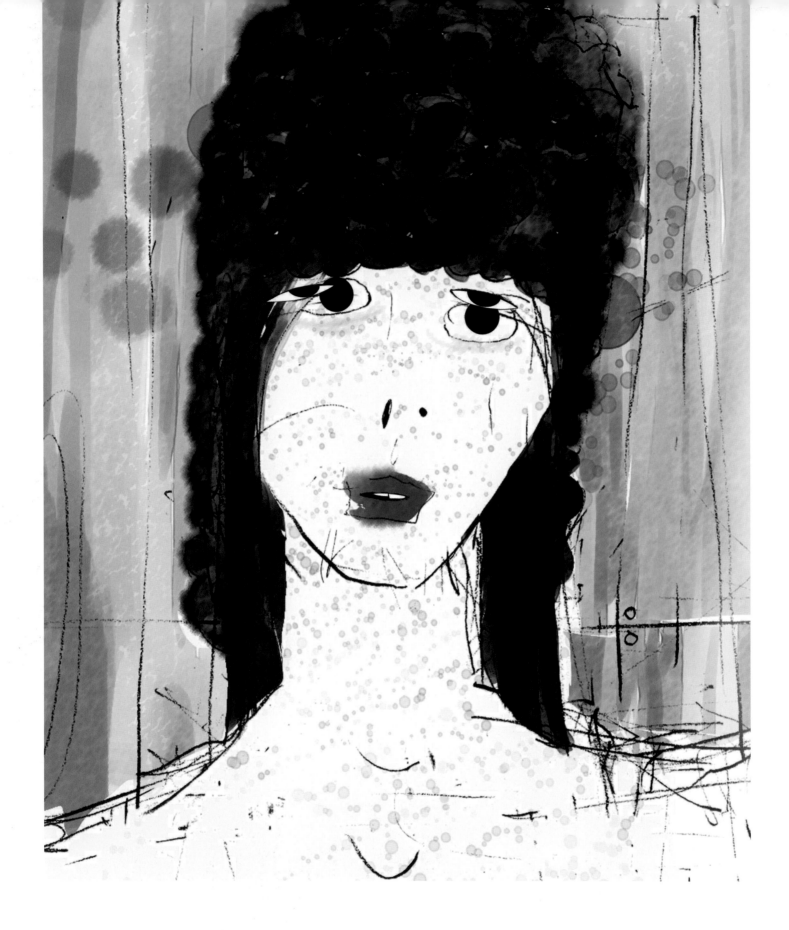

Hat by Blockhead
Pencil on paper, Photoshop,
Illustrator and Painter
Adrenalin (UK/Germany/France), 2002

'Herevolver'
Pencil on paper
Artist's collection, 2002

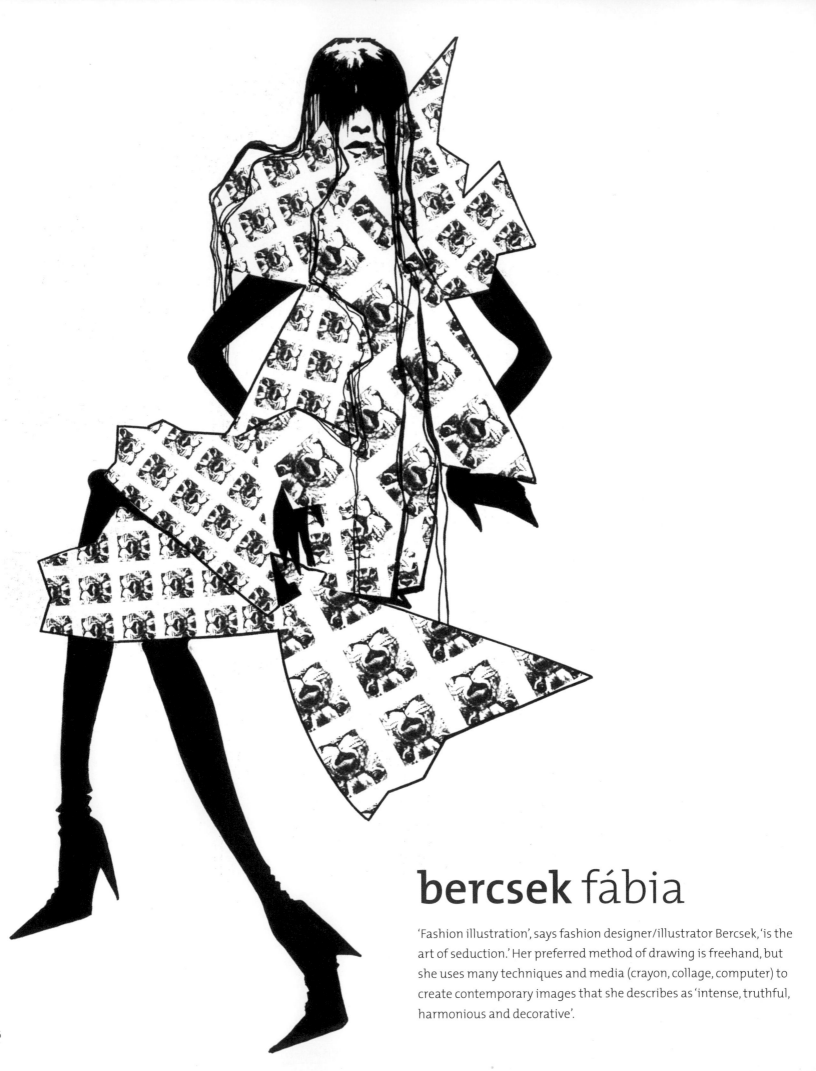

bercsek fábia

'Fashion illustration', says fashion designer/illustrator Bercsek, 'is the art of seduction.' Her preferred method of drawing is freehand, but she uses many techniques and media (crayon, collage, computer) to create contemporary images that she describes as 'intense, truthful, harmonious and decorative'.

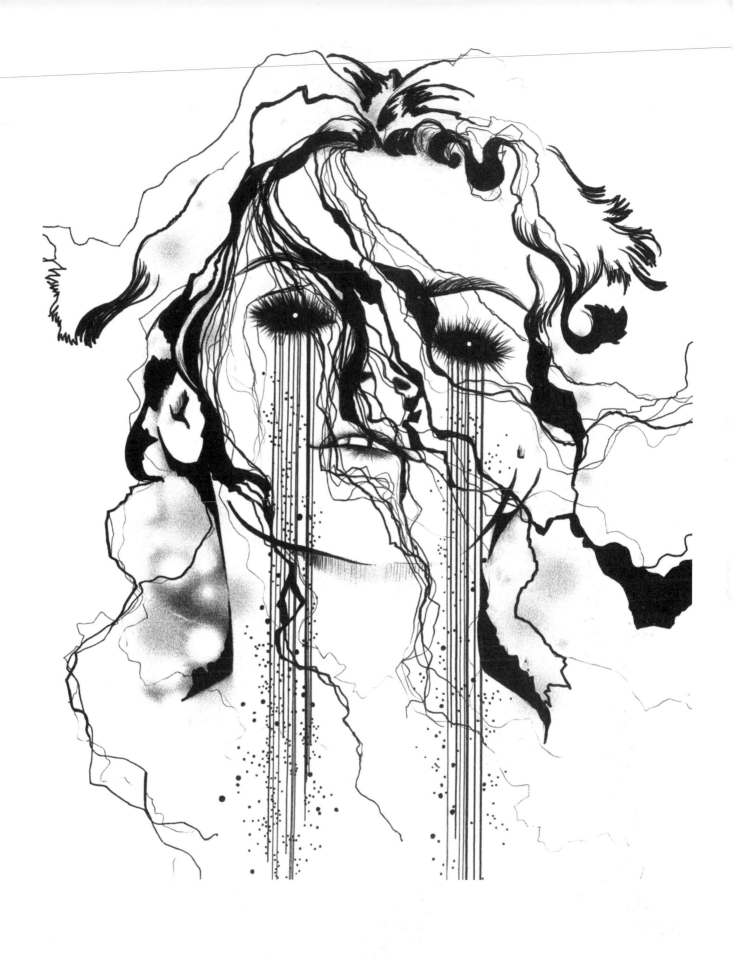

'Woman Crying'
Mixed media on paper
2Fanzine #3 (Brazil), 2003

'Woman with Lions'
Mixed media on paper
Artist's collection, 2003

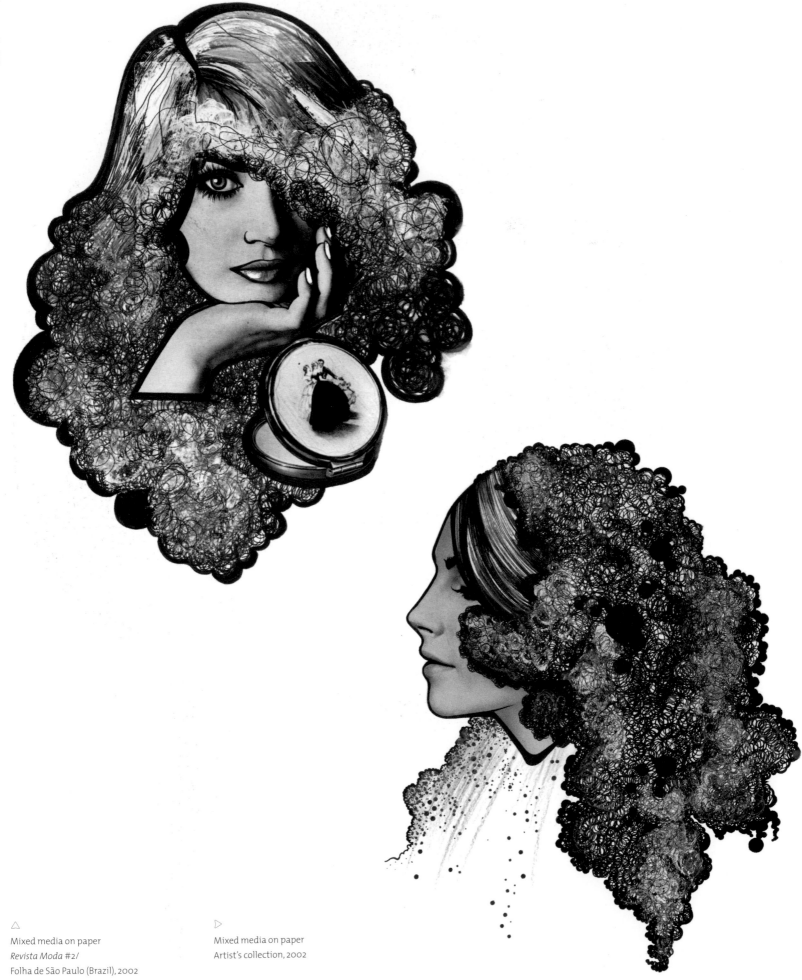

△
Mixed media on paper
Revista Moda #2/
Folha de São Paulo (Brazil), 2002

▷
Mixed media on paper
Artist's collection, 2002

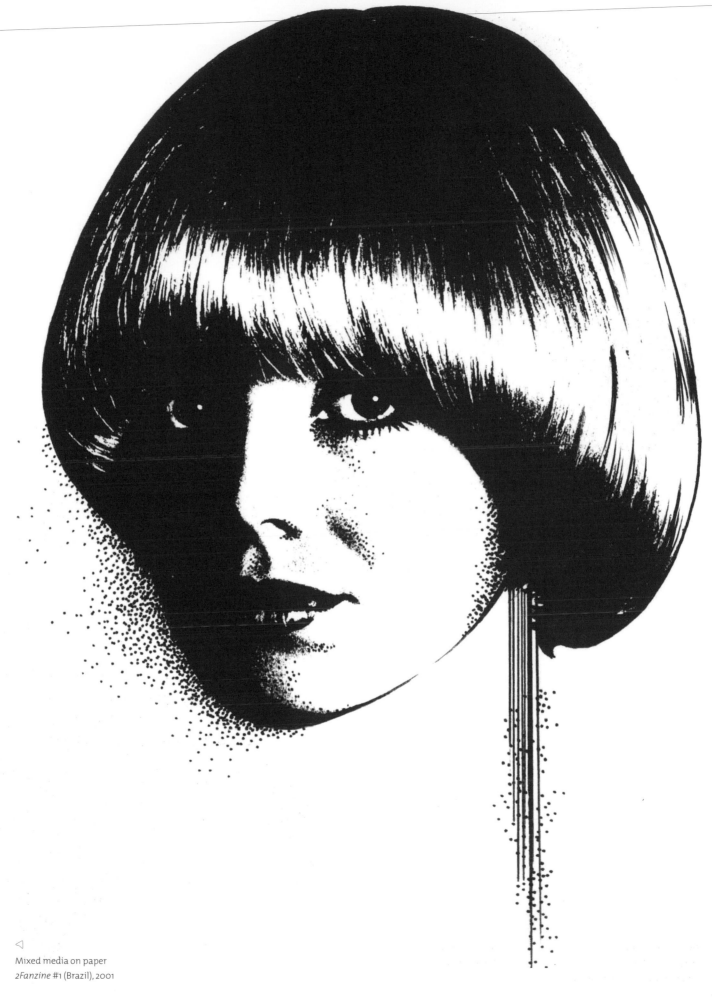

Mixed media on paper
2Fanzine #1 (Brazil), 2001

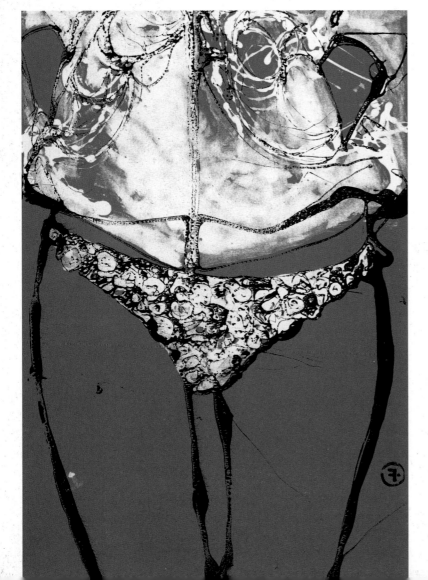

berthoud françois

Known for his direct and graphic linocut illustrations, Berthoud has begun to approach his images with other techniques, notably enamel drip. 'What I like about the enamel process is that it is fluid and immediate,' he says. When working on the computer Berthoud favours a few select effects, which he chooses before he starts. 'I like the technical aspect of things. The computer sounds very hi-tech, but when I work with enamel and dripping on paper the clinical processes are also very complex and sophisticated.'

△
'Girl with Earings'
Oil and enamel on paper
Flair (Italy), 2003

◁
'Girl Walking'
Oil and enamel on paper
Flair (Italy), 2003

▷
'Girl Sitting'
Oil and enamel on paper
Flair (Italy), 2003

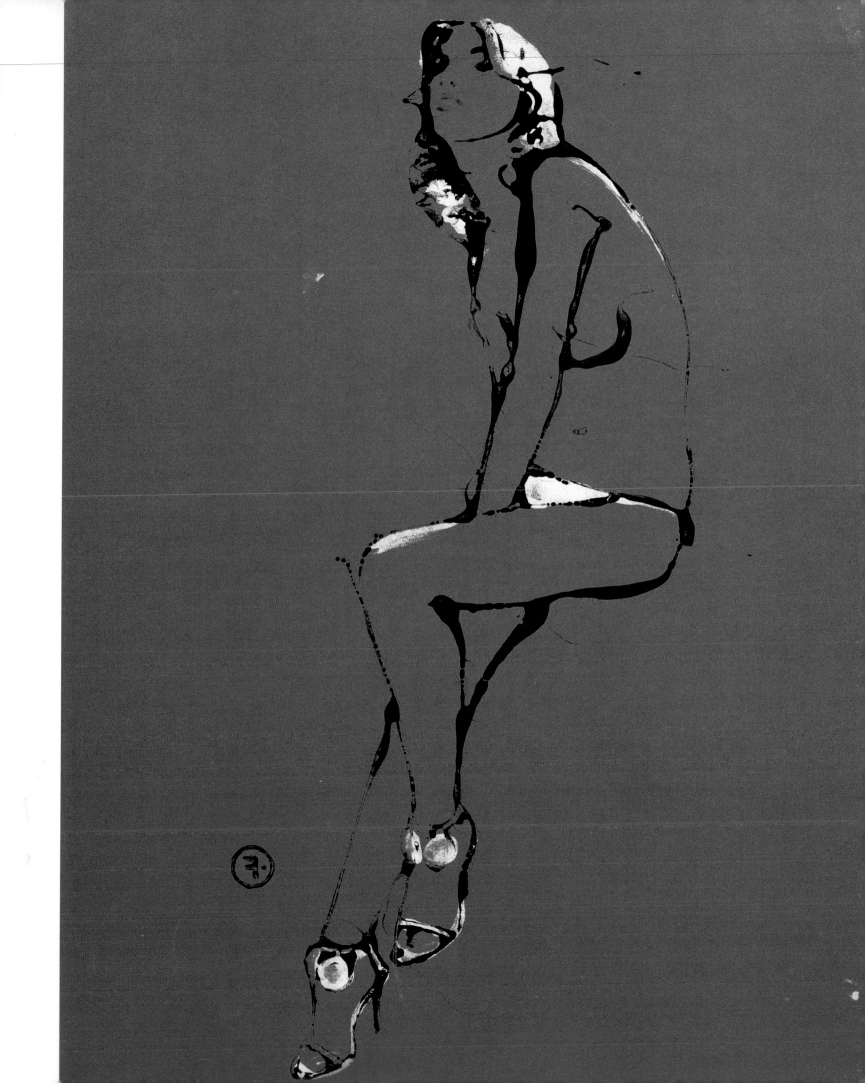

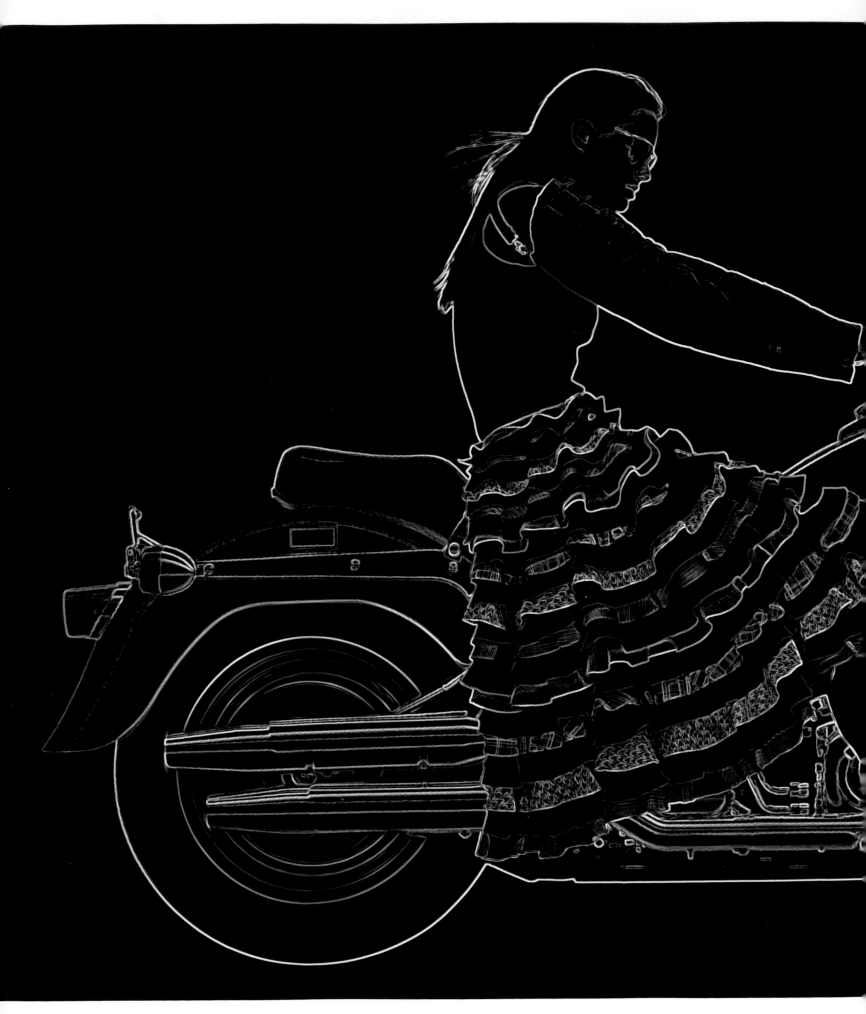

berthoud françois
'On Your Bike'
Photoshop
Artist's collection, 2001

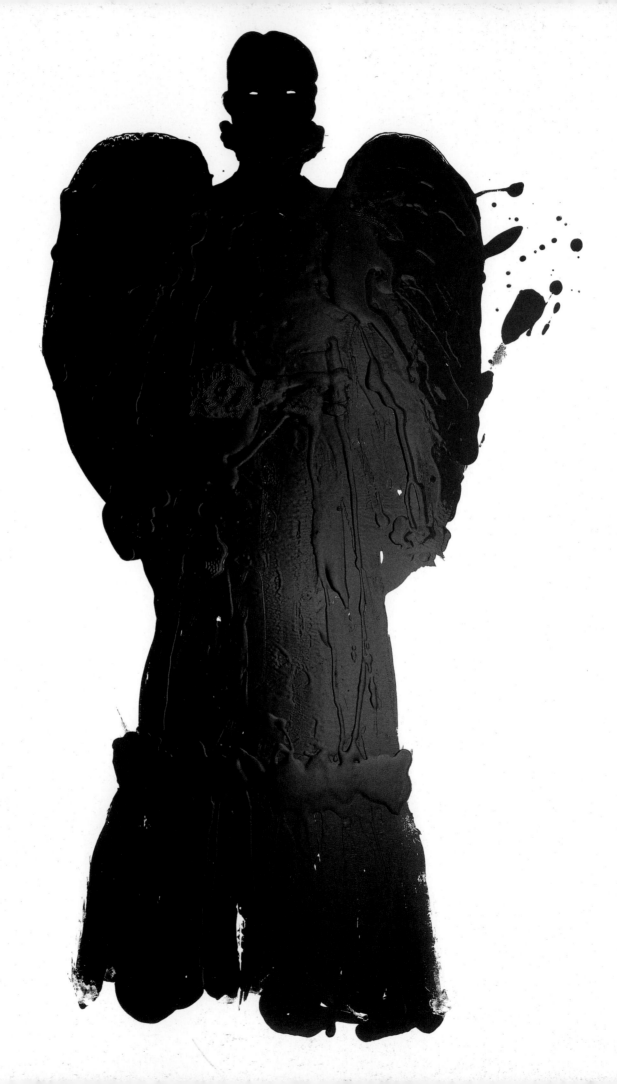

▷

'Black Angel', Viktor & Rolf
Enamel on paper
Dazed & Confused (UK), 2001

▷▷

'Preparation 2', Viktor & Rolf
Photoshop
Dazed & Confused (UK), 2001

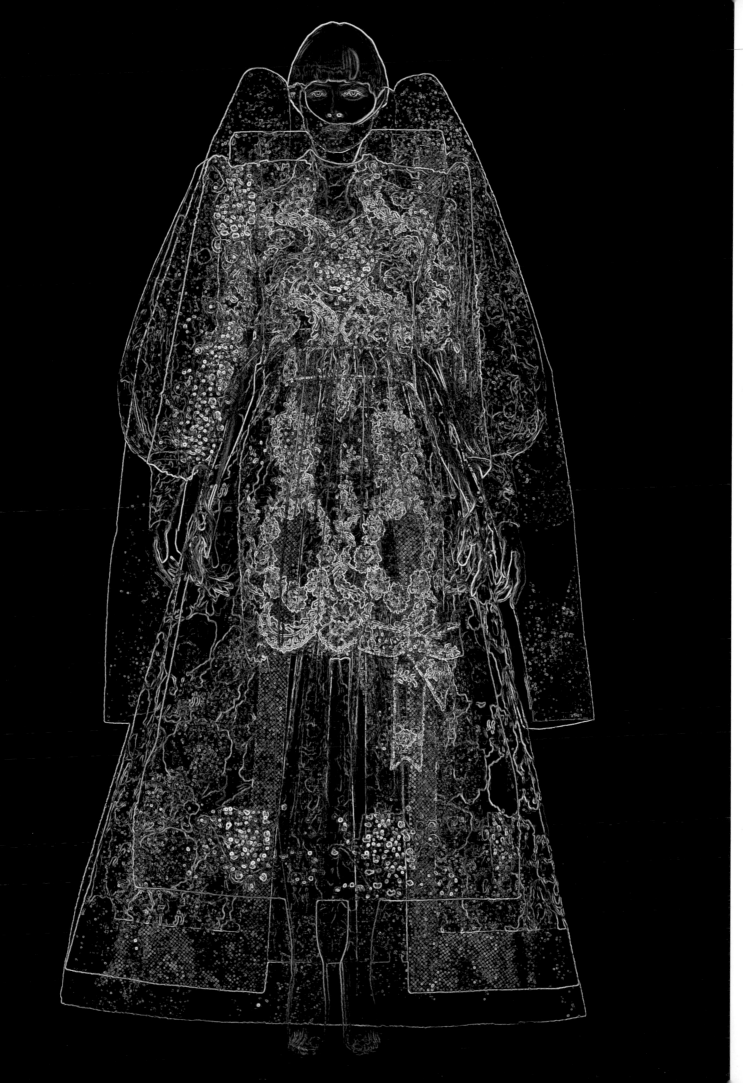

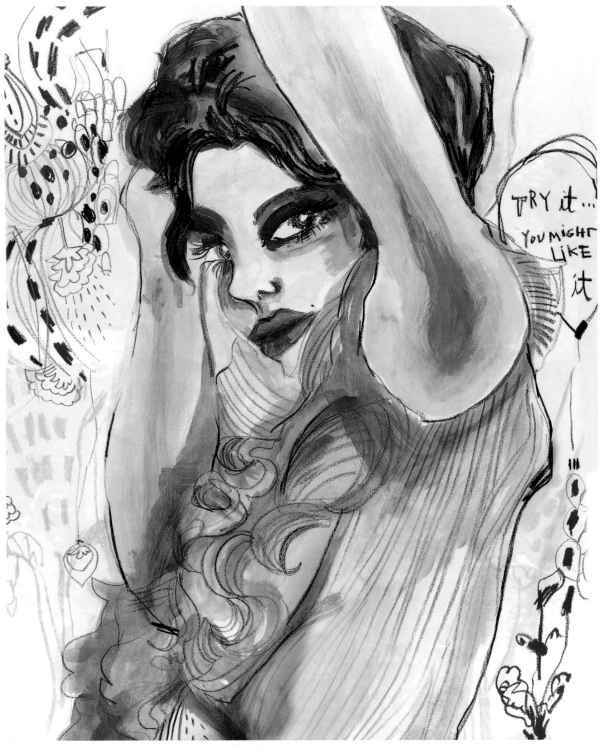

buzzelli kime

For as long as she can remember, Buzzelli has been experimenting with various media in an effort to 'transform the hideous into something with glamour'. Make-up, watercolour, thread, fabric and a variety of 'decomposing materials' are incorporated into her drawings, which are sometimes stuffed and made three-dimensional. 'I'm obsessed', Buzzelli confesses, 'with lost innocence, teen lust – that making out in a back seat kinda feeling.'

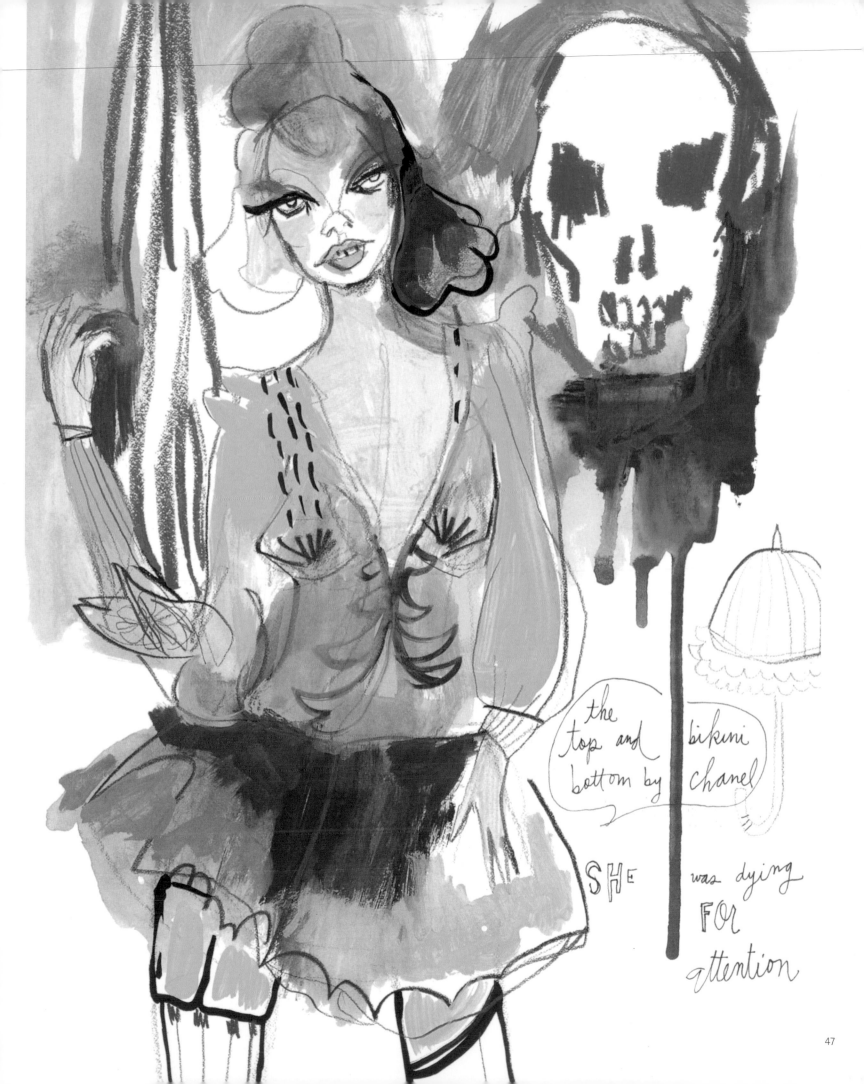

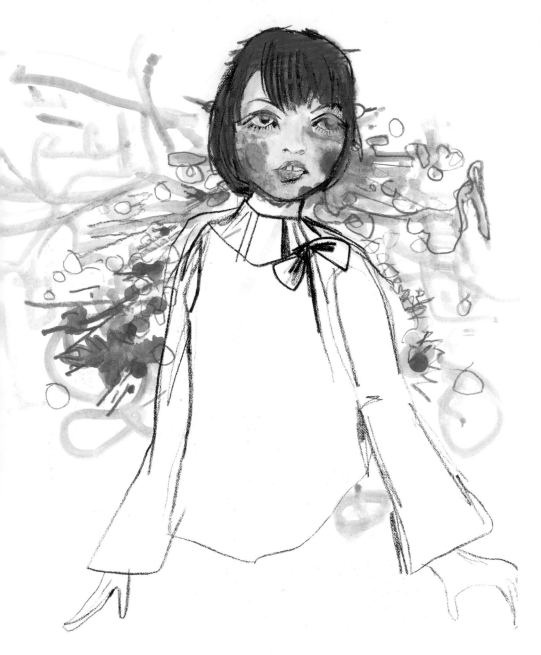

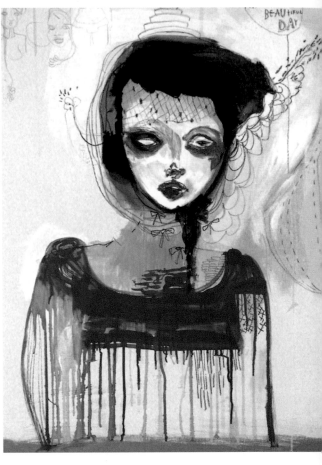

△
'Girl with Bow'
Mixed media collage
Artist's collection, August 2003

◁
'Girl with Dark Hair'
Mixed media collage
Artist's collection, August 2003

▷
'Go On, Go On'
Mixed media collage
Artist's collection, August 2003

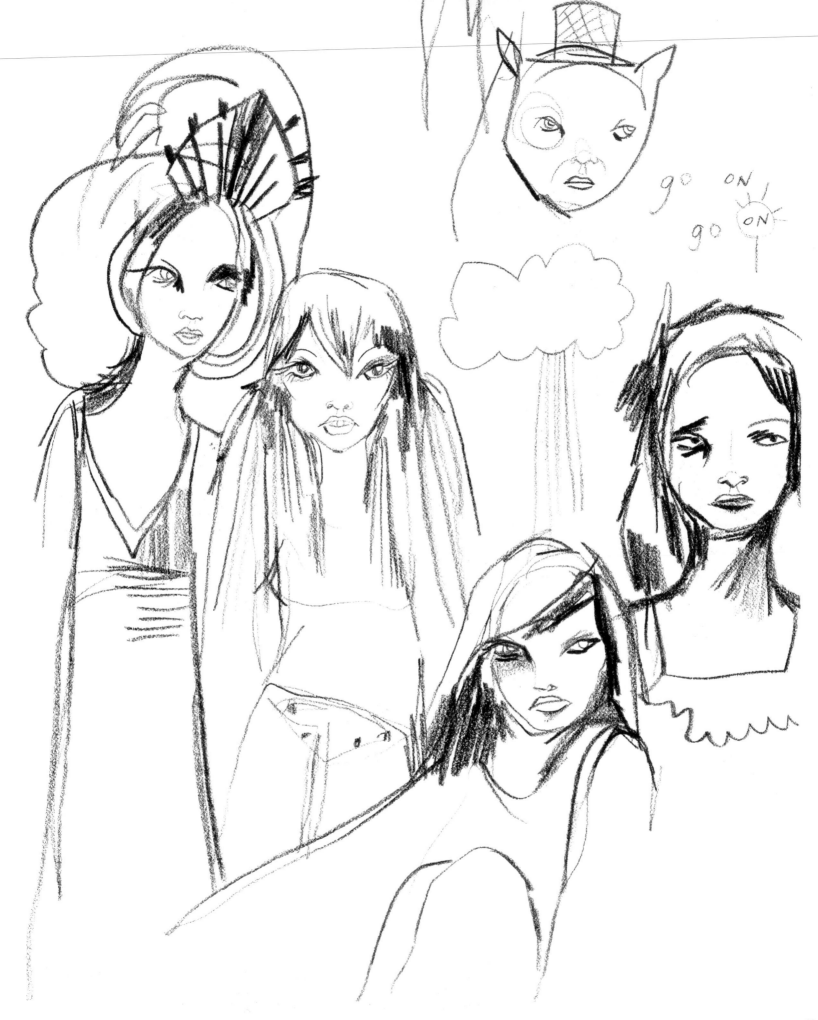

go on

go on

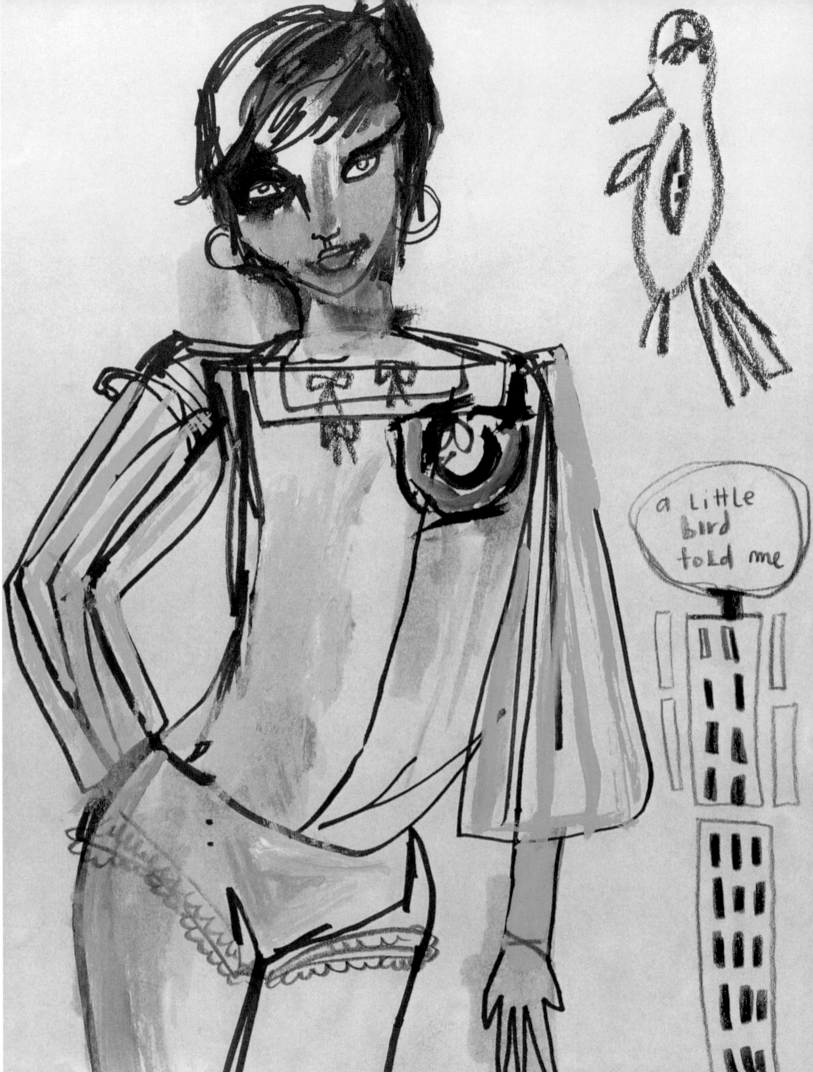

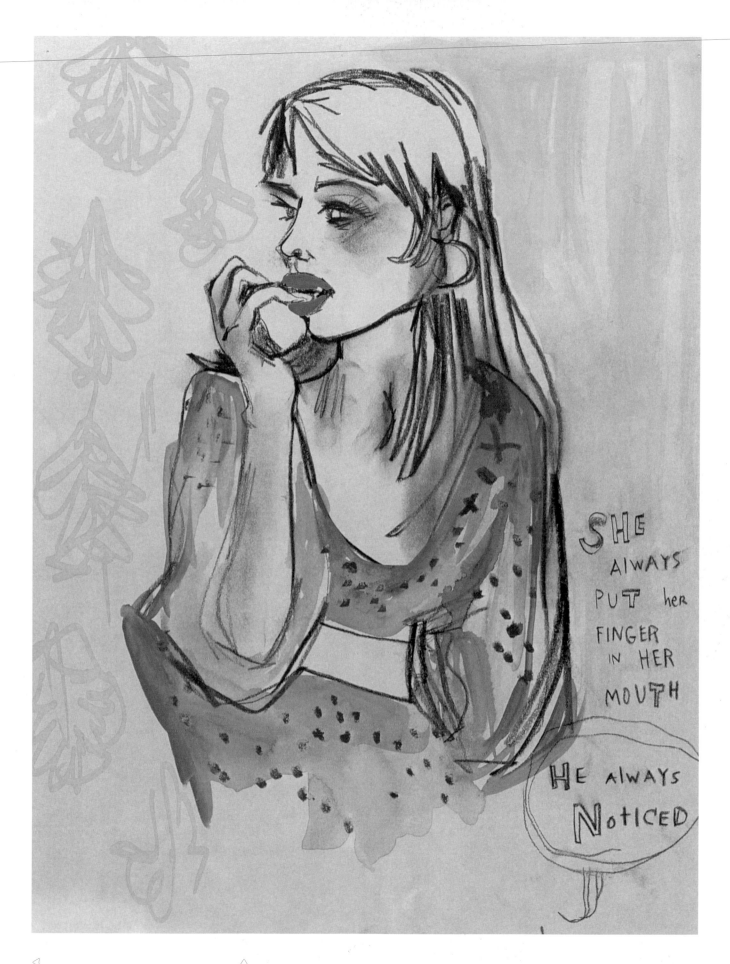

◁
'A Little Bird Told Me'
Mixed media collage
Artist's collection, April 2002

△
'She Always Put Her Finger in Her Mouth'
Mixed media collage
Artist's collection, April 2002

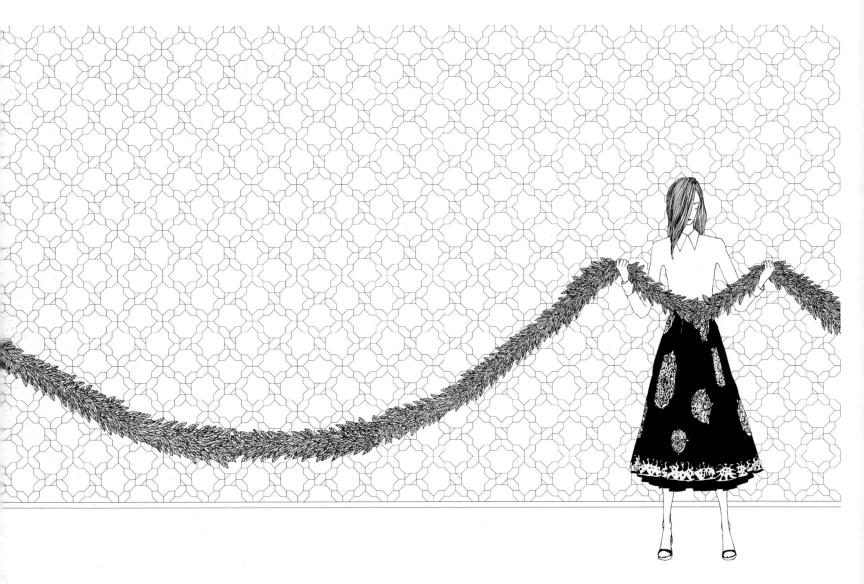

cardenas alejandro

Cardenas's pieces start with him putting pen to paper, making a drawing. He scans these drawings into the computer, adding colour and then letting them fly. 'Each illustration does its own thing,' he says. 'I get to make them, and then let them go.'

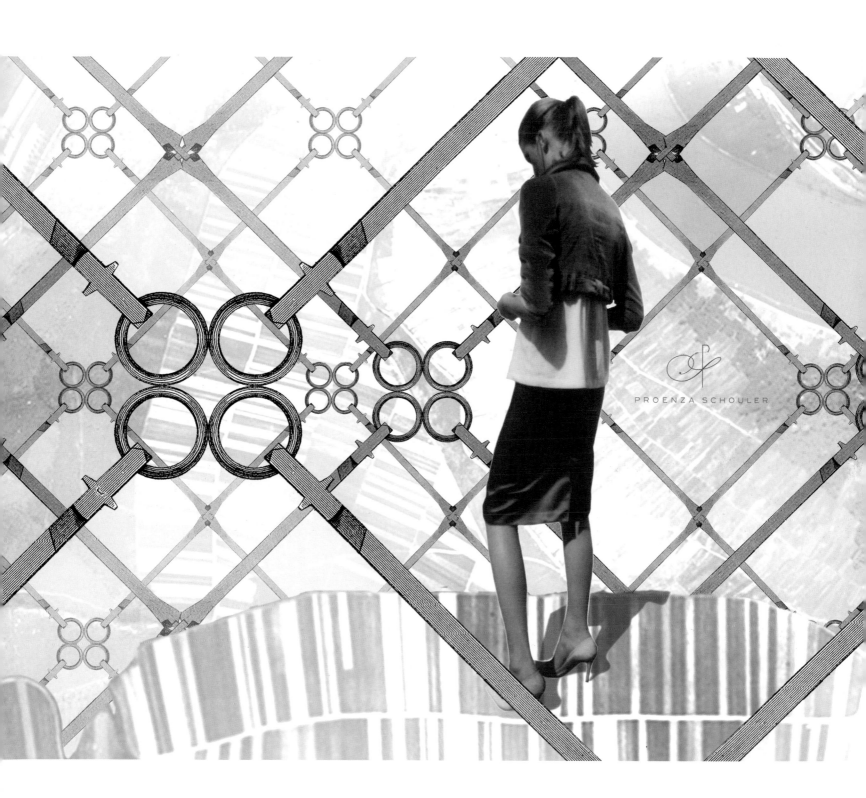

PROENZA SCHOULER

▽
'Diamond Terrace', Miu Miu
Pen and ink, Illustrator, Photoshop
Exit Magazine (UK), 2002

△
Pen and ink, photograph, Photoshop collage;
photographer: Terry Tsiolis
Window design (Proenza Schouler)
for Colette, 2002

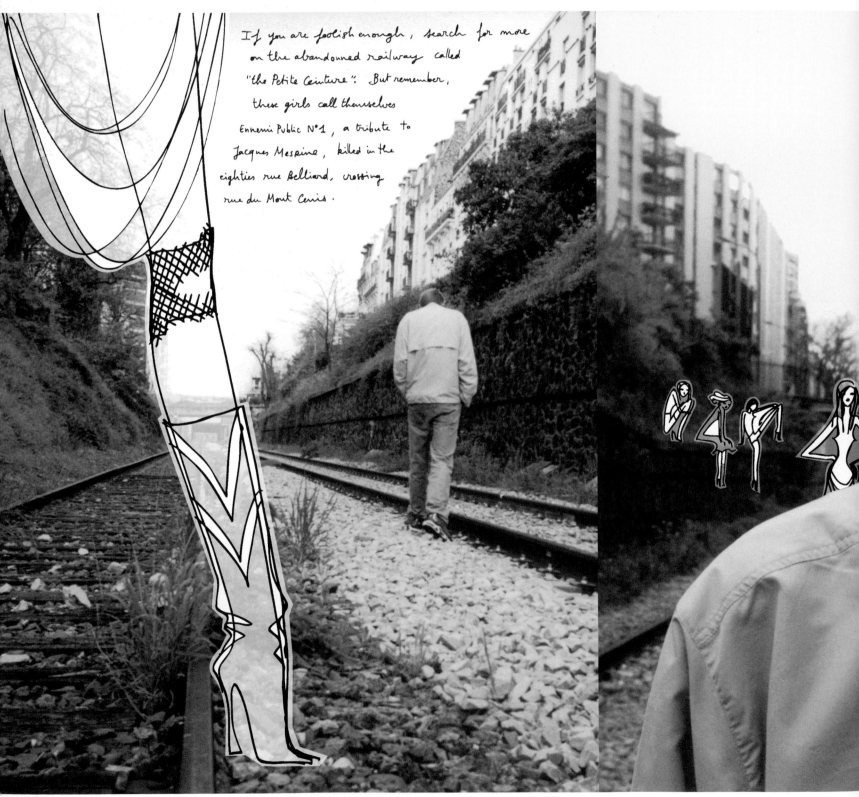

If you are foolish enough, search for more on the abandonned railway called "the Petite Ceinture". But remember, these girls call themselves Ennemi Public N°1, a tribute to Jacques Mespine, killed in the eighties rue Belliard, crossing rue du Mont Cenis.

'Drawing fashion', says illustrator/animator Florence Deygas, 'is like the direction of a motion picture: it's the ability to lead the eye in a subtle manner to the right spot.' Deygas entices the eye with the spontaneity and nonchalance of her flexible, 'smiling' line. She begins on paper and finishes her drawings in Illustrator. Her inspiration? People she sees in the street. Her goal? To create accessible worlds into which others can enter.

◁
'Paris 18, petite ceinture'
Pencil on paper, Photoshop
Big #38 (USA), 2001

△
'Paris 18, passe muraille'
Pencil on paper, Photoshop
Big #38 (USA), 2001

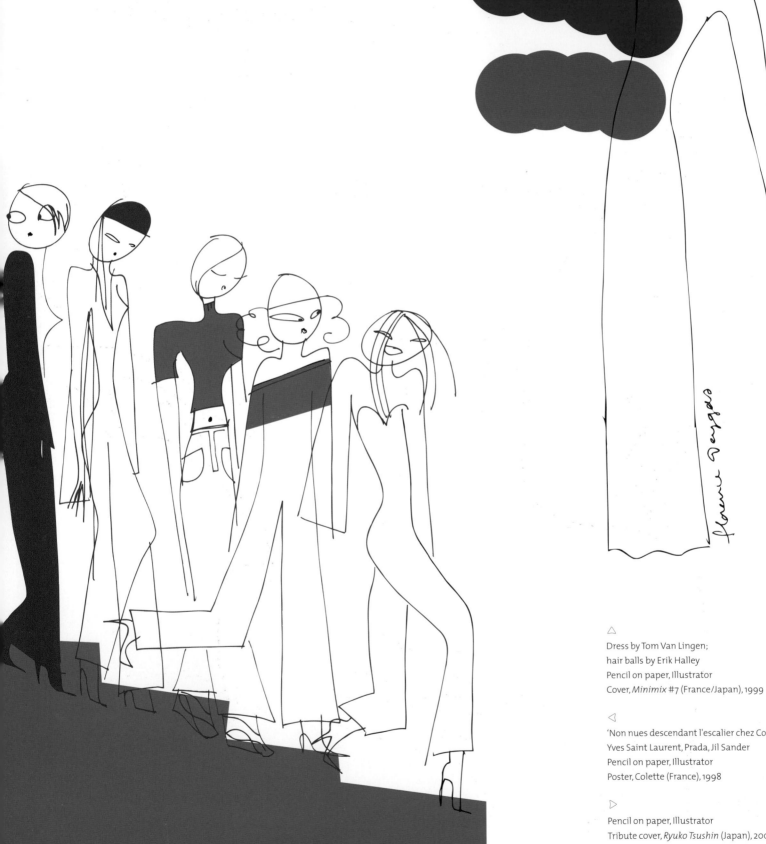

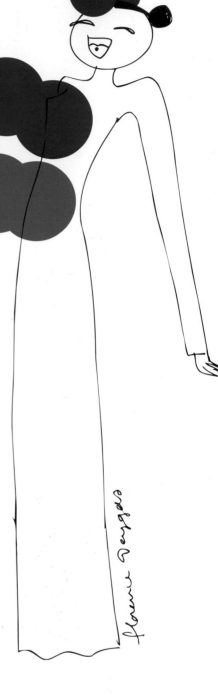

△

Dress by Tom Van Lingen;
hair balls by Erik Halley
Pencil on paper, Illustrator
Cover, *Minimix* #7 (France/Japan), 1999

◁

'Non nues descendant l'escalier chez Colette'
Yves Saint Laurent, Prada, Jil Sander
Pencil on paper, Illustrator
Poster, Colette (France), 1998

▷

Pencil on paper, Illustrator
Tribute cover, *Ryuko Tsushin* (Japan), 2002

esdar maren

Guided by intuition and imagination, Maren Esdar creates extravagantly surreal and 'cerebral' hand-crafted collages (to which she sometimes adds a computerized background). An artist and fashion stylist, she finds that her illustrations inspire her designs and vice versa. The films of Peter Greenaway are an important influence on her work. 'My collages', she says, 'are like a play where beauty and cruelty find harmony.'

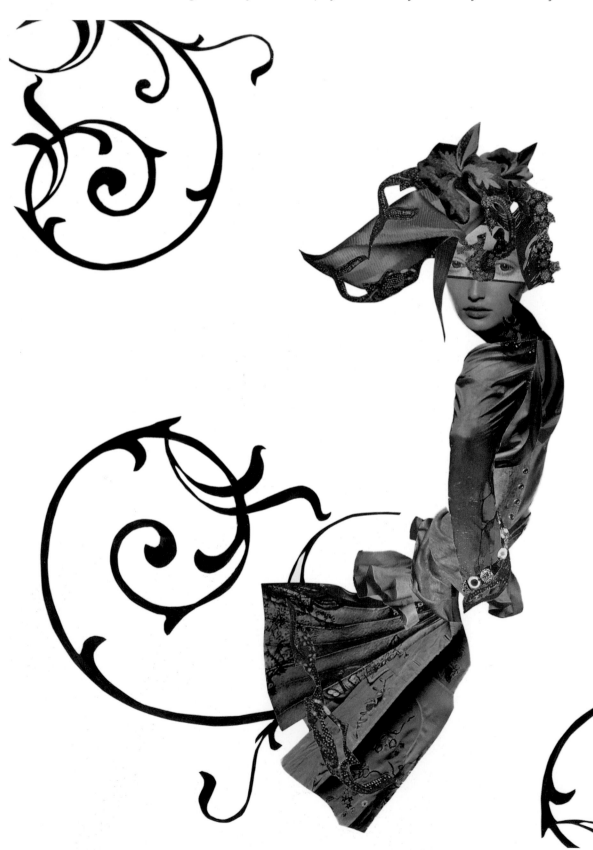

▷
'Ornament Girl'
Mixed media collage
Vorn (Germany), 2003

▷▷
'Girl with Butterflies'
Mixed media collage
Created for *Fashion Illustration Next*, 2003

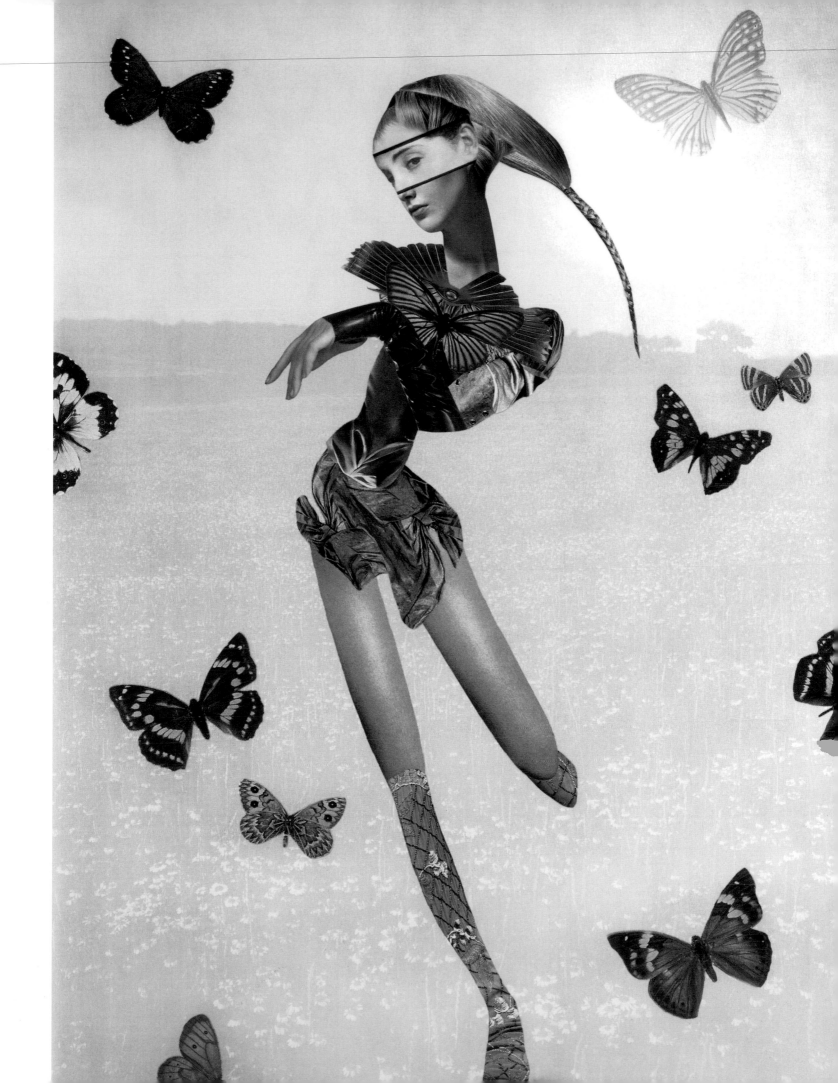

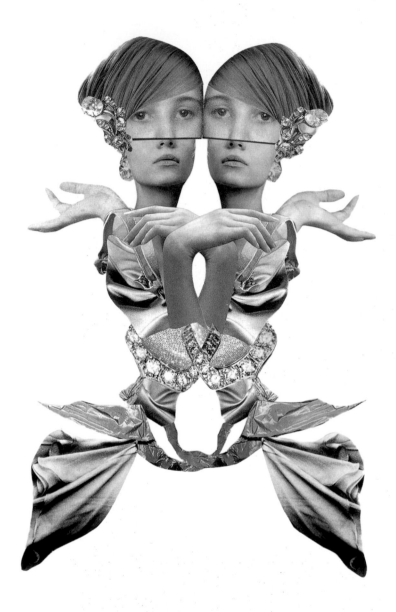

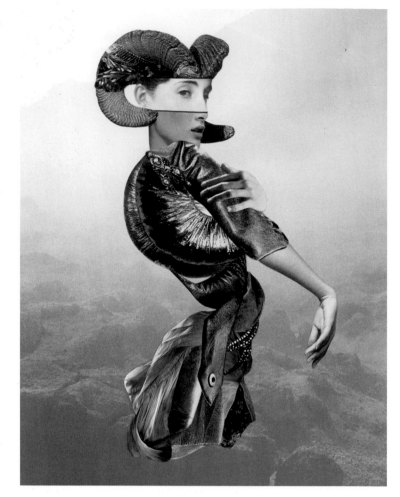

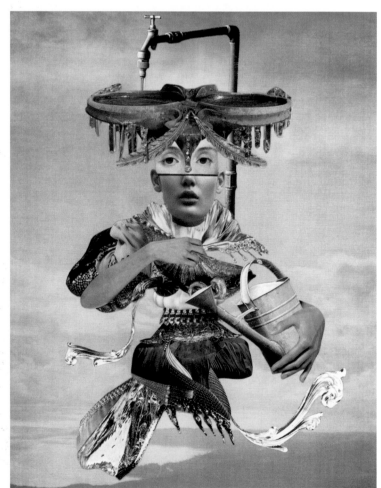

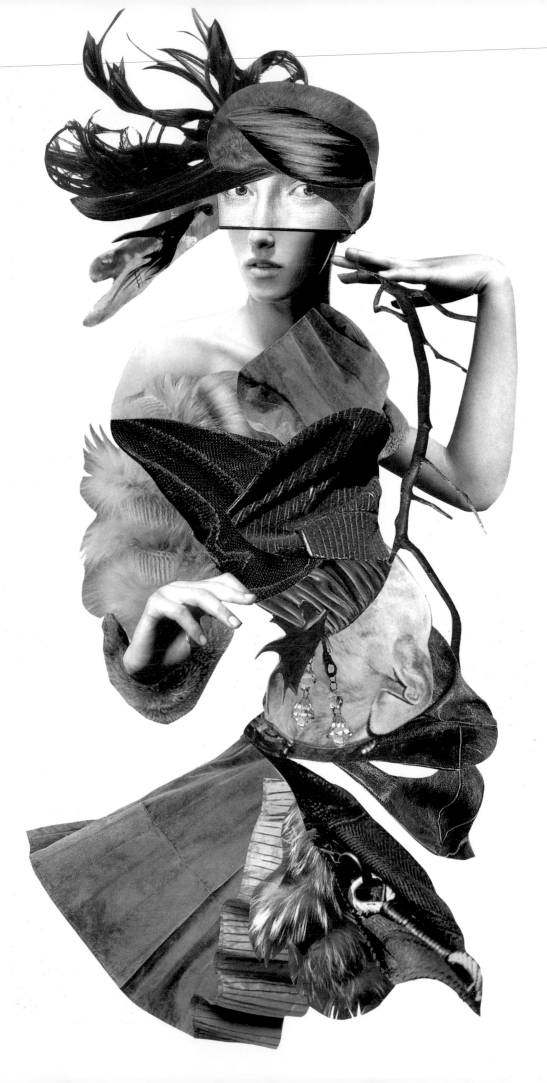

▷
'Aries'
Mixed media collage
Annabelle (Switzerland), 2003

◁◁
'Gemini'
Mixed media collage
Annabelle (Switzerland), 2003

◁
'Aquarius'
Mixed media collage
Annabelle (Switzerland), 2003

▷
'Into the Woods'
Mixed media collage
Sepp (Germany), 2003

Gloss CD sleeve for Grapevine
Ballpoint pen and black ink on paper
Pony Canyon Inc. (Japan), 2000

▷▷
Ballpoint pen and black ink on paper,
coloured in Illustrator
Advertisement for Clone (Italy), 2000

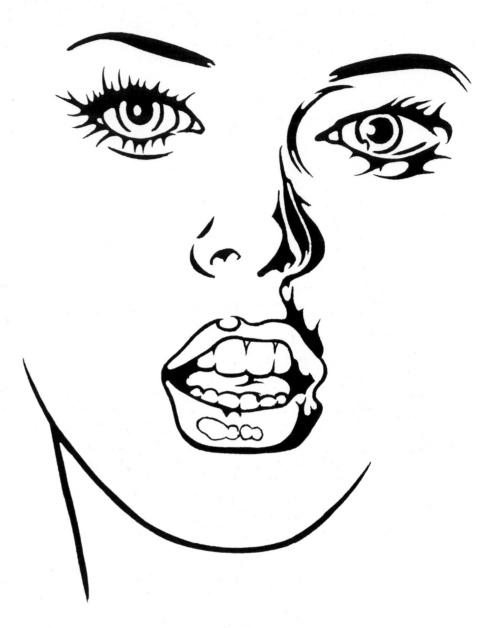

galdos del carpio
tristan

Galdos del Carpio likes to work late at night, drinking coffee and listening to film soundtracks. His pristine drawings are created with ballpoint pen or acrylic paint. The artist says that his initial sketches look like kids' drawings – 'spontaneous and strange', qualities he values. 'My ambition', he says, 'is to make my drawings lively, neat, and shiny like fruits.'

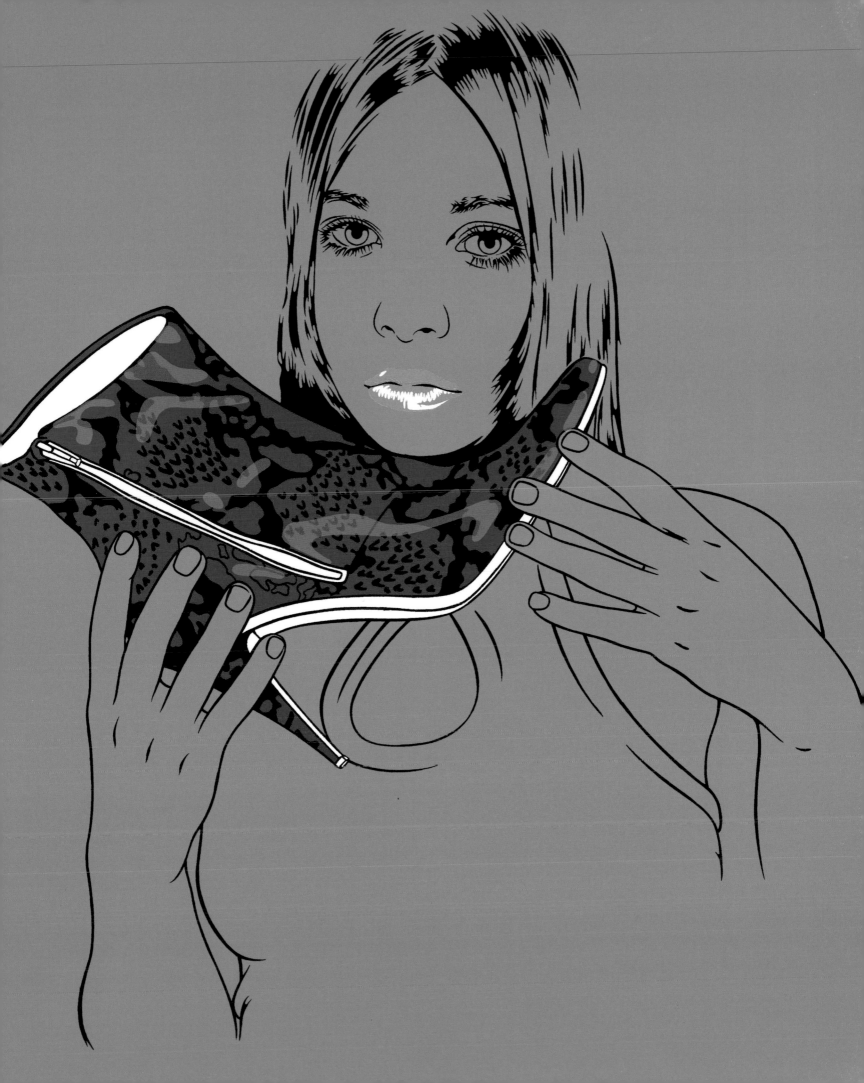

'Lucille'
Ballpoint pen and black ink on paper,
coloured in Illustrator
Cosmogirl (USA), 2001

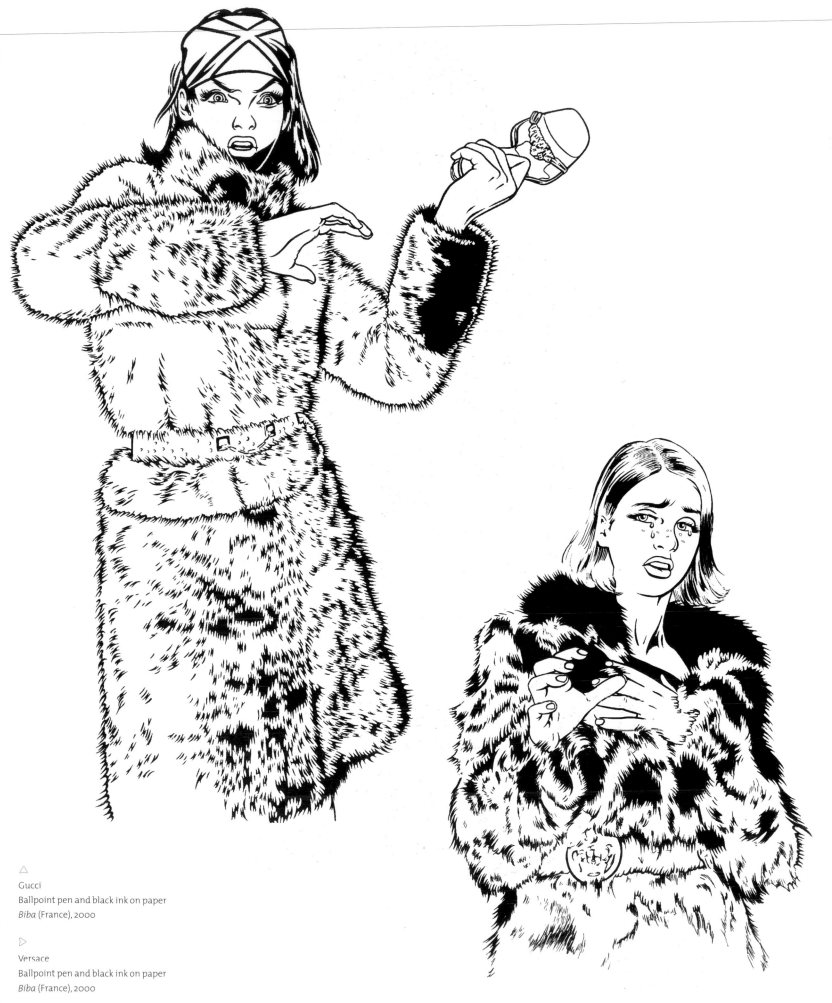

△

Gucci
Ballpoint pen and black ink on paper
Biba (France), 2000

▷

Versace
Ballpoint pen and black ink on paper
Biba (France), 2000

gibb kate

Ask Kate Gibb what she does, and she will reply: 'I'm a screen printer.'
Gibb's silkscreens are made from drawings, stencils and photographs,
which she makes or finds in out-of-the-way places. Her adherence to
printing techniques lends unity to the body of her work. 'I'd like to
think', Gibb says, 'that my work is simple and effective. That it's not
too hard to interpret and can be appreciated by a wide audience.'

▷ ▷▷
Dries Van Noten
Silkscreen print; photographer: Ellen Nolan
Spring/summer catalogue, 2001

△

Argyle knitwear
Illustration, silkscreen print;
photographer: Laila at ALEX AND LAILA
Arena Homme+ (UK), c. 2000

▷

Dries Van Noten
Silkcreen print; photographer: Ellen Nolan
Spring summer/catalogue, 2001

▷
Illustration, silkscreen print
CD sleeve for 'Come With Us'
by The Chemical Brothers, 2002

◁ △
Dries Van Noten
Silkcreen print; photographer: Ellen Nolan
Spring/summer catalogue, 2001

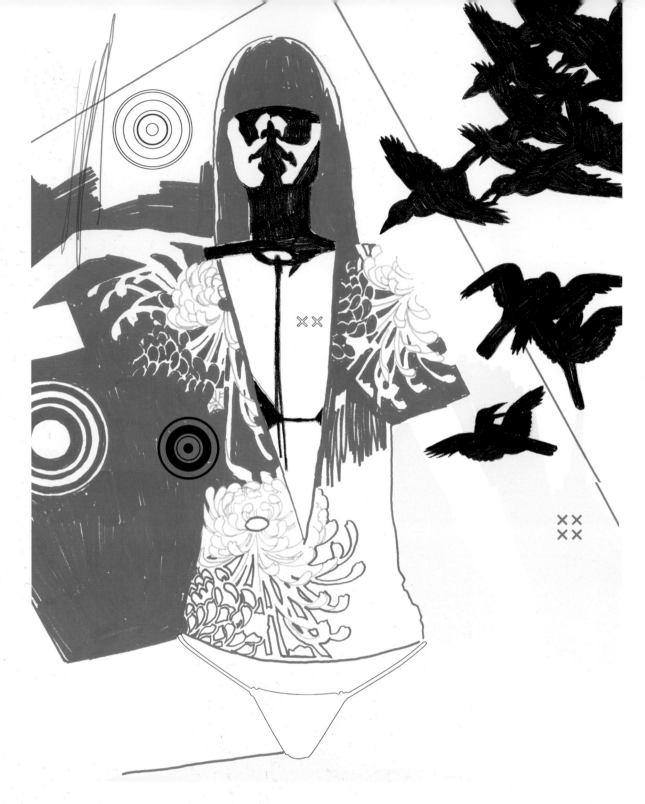

goodall jasper

'I'm not really like my work,' says Jasper Goodall. 'I think it kind of an indulgence into desire, me daydreaming.' Goodall's slick, sexy illustrations are multimedia pieces made using pencils, felt-tips, light boxes, Illustrator and a technique he refers to as 'Photoshop vivisecton'. To Goodall, a fashion illustration need not depict clothes so much as project an attitude or vibe.

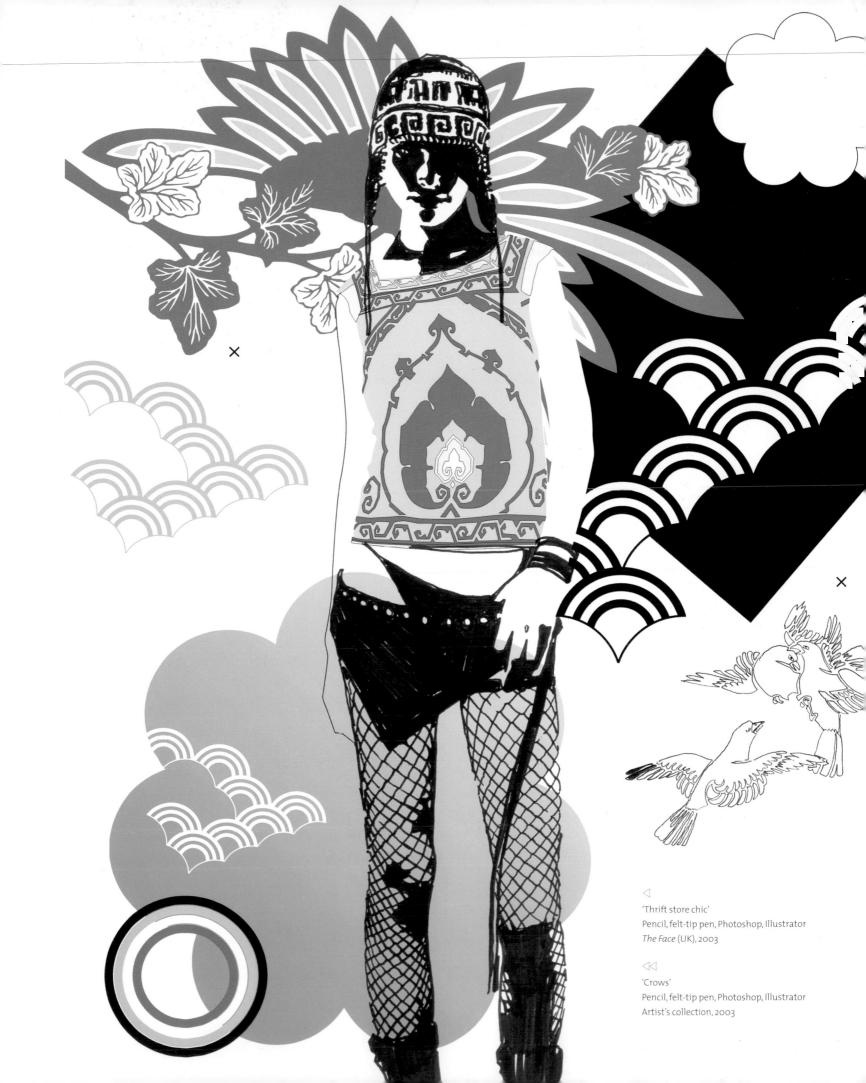

'Thrift store chic'
Pencil, felt-tip pen, Photoshop, Illustrator
The Face (UK), 2003

'Crows'
Pencil, felt-tip pen, Photoshop, Illustrator
Artist's collection, 2003

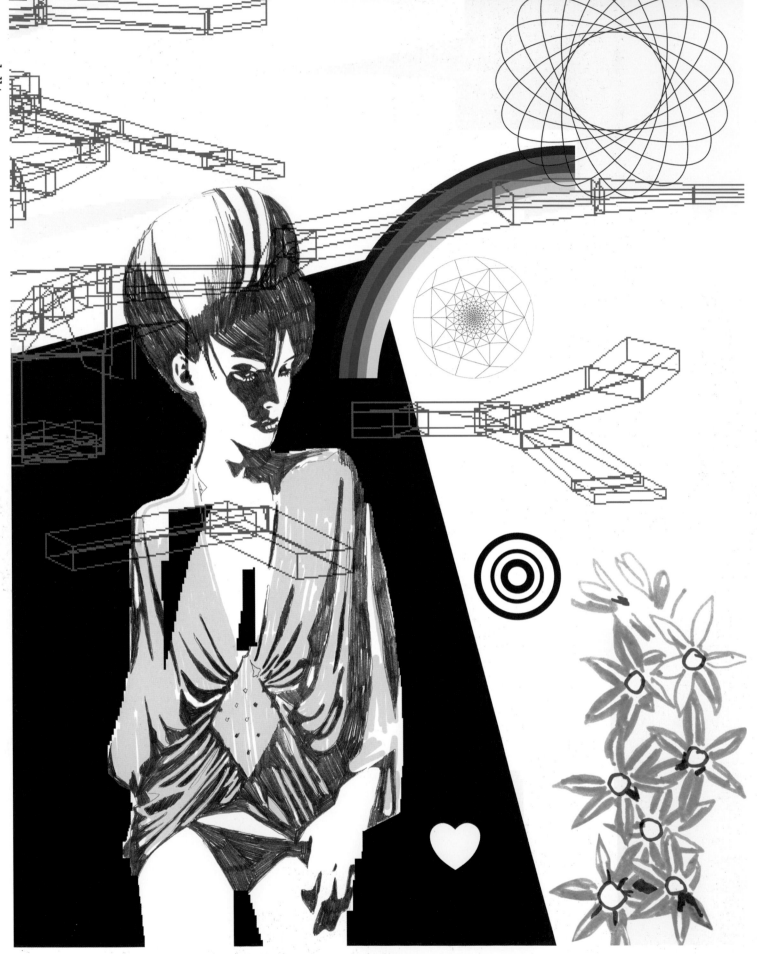

'Pink silk'
Pencil, felt-tip pen, Photoshop, Illustrator
Artist's collection, 2002

'Peacock'
Indian ink, Photoshop
Created for *Fashion Illustration Next*, 2003

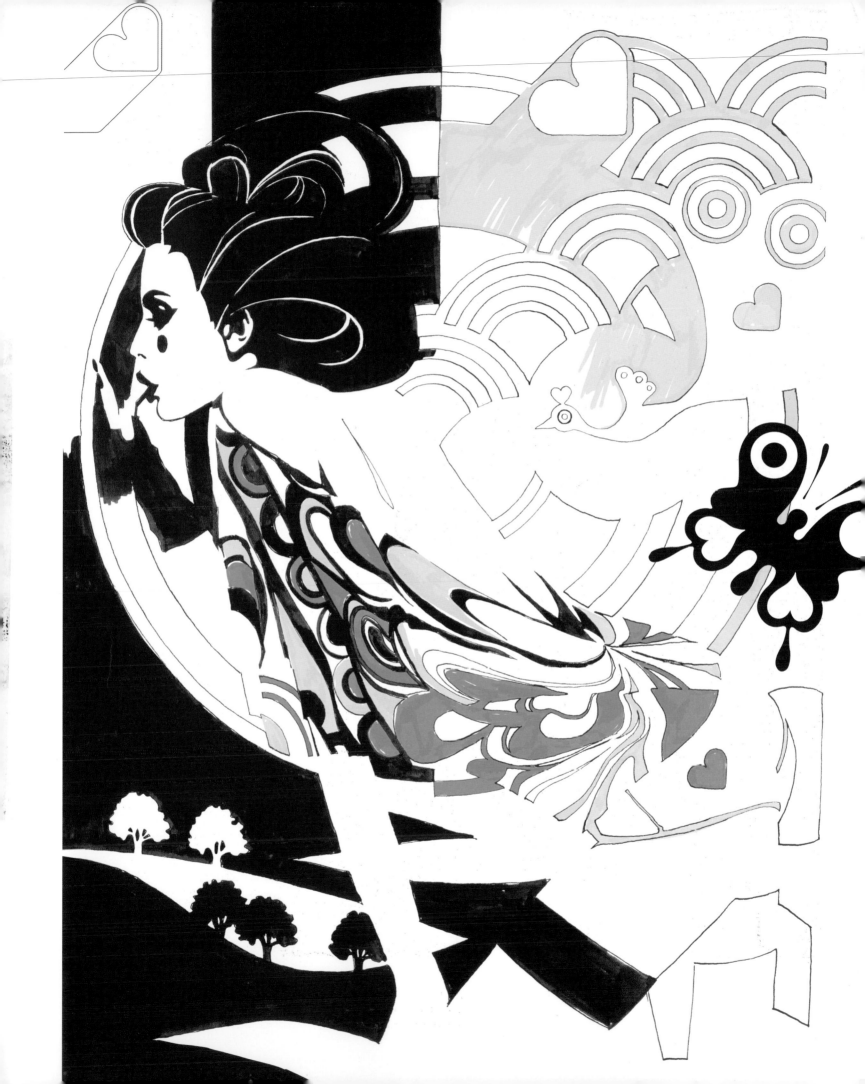

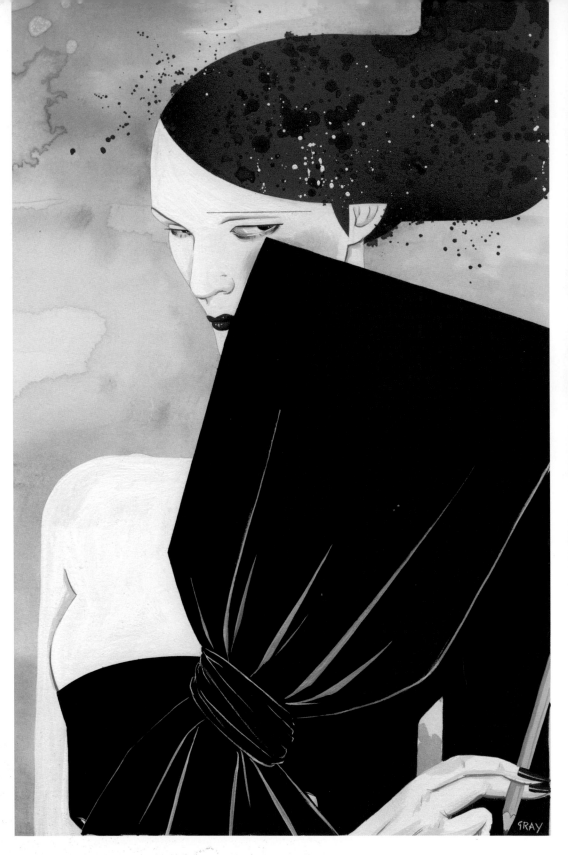

▷

Givenchy Haute Couture
Gouache and pencil
Sleek Magazine (Germany), 2003

▷▷

Widescreen cape by Boudicca
Gouache and pencil, 2002

gray
richard

'Fashion illustration', says Richard Gray, 'is the opportunity to
respond to a designer's creative vision with your own.' Working
by hand with ink, gouache, airbrushing, pencil and crayon – ideally
from a live model – Gray creates 'narrative' pieces, often with an
enticingly eerie and surreal edge. 'I love that illustration allows
you the complete freedom to use your imagination, to create
your own worlds and logic,' he confides.

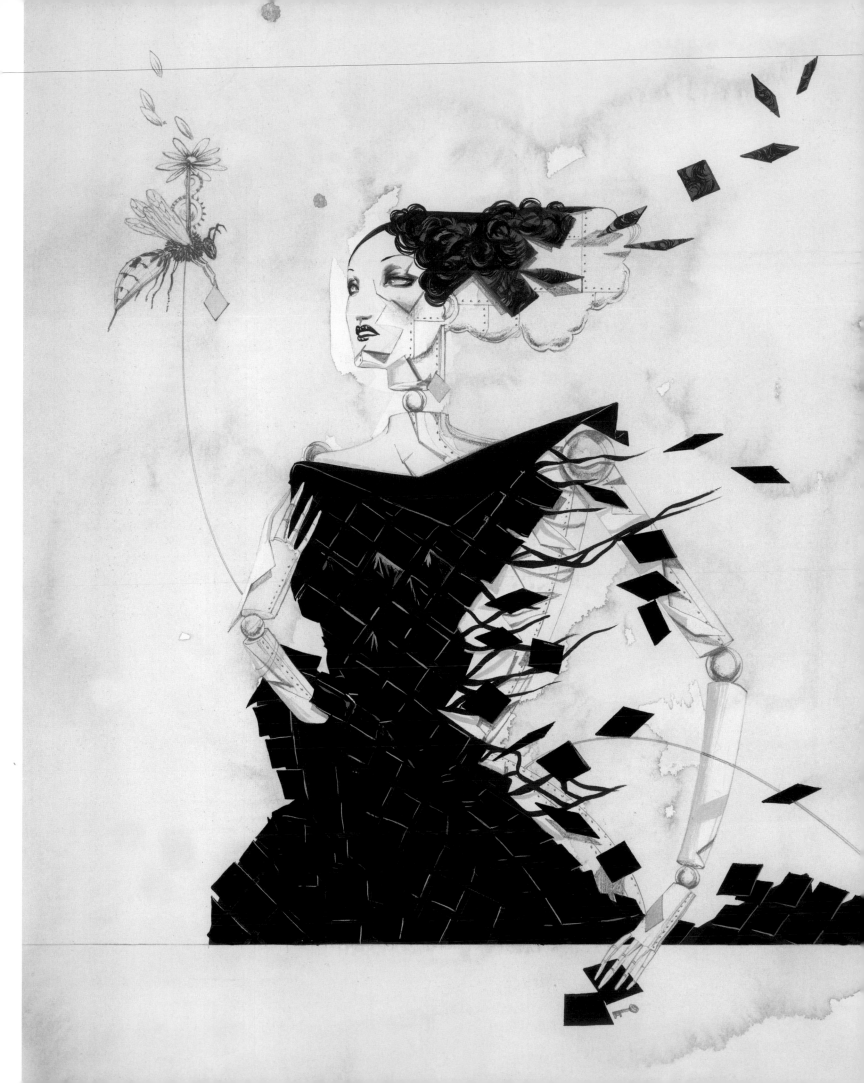

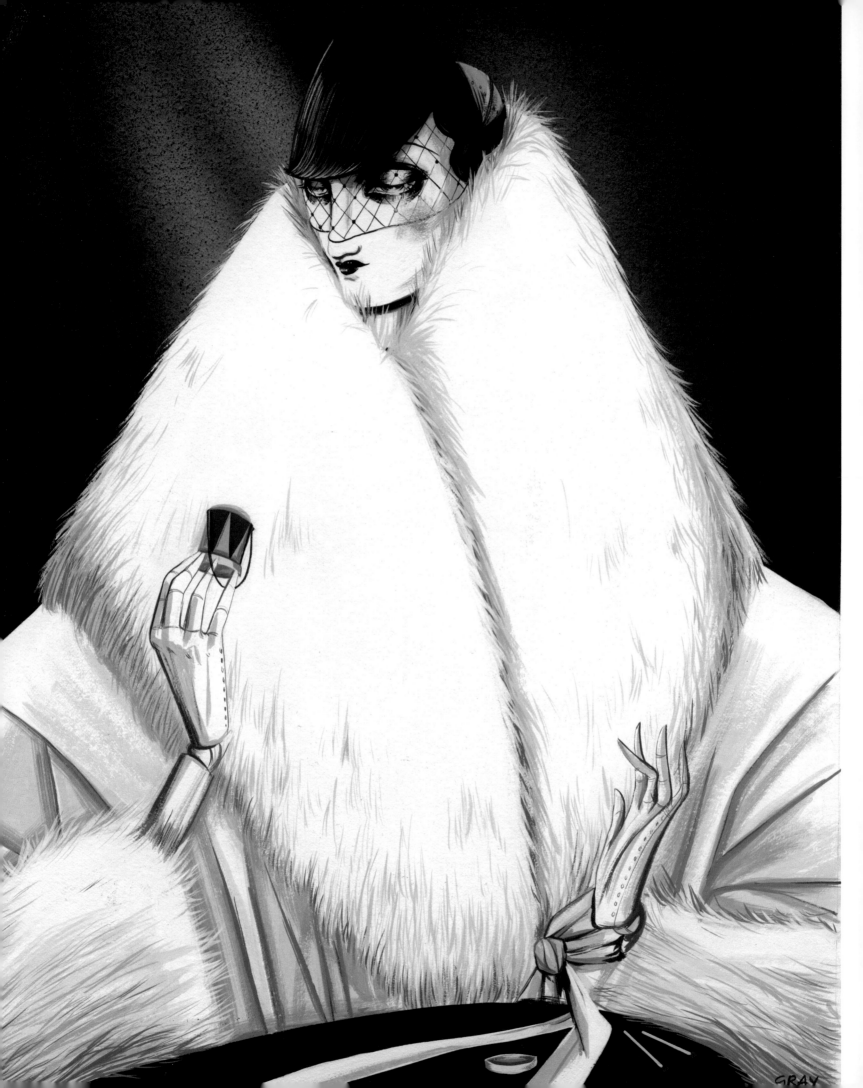

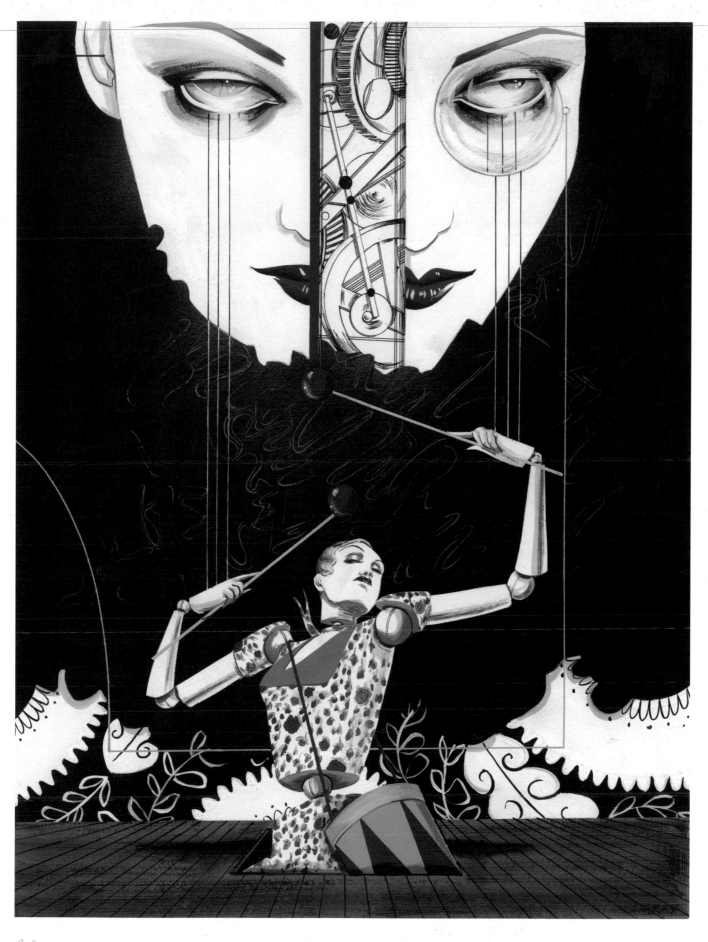

◁ △
'Trend Les Copains'
Airbrush and gouache
Io Donna (Italy), 2003

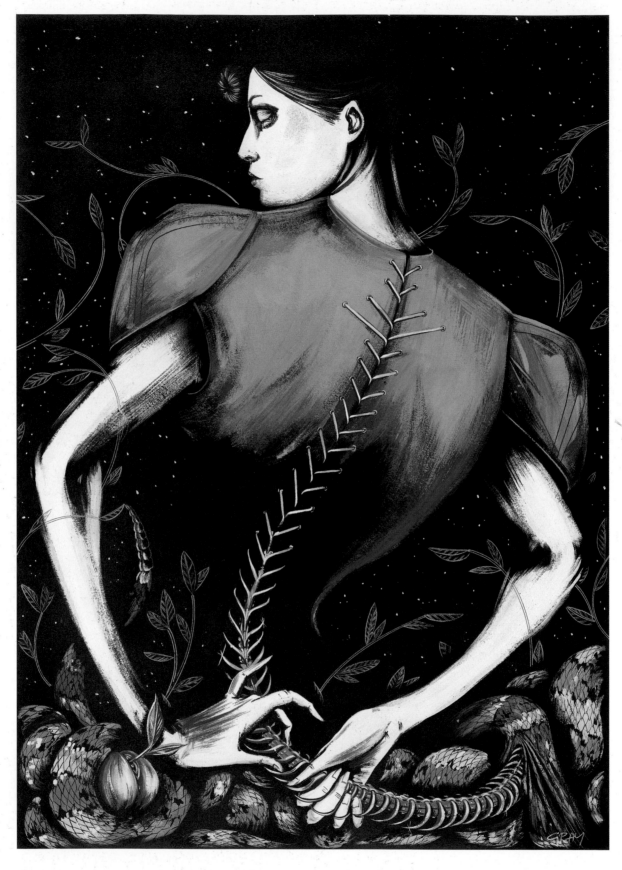

△

'Plans for a Woman'
Airbrush and gouache
For a collaborative exhibition
with Boudicca, 2000

▷

Alexander McQueen
Mixed media
Madame Figaro (France), 2002

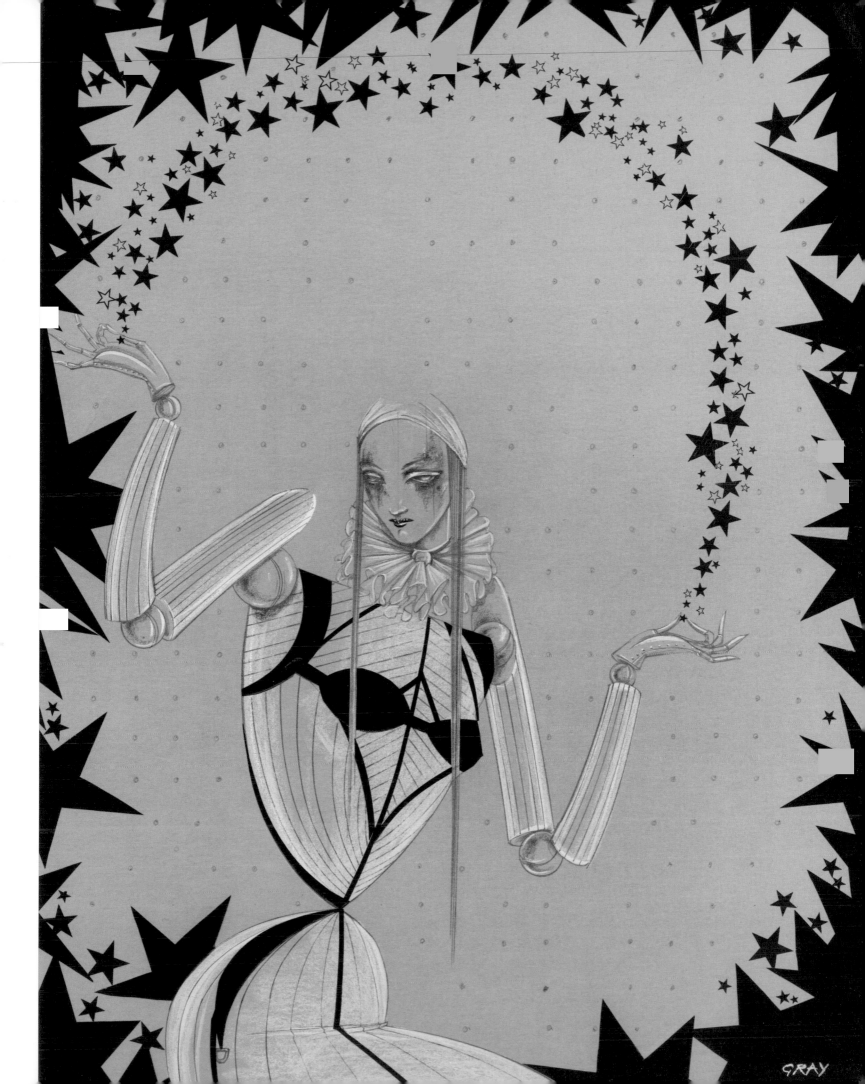

habermacher rené
& **tsipoulanis** jannis

'Most Wanted', Gaultier Paris (couture)
Photoshop
Numéro (France), 2003

'Grasping'
Bracelet by Lährm;
ring by Coleen B. Rosenblat
Photoshop
German *Vogue*, 2003

'Hypernatural,' is how René Habermacher describes the iconographic illustrations he creates with Jannis Tsipoulanis. The duo focus methodically on the composition, styling and lighting of a piece. Rough sketches are overworked and finished digitally. What drives the artists is to have their work be seen in print by millions. 'When you work digitally,' Habermacher explains, 'there is no "original" piece at the end of the working process, so the publication is the real manifestation of the work.'

◁

'Supersonique', Gucci
Photoshop
Numéro (France), 2003

△

'Kate Moss', Givenchy
Photoshop
Numéro (France), 2003

ito keiji

'Bossadelic!' is Keiji Ito's enthusiastic description of his style. He works with coloured pencils and acrylics, photographs, memos, colour copies and vintage prints to create his collages. He characterizes this process as 'very natural, like a sponge... I observe the world and spit it out in art form.'

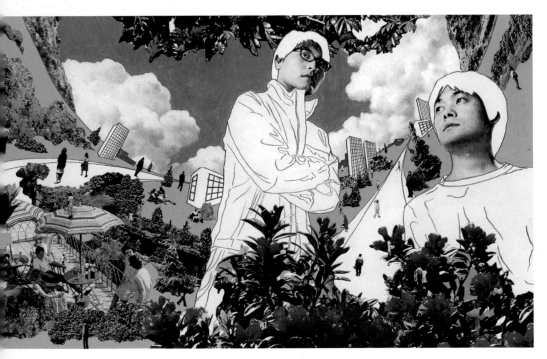

△
Collage
Corporate commission,
Tokyo Digital Life, *c.* 2001

▷
'Altered States of Consciousness
on a Poolside 3'
Collage, pencil, coloured pencil on paper
Artist's collection, 1999

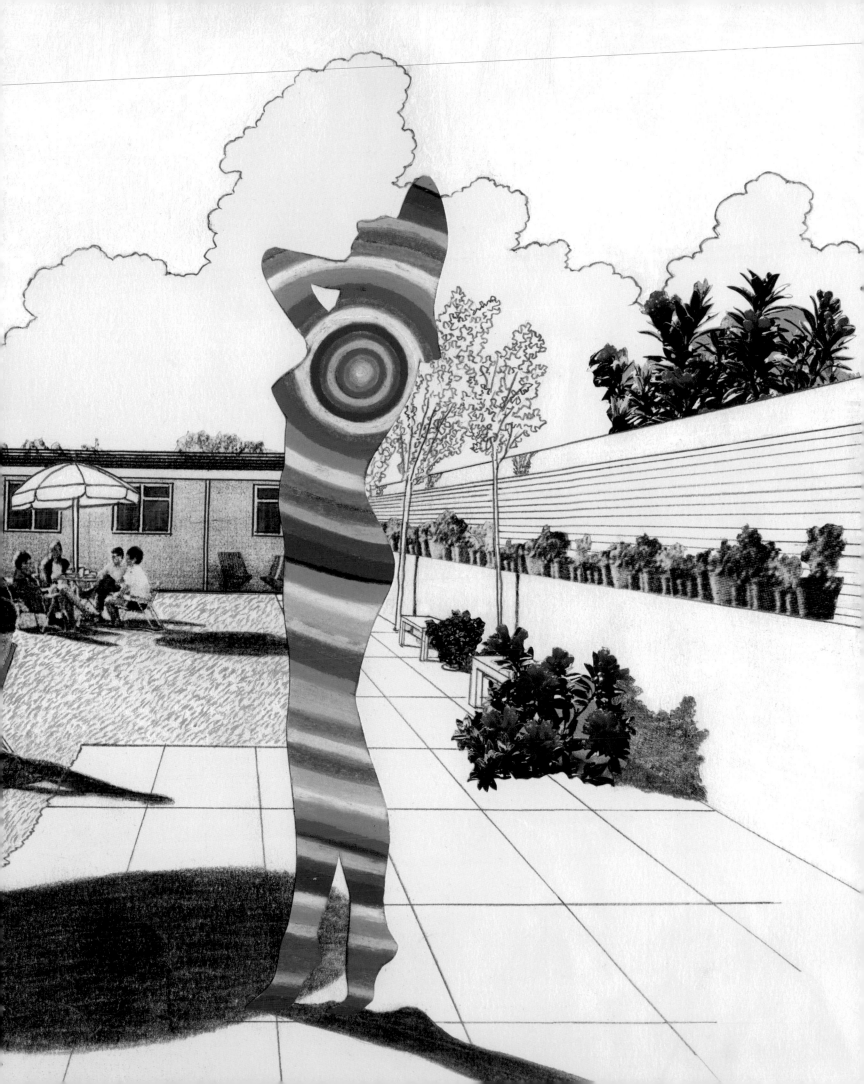

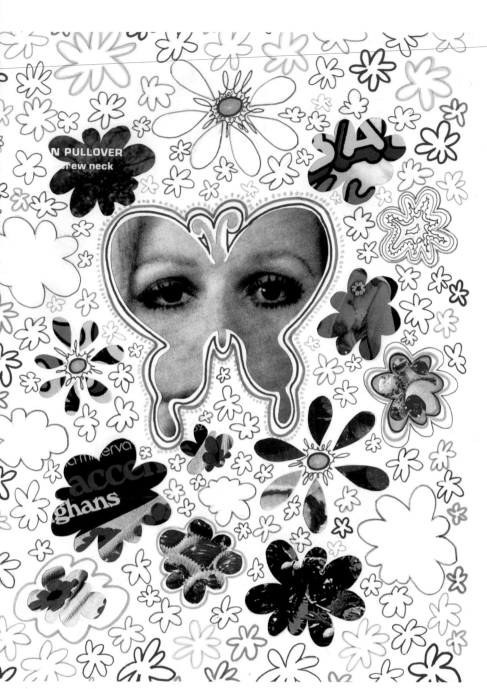

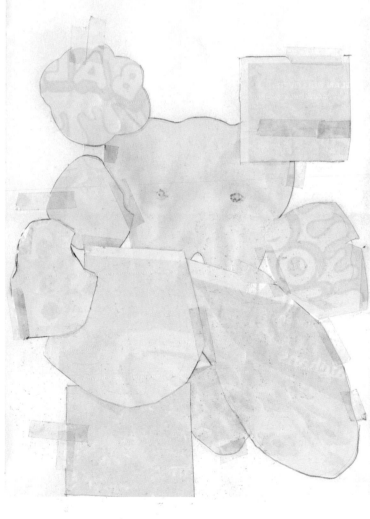

◁
'The Man I Dub'
Collage, marker on paper
Artist's collection, 2002

△
'Spring Manifestations'
Collage, marker, acrylic on paper
Artist's collection, 2002

▽
'The Dirty Back'
Tape, paper
Artist's collection, 2002

jeroense peter

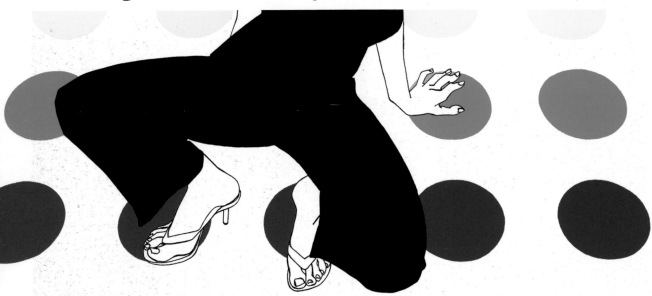

Peter Jeroense dislikes the digital. He draws in pen and ink and uses the cut and paste technique, drawing from his extensive archives. ('I photocopy a lot!' he says.) Trained as a designer, Jeroense thrives on 'the obsession of the "new" within the fashion system'. His modern aesthetic centres on the contrast between positive and negative and is almost always executed in the deepest black. 'I like black', says Jeroense, 'because of its directness and graphic force. It absorbs most of the 3-Dness. It's flat and stark. I love it when the environment seems to blend in with the body, when the table becomes part of a Chanel jacket.'

▷
Sigerson Morrison
Collage of pen/ink and photocopy
Advertising campaign, 2002

▷
Balenciaga
Collage of pen/ink and photocopy
Nylon (USA), 2000

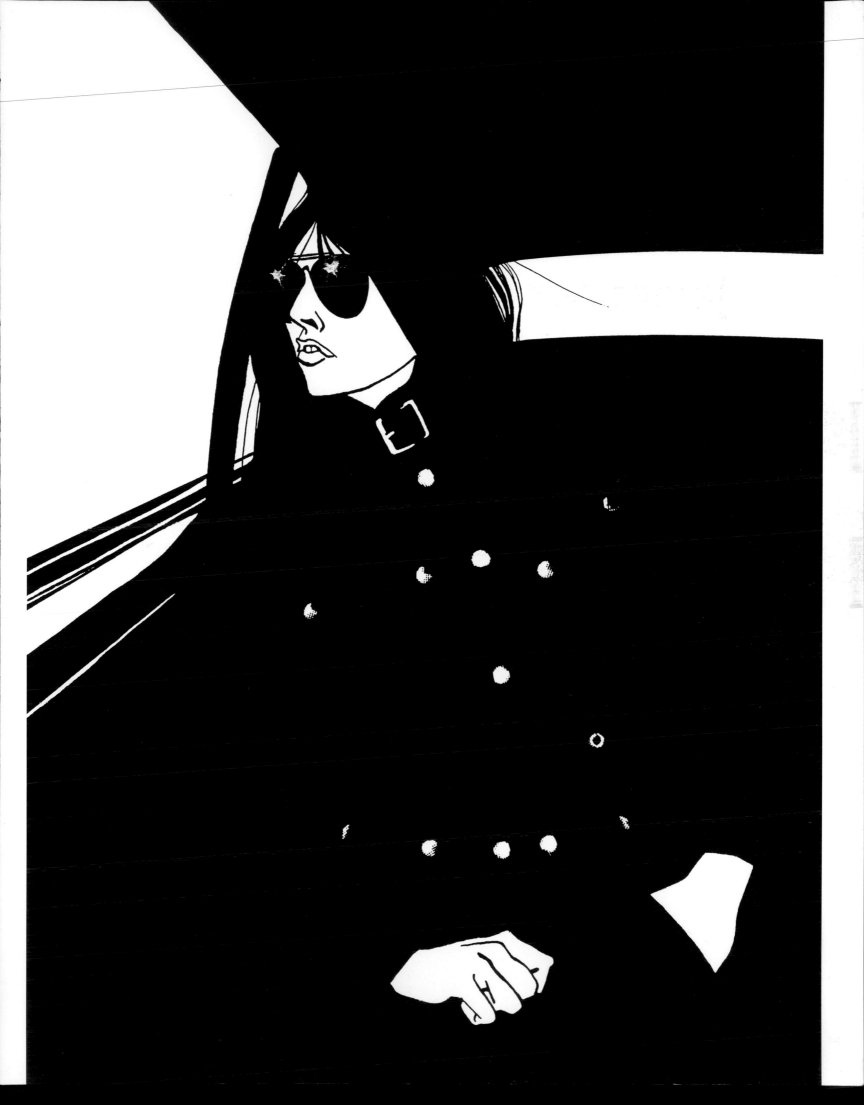

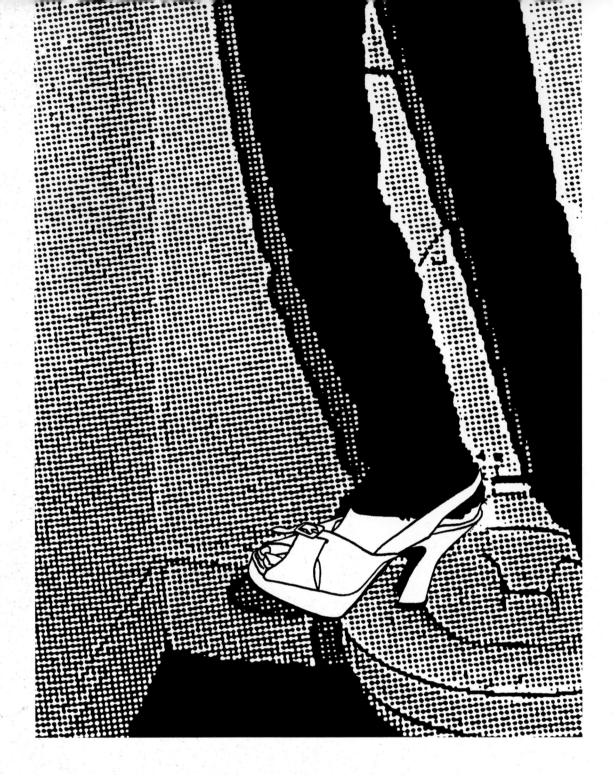

△
Prada
Collage of pen/ink and photocopy
Unpublished study for
The Black Book (USA), 2000

▷
Viktor & Rolf
Collage of pen/ink and photocopy
Woman By (Catalogue Centraal Museum,
Utrecht), 2002

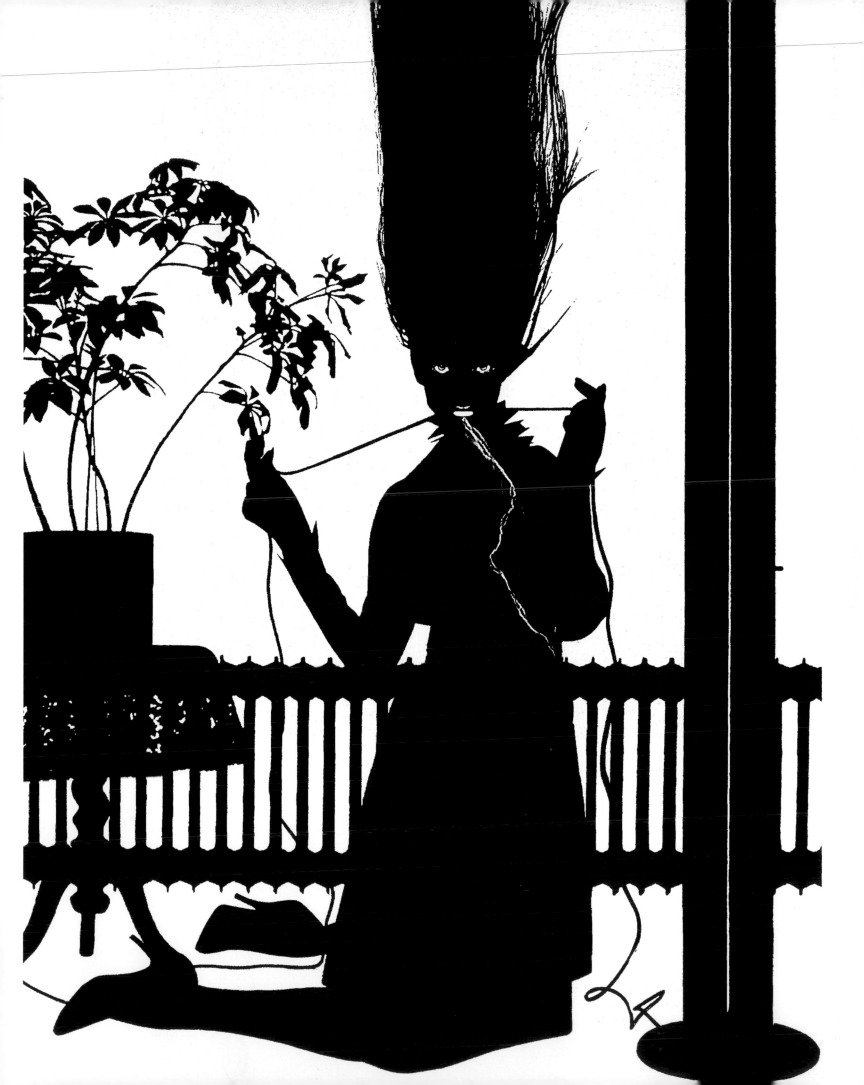

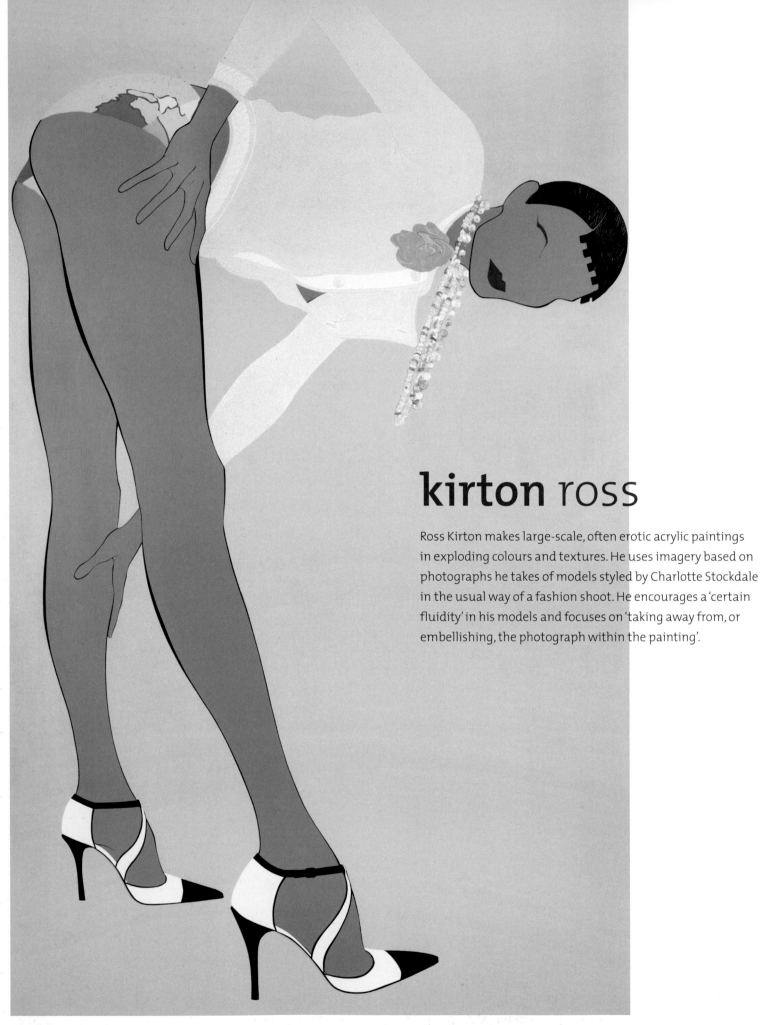

kirton ross

Ross Kirton makes large-scale, often erotic acrylic paintings in exploding colours and textures. He uses imagery based on photographs he takes of models styled by Charlotte Stockdale in the usual way of a fashion shoot. He encourages a 'certain fluidity' in his models and focuses on 'taking away from, or embellishing, the photograph within the painting'.

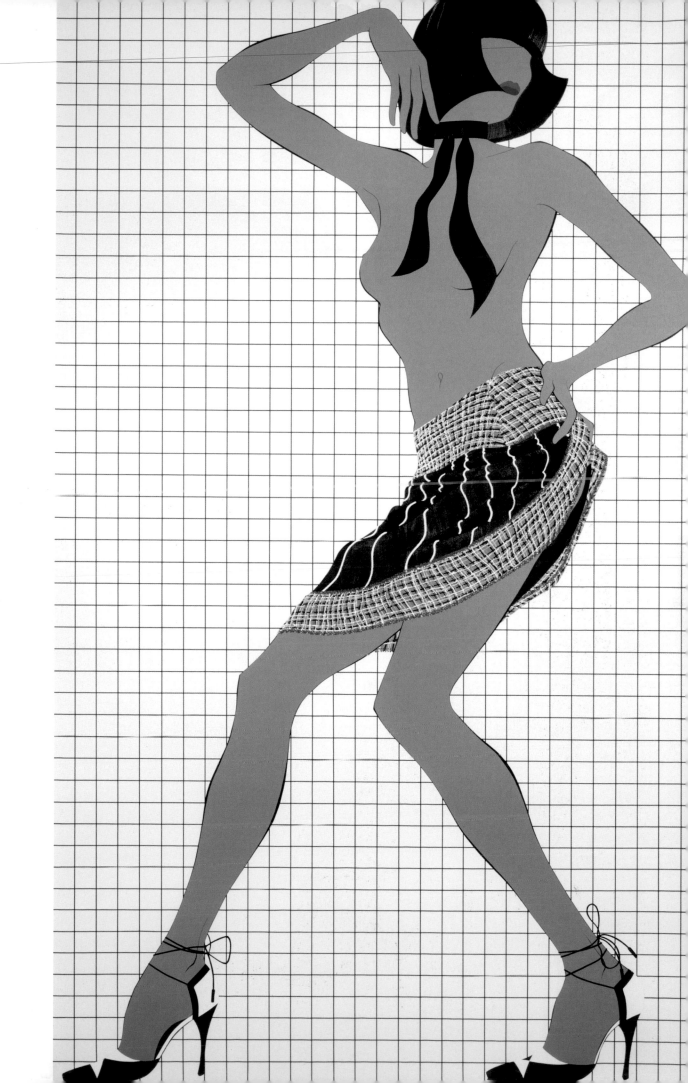

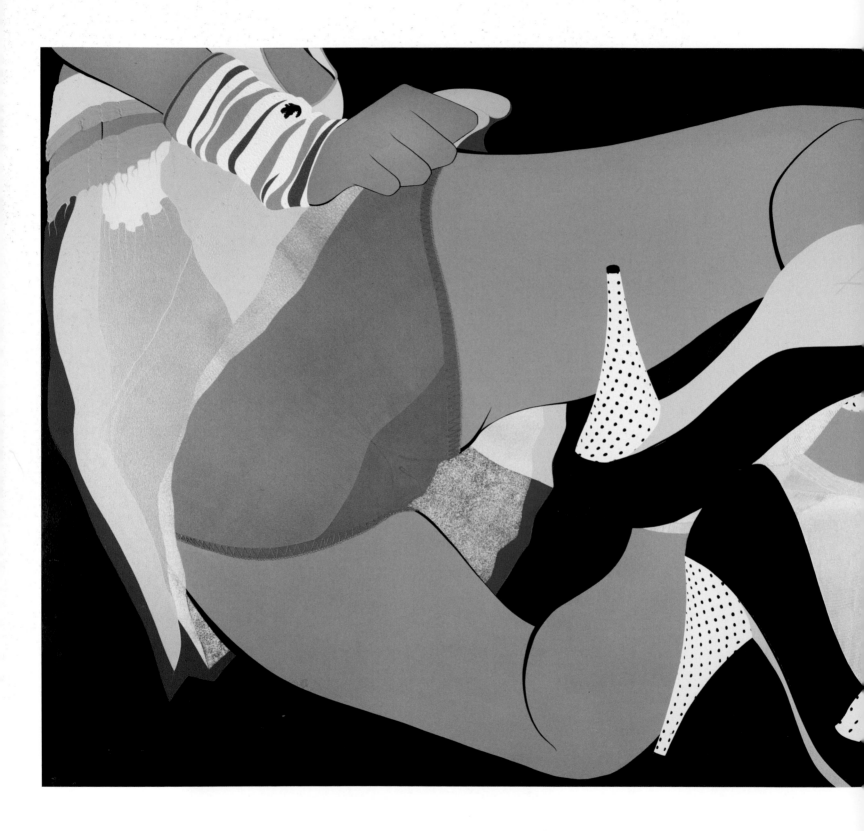

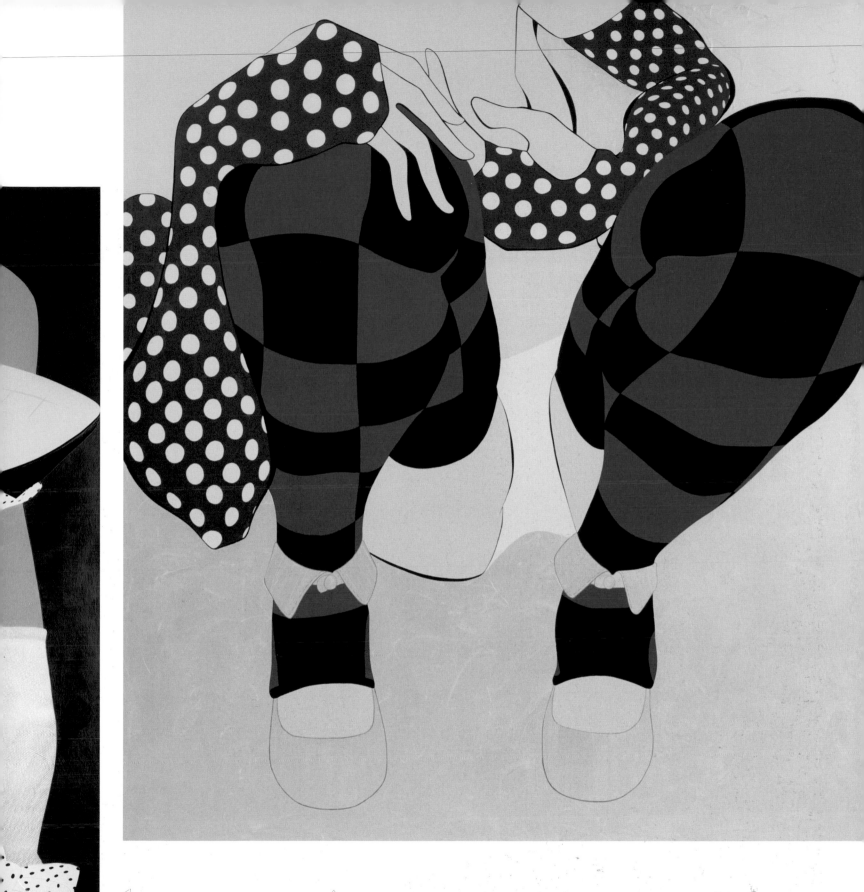

◁
'Phat Fanny'
Acrylic on linen, July 2003

△
'Polkadots'
Acrylic on linen, July 2003

top and fur PRADA

london philidor

Working into the early hours of the morning, Philidor London applies a 'fetishistic concentration' to his pencil and pastel drawings, which are imbued, he says, with 'an obscure eroticism and an elegant eros'. London's goal is to wed a historical feel with graphic, modern lines. 'I want to make my drawings clean but give them a monumental atmosphere,' he says.

▷
Prada
Coloured pencil on paper
Artist's collection, 2001

▷
Ralph Lauren Purple Label
Coloured pencil on paper
MAN (Holland), 2003

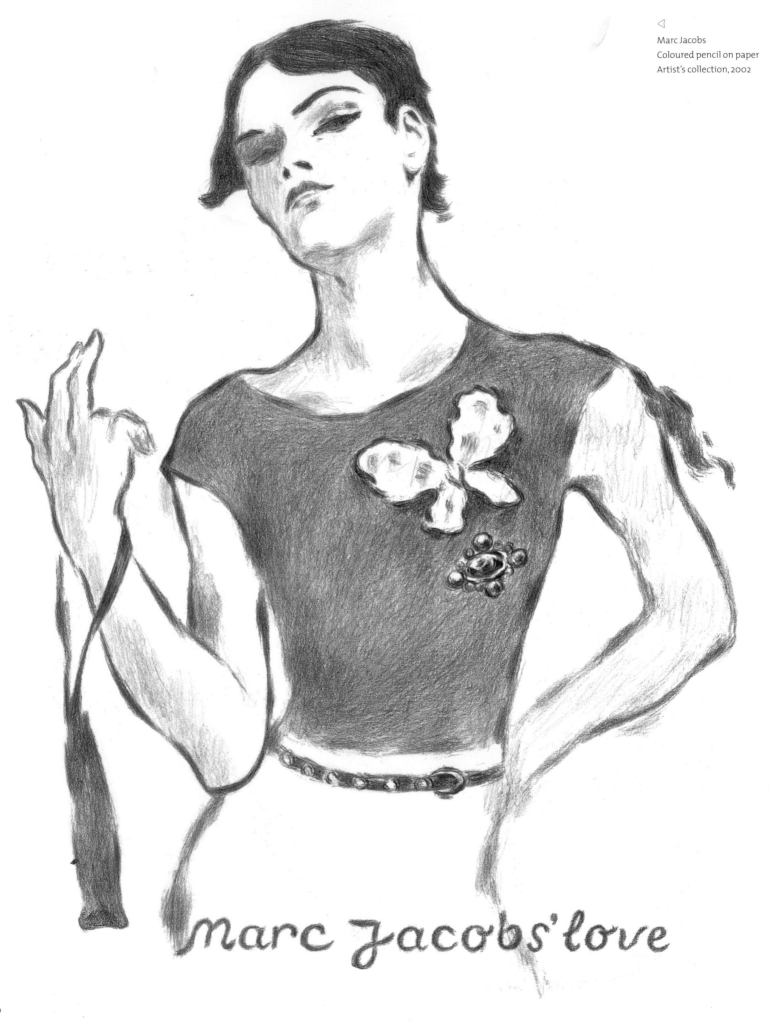

◁

Marc Jacobs
Coloured pencil on paper
Artist's collection, 2002

marc Jacobs' love

▷

Fendi
Coloured pencil on paper
Artist's collection, 2001

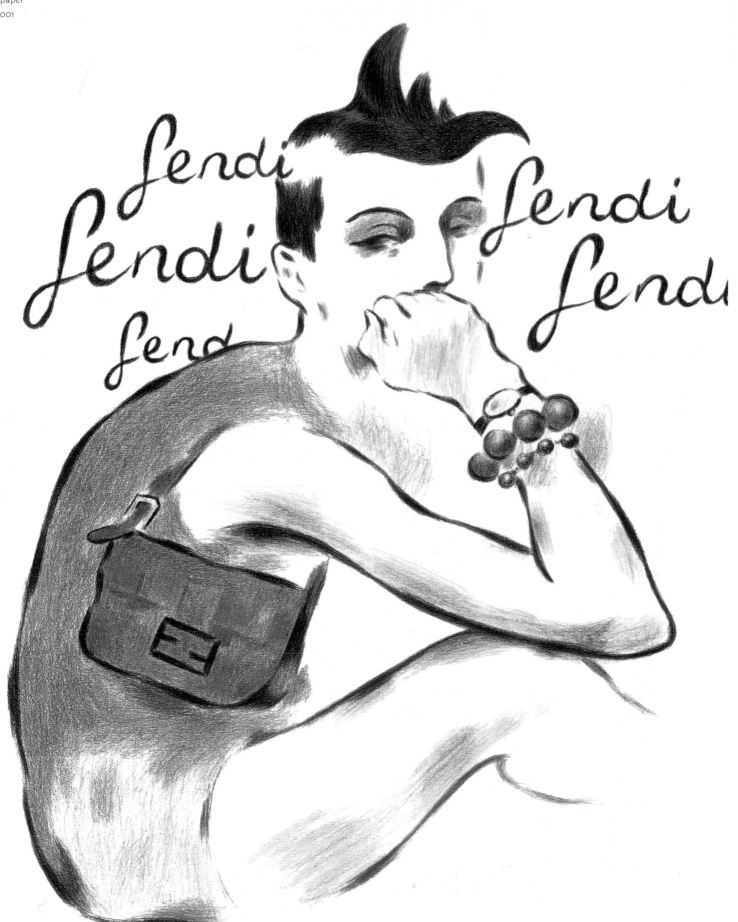

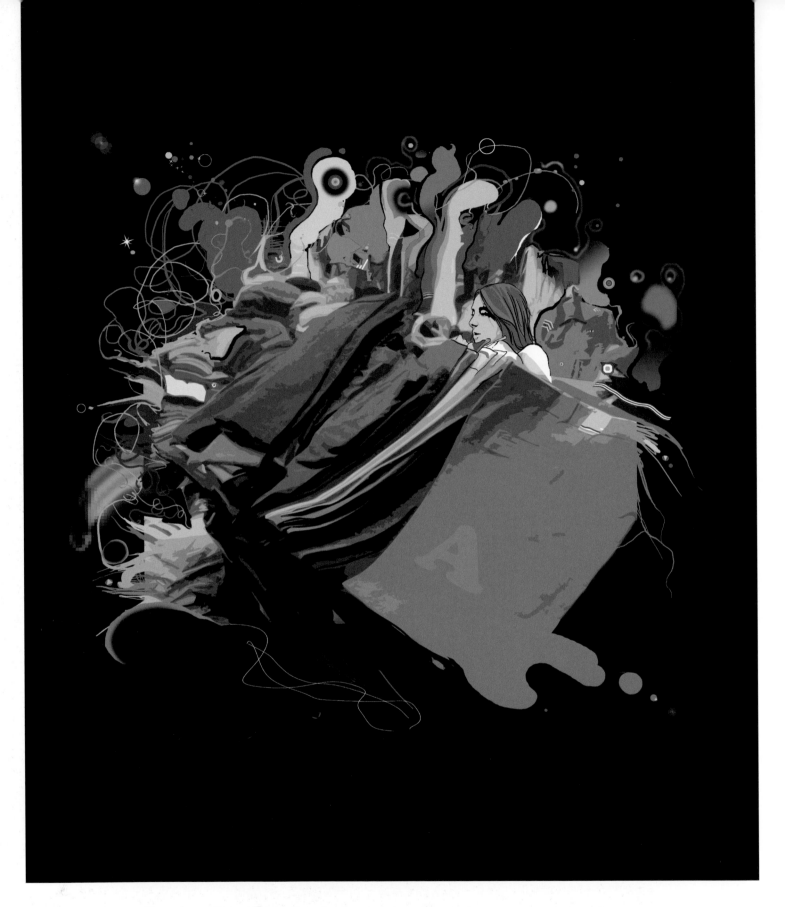

manel stéphane

Fashion illustration is 'a sexy way to draw our time', says Manel, who is known for his glamorous, rapidly drawn illustrations (which are usually executed on his Macintosh G4 with a Wacom palette). While he finds it difficult to describe his style, Manel strives to be sincere and also to keep some mystery in his work. He loves it when 'the line smudges a little, when it gets dirty and my hand messes around.'

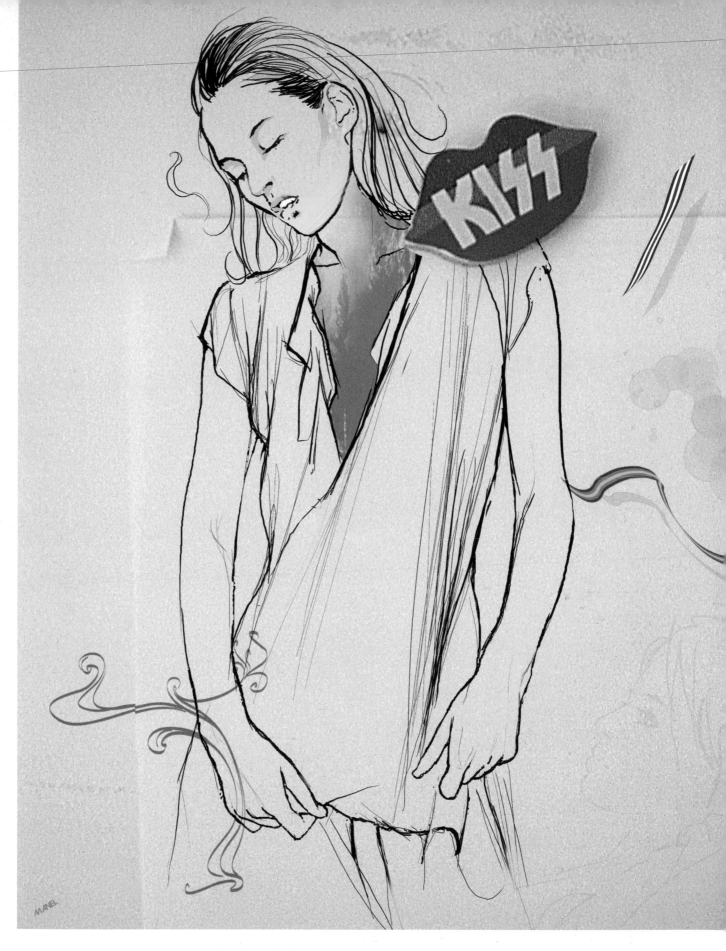

◁

'Anoushka'
Wacom palette, Photoshop
Olympic de Paris
(L'Appareil Photo Editeur, Tokyo), 2002

△

'Kissburn'
Felt pen on paper, Wacom palette,
Photoshop
MAN (Holland), 2002

mascia
pierre-louis

'No style, just me,' Mascia responds when asked to describe his aesthetic. His preferred technique is collage, and he cuts, folds, rips, glues and attaches many types of paper in an effort to reveal 'a gesture, an attitude, a universe'. He aims 'to see what the photograph cannot...to make from the small something of greatness and beauty'.

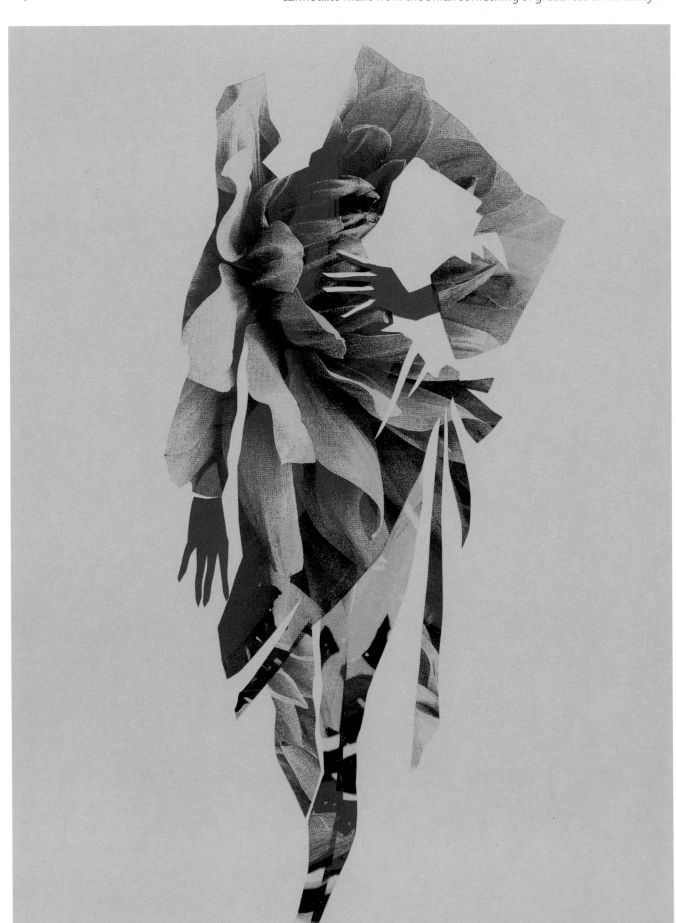

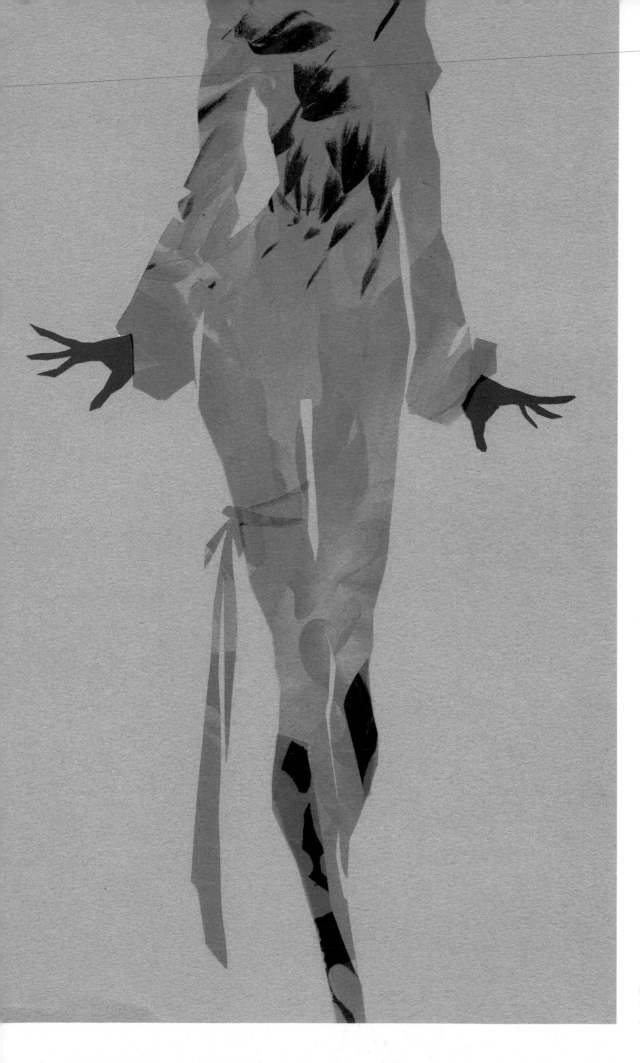

Première Classe (France)
Collage, paper
Advertising campaign, 2002

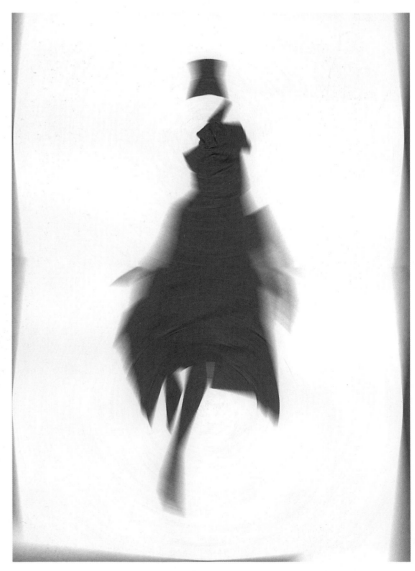

⇧ △ ▷ ▷▷
Yohji Yamamoto
Collage, paper, Photoshop
Artist's collection

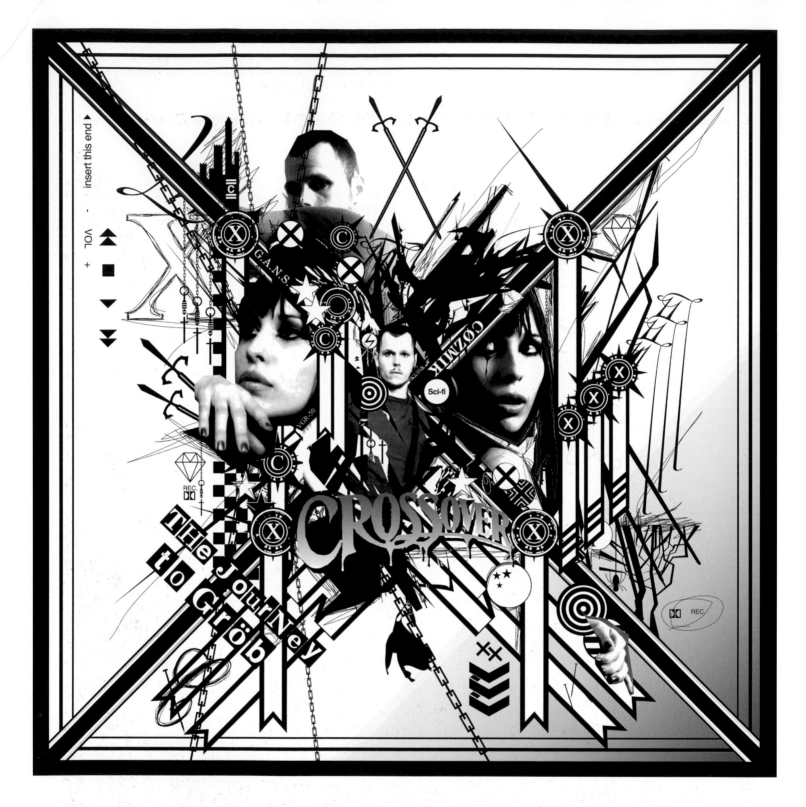

minami kenzo

Minami drinks 'lots of coffee' in the process of creating his illustrations and murals in his 'turn-of-the-century French poet meets Megadeth' style. Each piece starts with a concept that frames and gives unity to the project. 'I often start with a word, sometimes for its literal meanings, other times for the impressions it gives – colours, temperature, emotions, memories, etc.', says Minami, 'so a dictionary is one of the most inspiring things around my work space.' Even when his starting point is lo-fi (pen, ink, wall paint), there is always a hi-tech element to his work, which is concerned with diversity and harmony within unexpected elements.

◁

▽

Album cover for 'The Journey to Gröb'
by Crossover; photographer: Slavica Zeiner
Marker on paper, Illustrator, Photoshop
International Deejay Gigolo, 2002

'Sovereign'
Illustrator and Photoshop
Artist's colléction, 2002

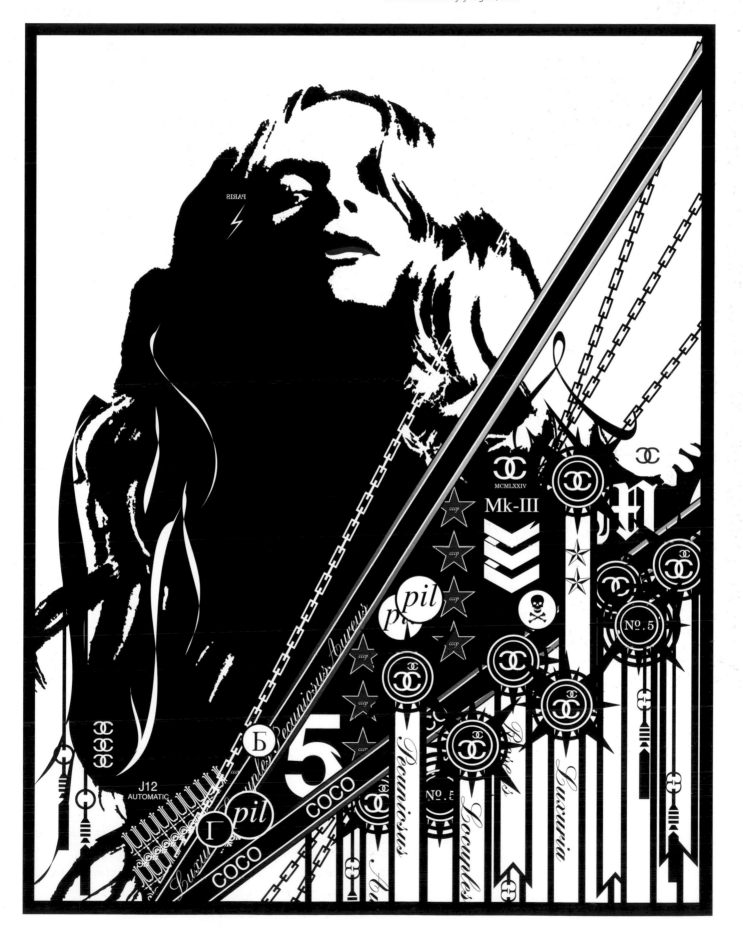

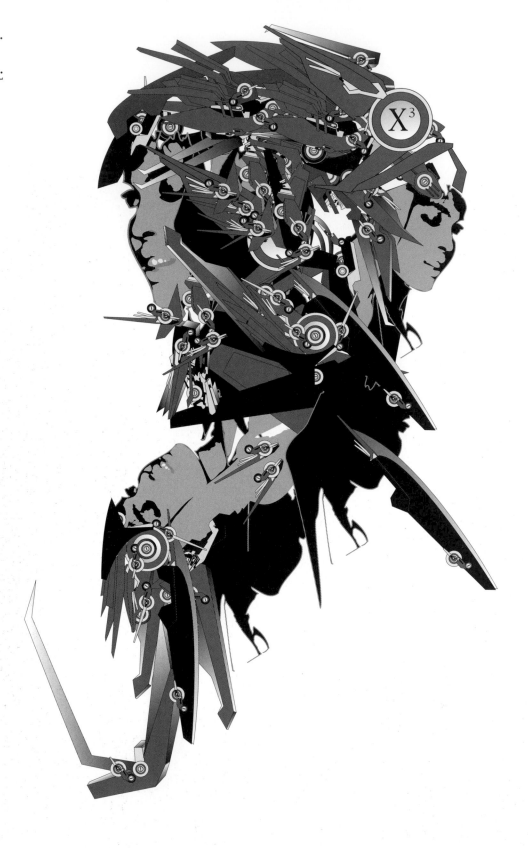

△
'Fresh Widow'
Illustrator
Artist's collection, 2001

▷
'Power'
Illustrator and Photoshop;
photographer: Nagi; model: Ai Tominaga
Addict (Holland), 2002

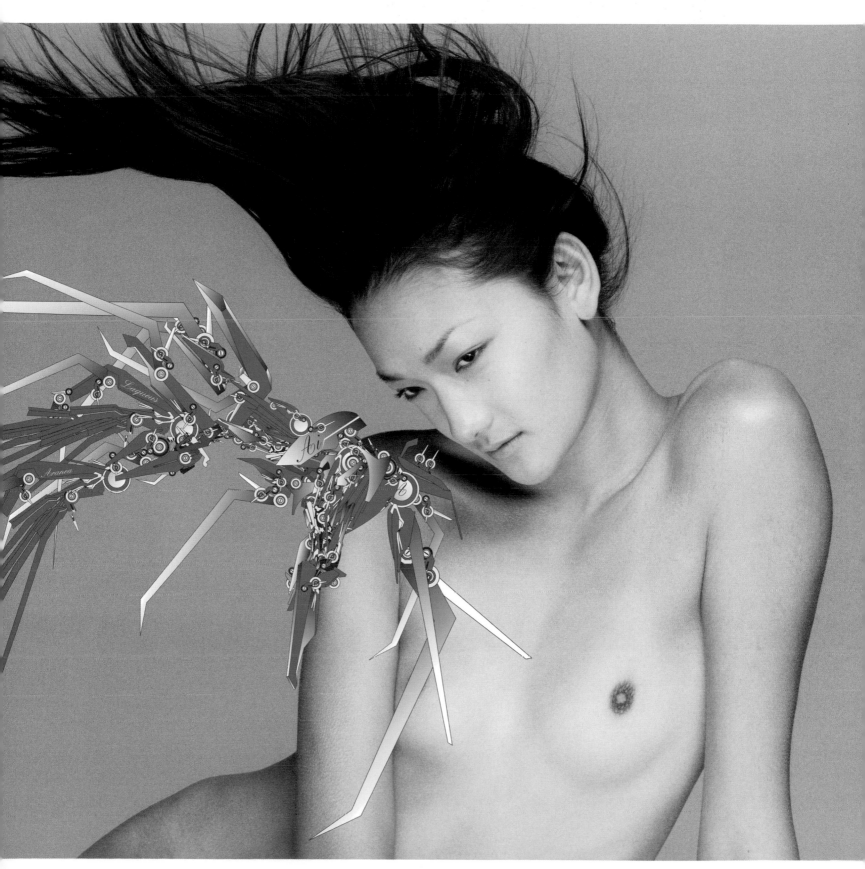

mode 2

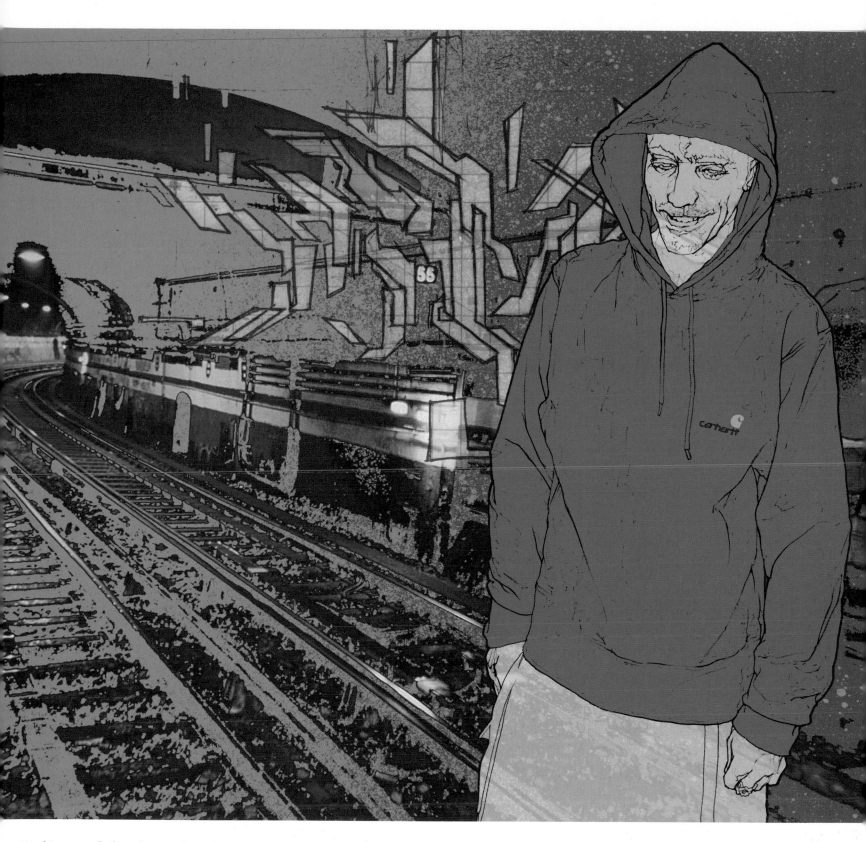

Working mostly from his head, Mode 2 draws with pencil, pen or spray paint on paper, before scanning the results into Photoshop for tweaking. 'I have a style', he says, 'that is a result of reading comic books during childhood, then being into graffiti for many years and trying to develop my own hybrid from all those influences.' A self-taught artist, Mode 2 describes himself as 'anatomy-conscious'. He prizes great draftsmanship and consciously tries to draw more normal, fleshier girls than those usually seen in fashion imagery.

◁ △
Carhartt spring/summer 2001
advertising campaign
Photography, pencil illustration
and collage in Photoshop;
model: Kayone
For WorkInProgress

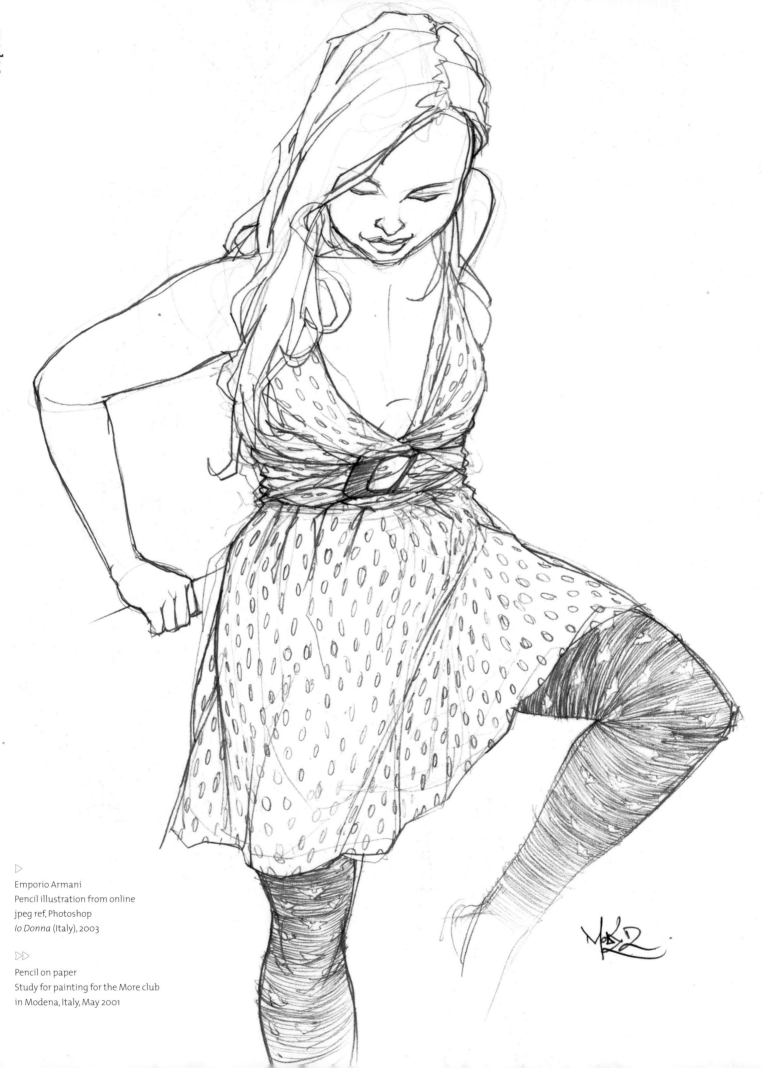

▷
Emporio Armani
Pencil illustration from online
jpeg ref, Photoshop
Io Donna (Italy), 2003

▷▷
Pencil on paper
Study for painting for the More club
in Modena, Italy, May 2001

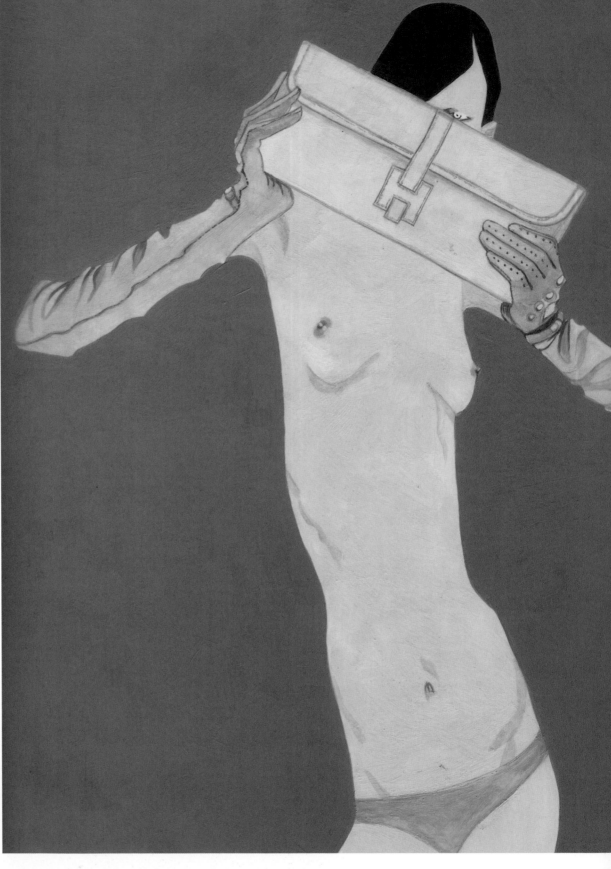

▷

Hermès
Oil paint on paper
Numéro (France), 2000

▷▷

Alexandre Matthieu
Oil paint on paper
Soda (Switzerland), 2000

nawel

'I try to take the things that touch me most from each period,' Nawel says. Working closely with the stylist Kanako B. Koga, she aims for 'a mixture of past and present, ancient and modern'. Her dreamlike, moody drawings often capture moments of introspection or detachment. 'I love it when the points of reference fade away and what remains is something impalpable and hard to name; that's what I'm trying to express, something like a sense of the immaterial.'

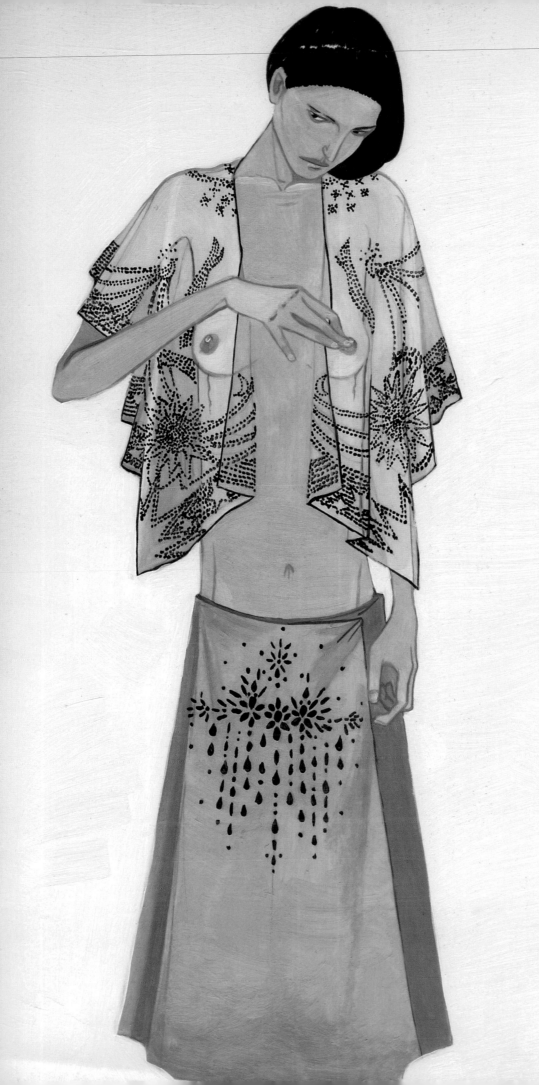

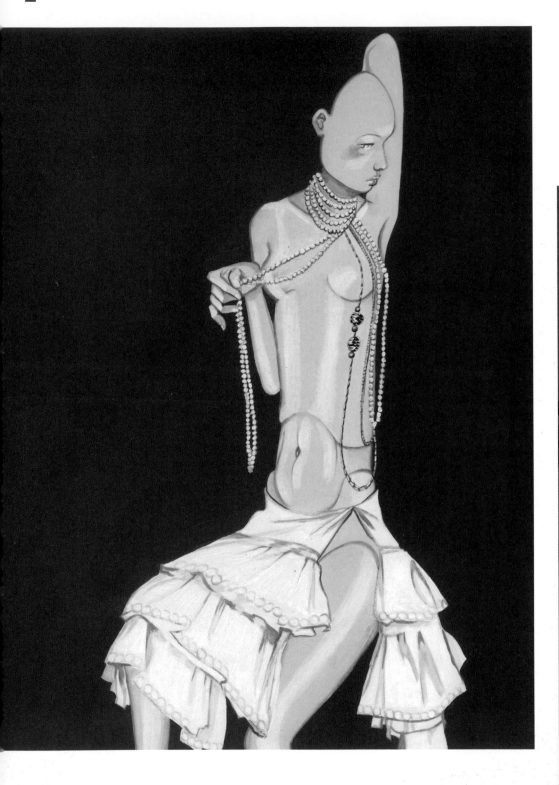

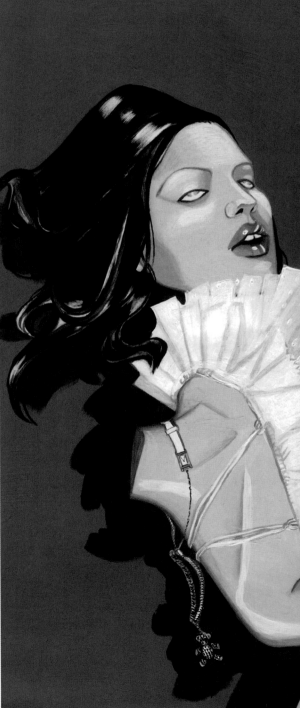

△
Chanel
Oil paint on paper
Jalouse (USA), 2001

▷
Balenciaga
Oil paint on paper
Jalouse (USA), 2001

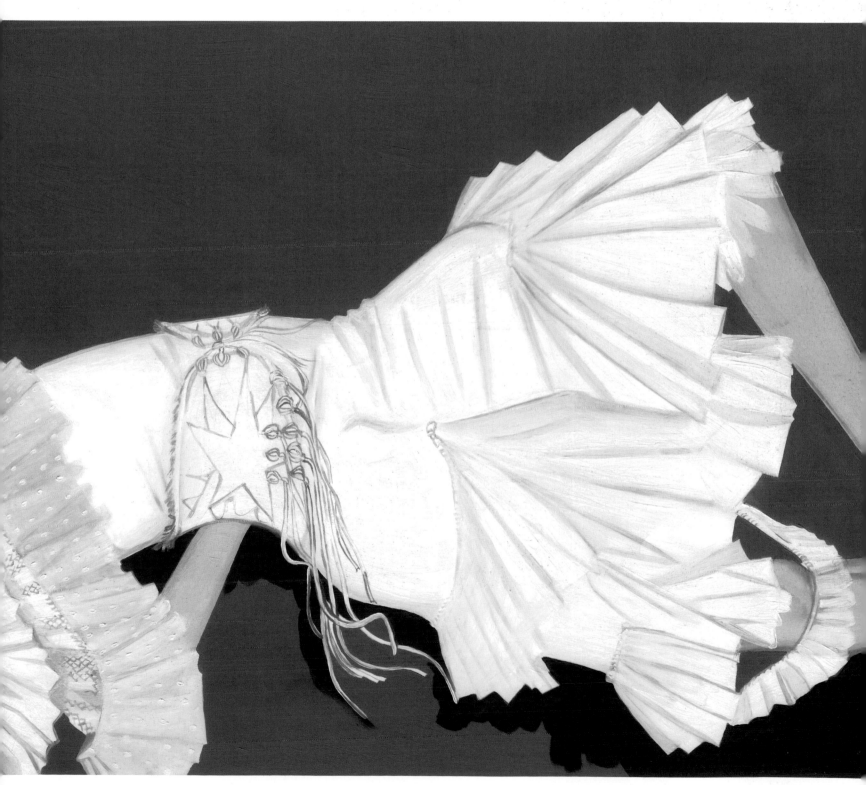

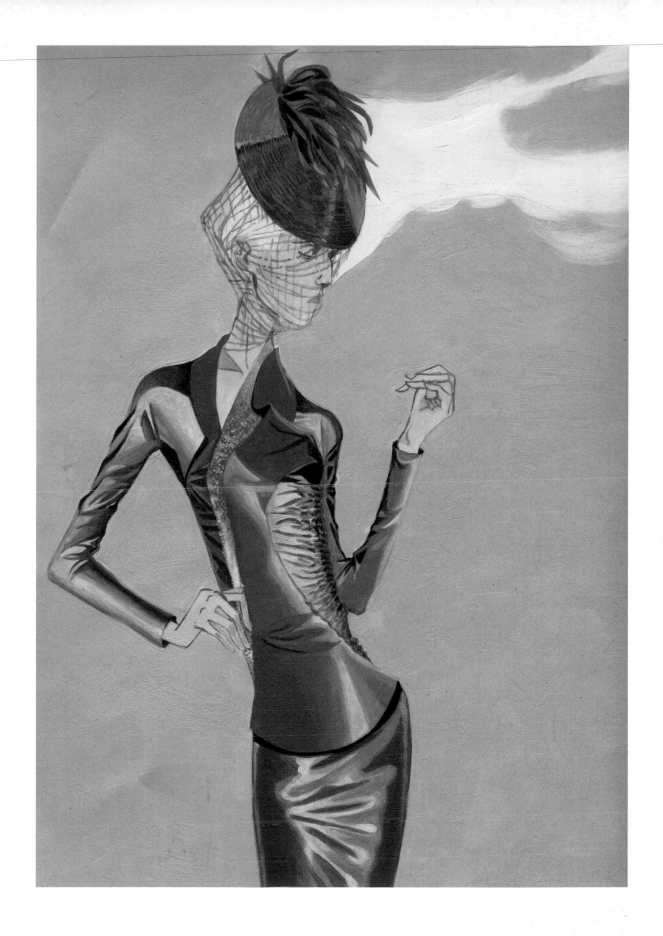

▽
Dior Haute Couture
Oil paint on paper
Citizen K (France), 2000

◁
Chanel Haute Couture
Oil paint on paper
Citizen K (France), 2000

ota koji

Fashion illustration is something 'fresh and exultant', says Ota. Some of his work is carried out using technology on the Mac, but his exhibition pieces, in acrylic paint on canvas, contain an air of mystery. He aims for 'something one cannot know or understand or explain'. The images come, he says, from 'the deepest place in my heart'.

◁
'Keep the Dog Barking'
Acrylic on canvas
Artist's collection, 2002

△
'At Dusk (Keiko and Yutaro)'
Acrylic on canvas
Artist's collection, 2001

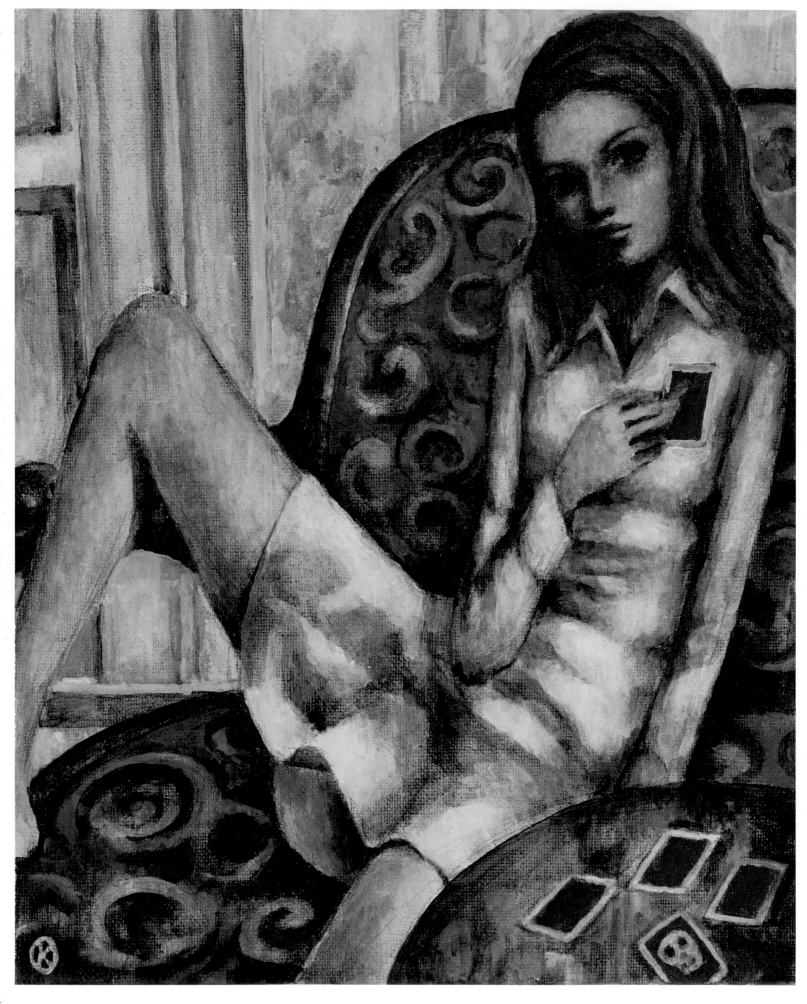

△
'Karate Master'
Acrylic on canvas
Artist's collection, 2003

◁
'Maria (Sprout 1)'
Acrylic on canvas
Artist's collection, 2002

◁◁
'Sumire'
Acrylic on canvas
Artist's collection, 2003

persson stina

'I have two styles – at least,' says Persson. 'One that's slick and pretty and one that's more rough and distorted. I like them both and sometimes they merge. That fusion (elegant, classy lines with smudged make-up, for example) interests me the most.' Persson works with Indian ink and watercolour dyes, sometimes using branches instead of brushes and pens. She also assembles collages, in Photoshop.

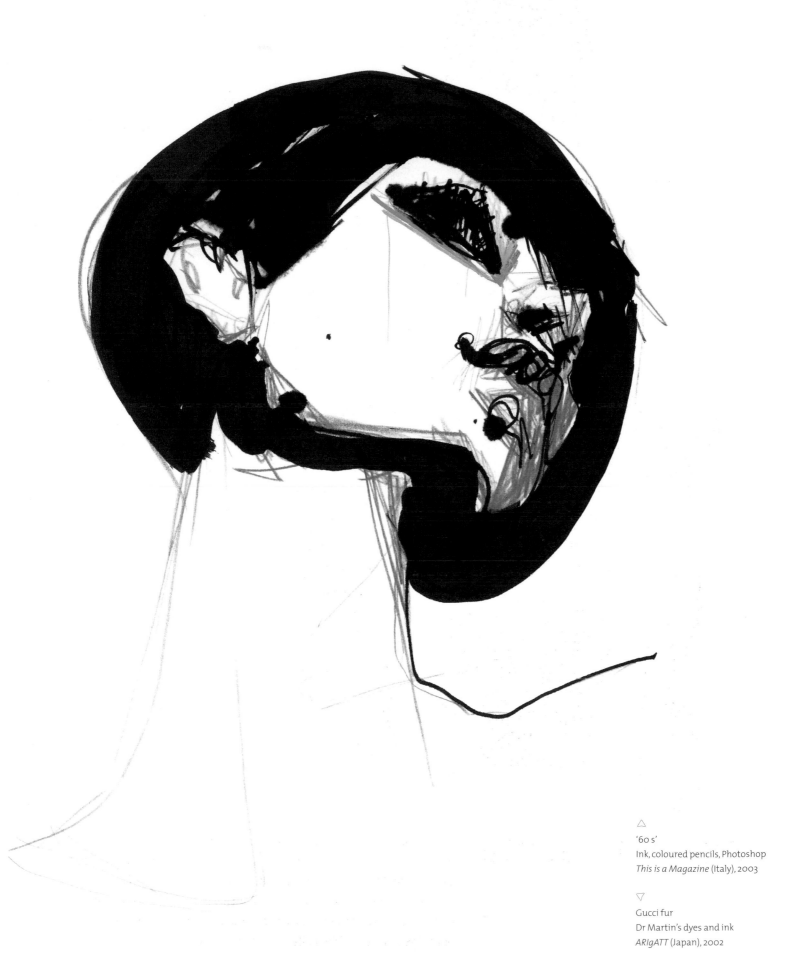

'60 s'
Ink, coloured pencils, Photoshop
This is a Magazine (Italy), 2003

Gucci fur
Dr Martin's dyes and ink
ARIgATT (Japan), 2002

127

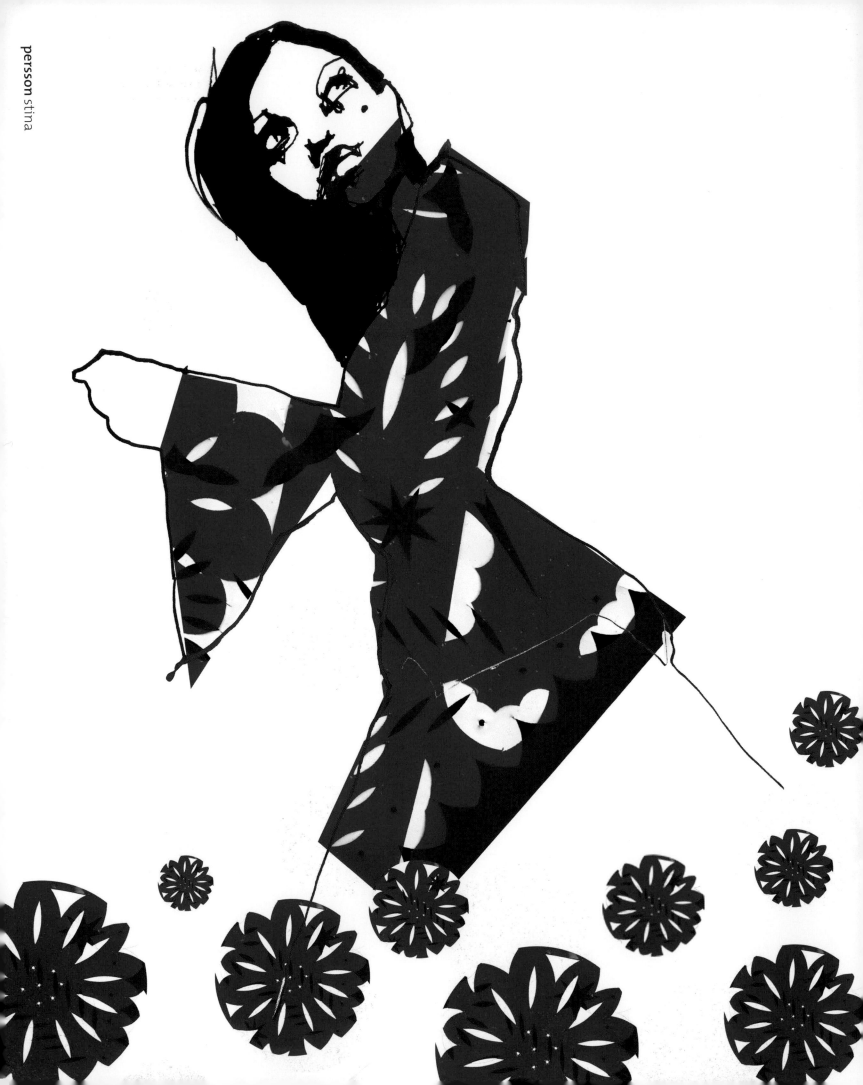

'Flower Field', Marimekko
Ink, cut paper, Photoshop
This is a Magazine (Italy), 2003

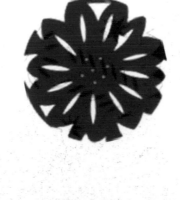

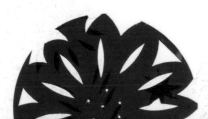

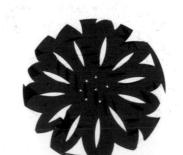

du preez warren
& thornton jones nick

'Our technique is to have no technique,' say du Preez and Thornton Jones, 'to push all the wrong buttons for the right reasons.' Their work is a collision of craft and technology; they create dynamic images, often heavily saturated with colour, and visibly computer-enhanced. The final result is what they call 'hypervisual'.

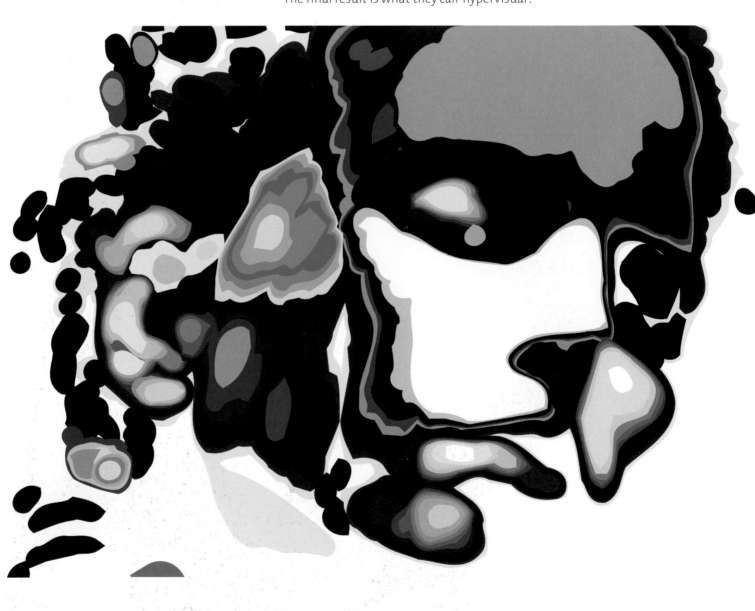

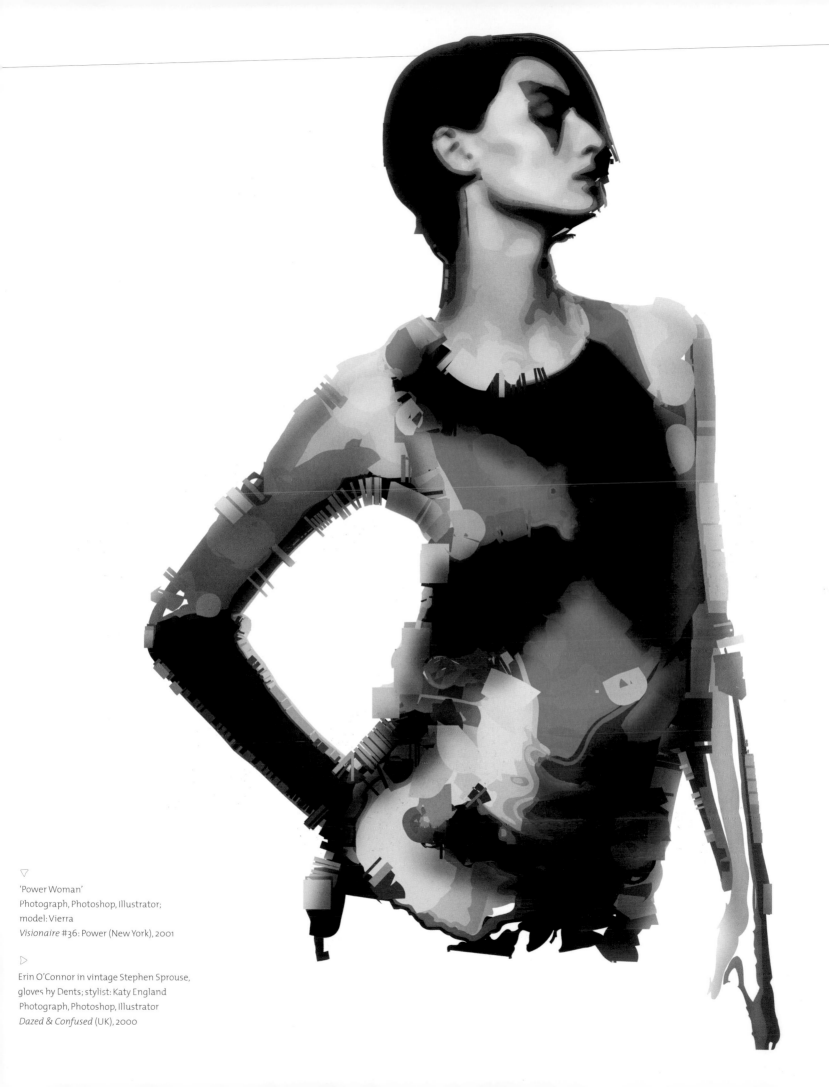

▽
'Power Woman'
Photograph, Photoshop, Illustrator;
model: Vierra
Visionaire #36: Power (New York), 2001

▷

Erin O'Connor in vintage Stephen Sprouse,
gloves by Dents; stylist: Katy England
Photograph, Photoshop, Illustrator
Dazed & Confused (UK), 2000

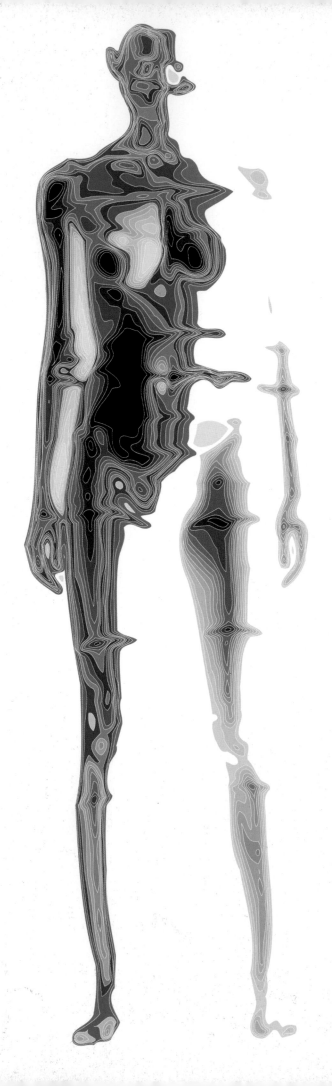

◁ ▷
'Mappy Woman 1 & 2'
Photograph, Photoshop, Illustrator;
model: Daniella Urzi
Visionaire Charlton Arts Exhibition
São Paulo, Brazil, 2001

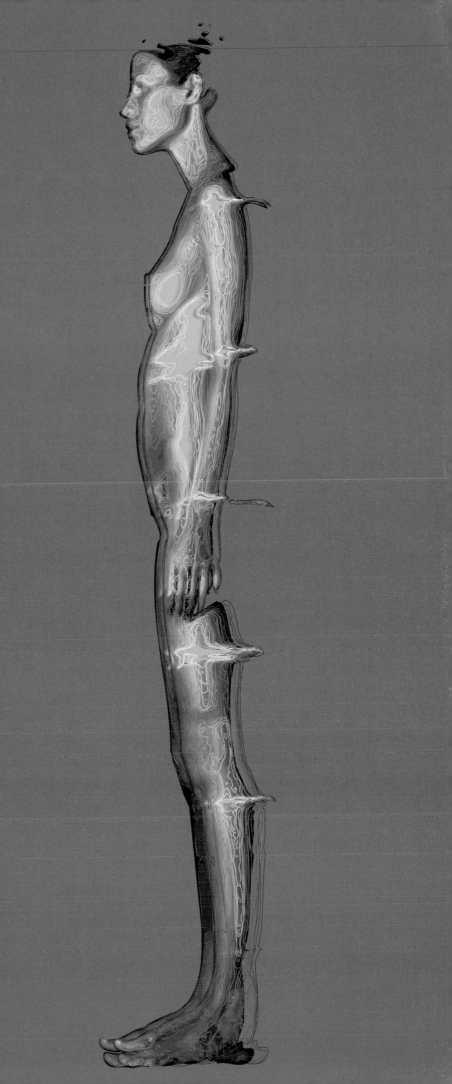

queen termite

Queen Termite, aka Yuko Kawano, draws not-so-innocent girls. Big-eyed and fashion-forward, they alternately communicate aggression and vulnerability. 'I have been rescued by numerous intelligent women in my life', Queen Termite explains, adding, 'they show animalistic love that's beyond reason, but at the same time, they are very human.' These women, her icons, are celebrated in her artwork.

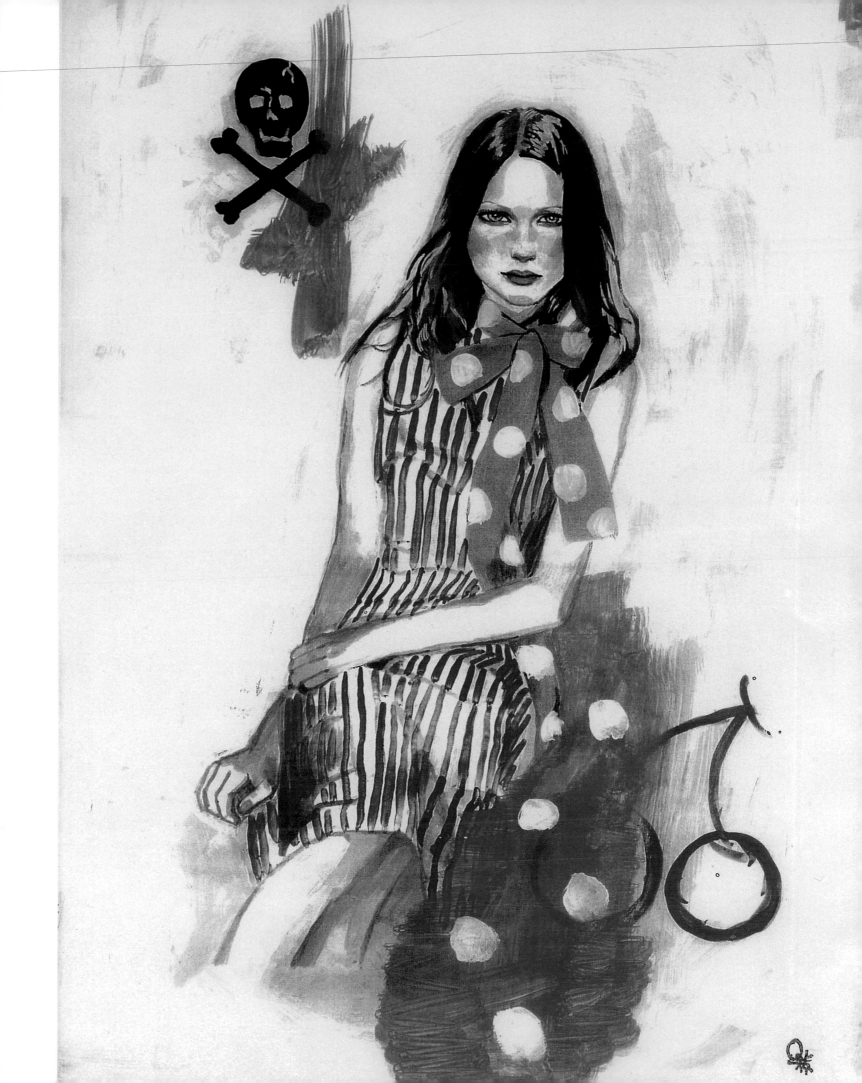

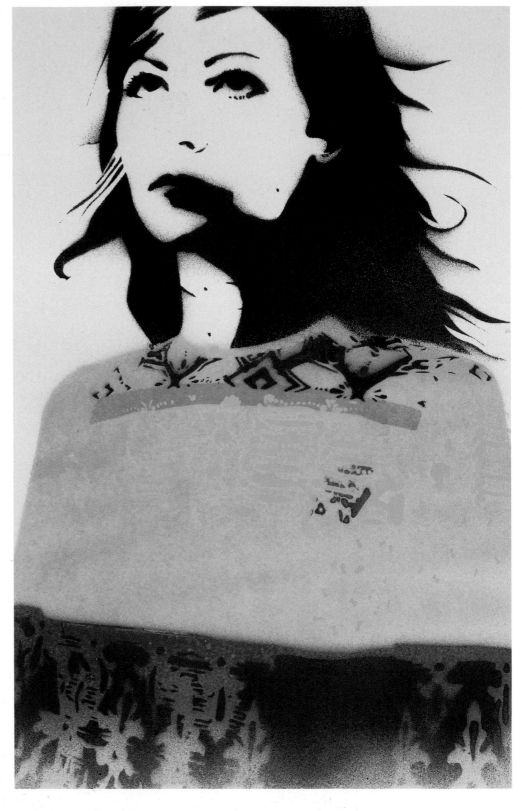

▷
Ghost
Stencilled aerosol on paper
i-D Magazine (UK), 2000

▷▷
Chanel
Stencilled aerosol on paper
Io Donna (Italy), 2003

reid
bernie

'My interest in illustration outweighs my interest in fashion stories, but they are a great platform for showing some imaginative stuff,' says Bernie Reid. Reid works with stylist Beca Lipscombe to create photographs that become the starting point for his drawings and aerosol stencils. Steadily focused on the evolution of his work, he describes its present style as 'craft-driven fashion vandalism'.

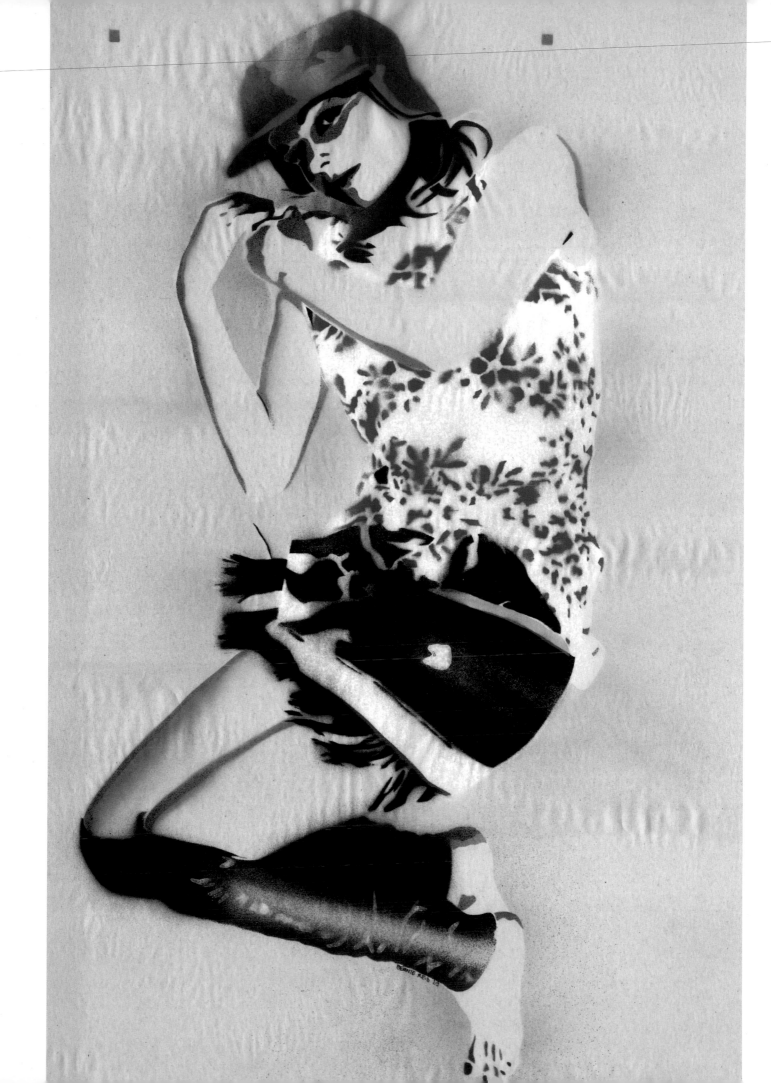

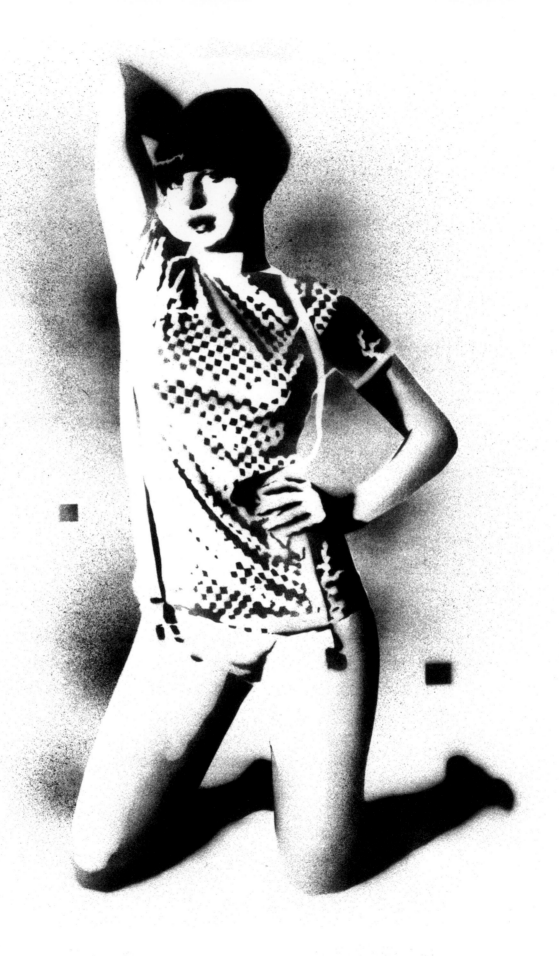

Stella McCartney
Stencilled aerosol on paper
For wall frieze installed in Stella McCartney's
NYC store, 2002

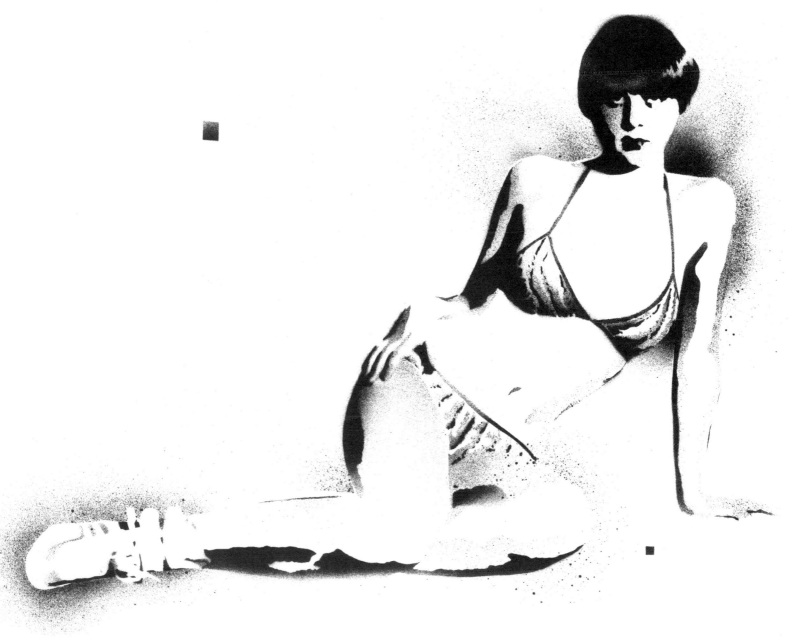

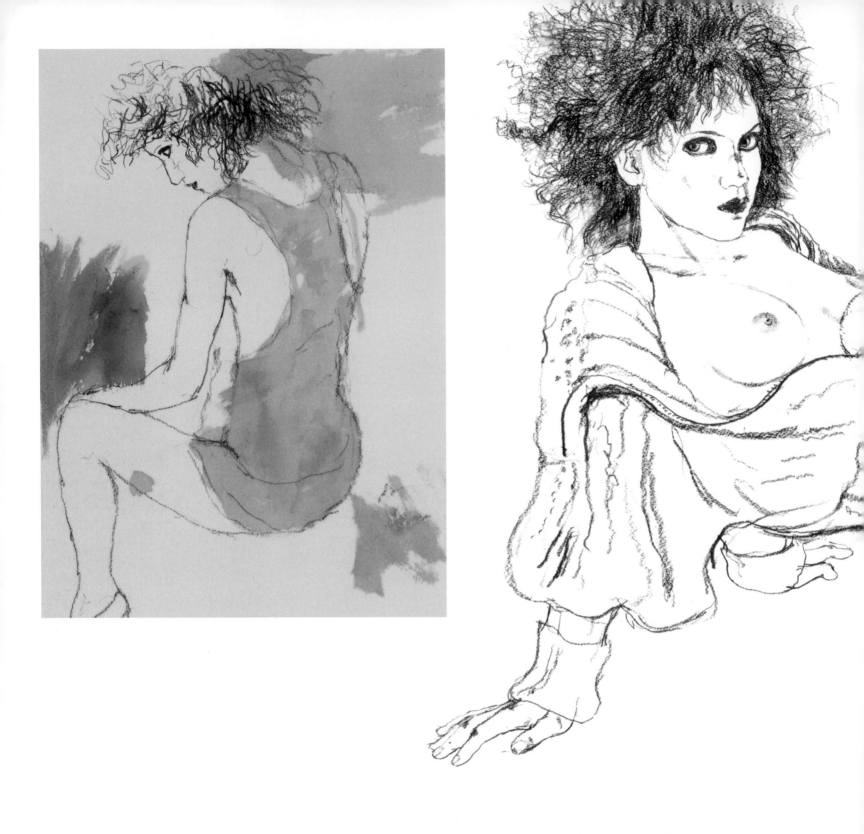

△
'Study: Tetyana Brazhnyk
in Stella McCartney'
Graphite and watercolour on paper, 2002

◁
'Tetyana Brazhnyk in Stella McCartney'
Graphite on paper
Stella McCartney advertising campaign, 2002

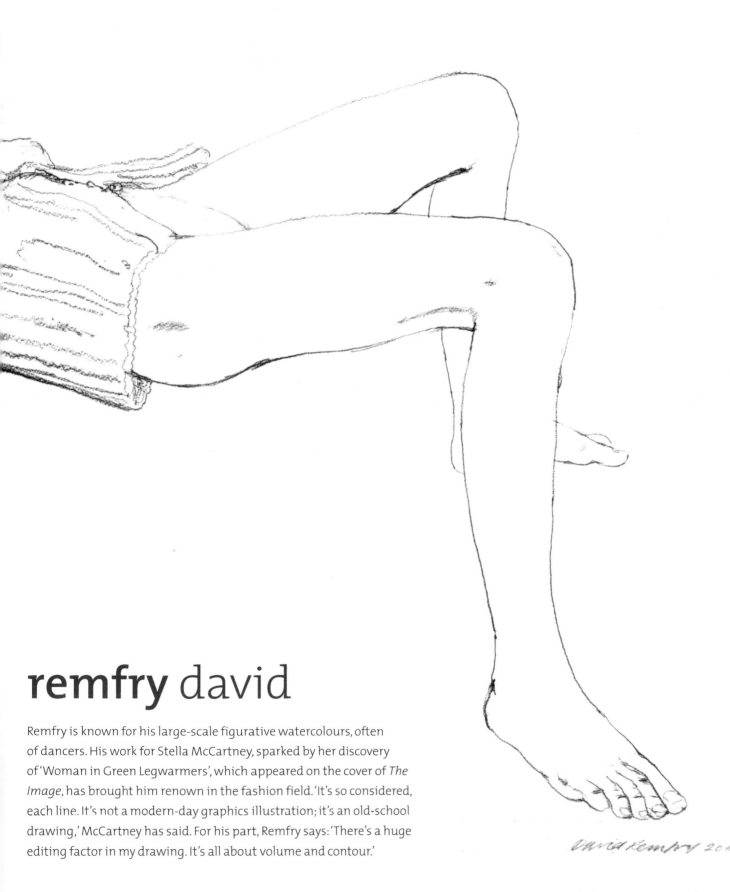

remfry david

Remfry is known for his large-scale figurative watercolours, often of dancers. His work for Stella McCartney, sparked by her discovery of 'Woman in Green Legwarmers', which appeared on the cover of *The Image*, has brought him renown in the fashion field. 'It's so considered, each line. It's not a modern-day graphics illustration; it's an old-school drawing,' McCartney has said. For his part, Remfry says: 'There's a huge editing factor in my drawing. It's all about volume and contour.'

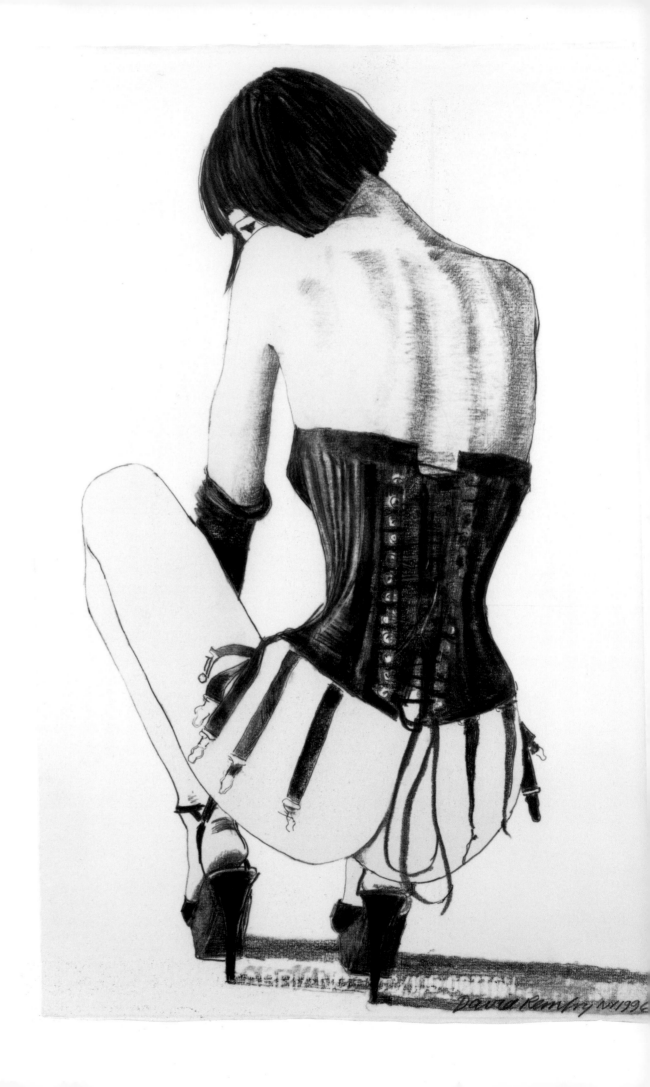

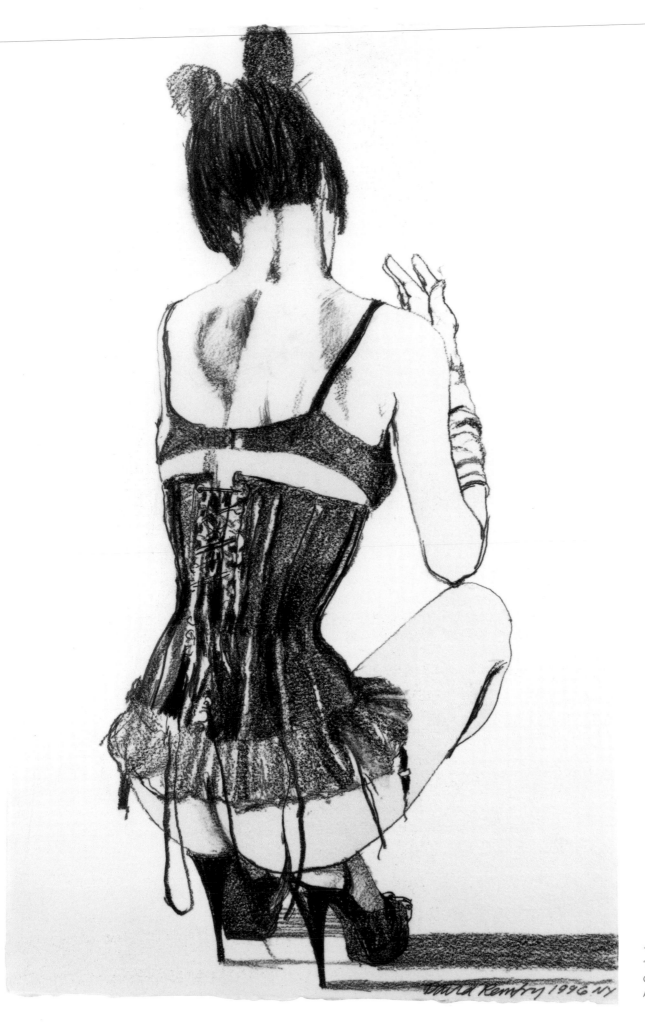

'Lulu'
Graphite on paper
Artist's collection, 1996

143

shiv

'Fashion illustration', declares Shiv, 'is an interpretation as opposed to a representation. For that you will take a photograph' – her usual starting point. Step two is usually in Photoshop, building up the image in layers, adding colours and textures. It's a technique that grew out of her background in painting, drawing and making collages.

◁

Photograph, Photoshop
Cover, *Frieze* (UK), 2001

△

Presto/Nike advertisement
Photograph, Photoshop
For Weiden + Kennedy, 2002

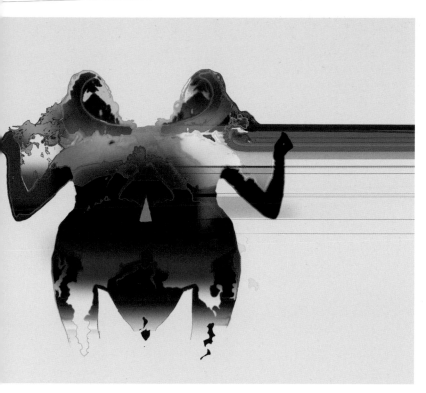

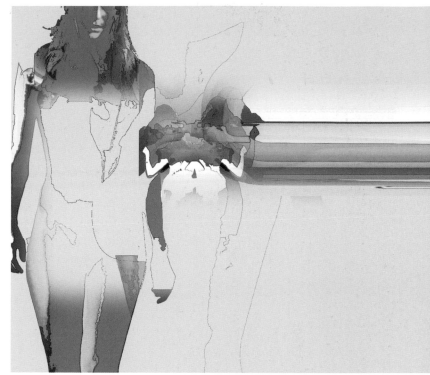

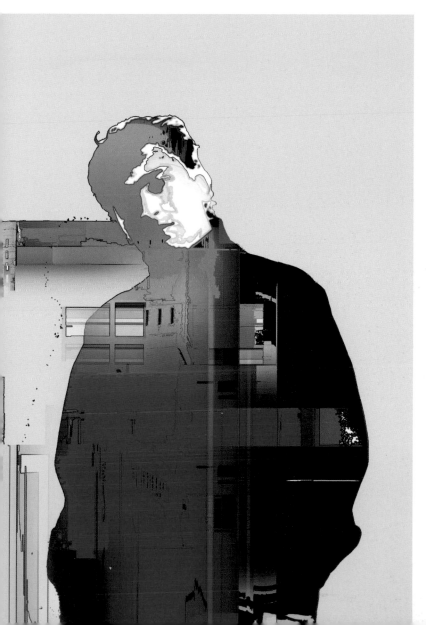

◁◁

Inner sleeve for 'Good Times' LP by Ed Case
Photograph, Photoshop
For Sony Records, 2002

▷ △ △

'The Rorchaus Test'
Photograph, Photoshop
(stills from animated exhibition piece)
'Steal Life' exhibition, Wildcat Gallery, 2003

◁

Cover for 'Good Times' LP by Ed Case
Photograph, Photoshop
For Sony Records, 2002

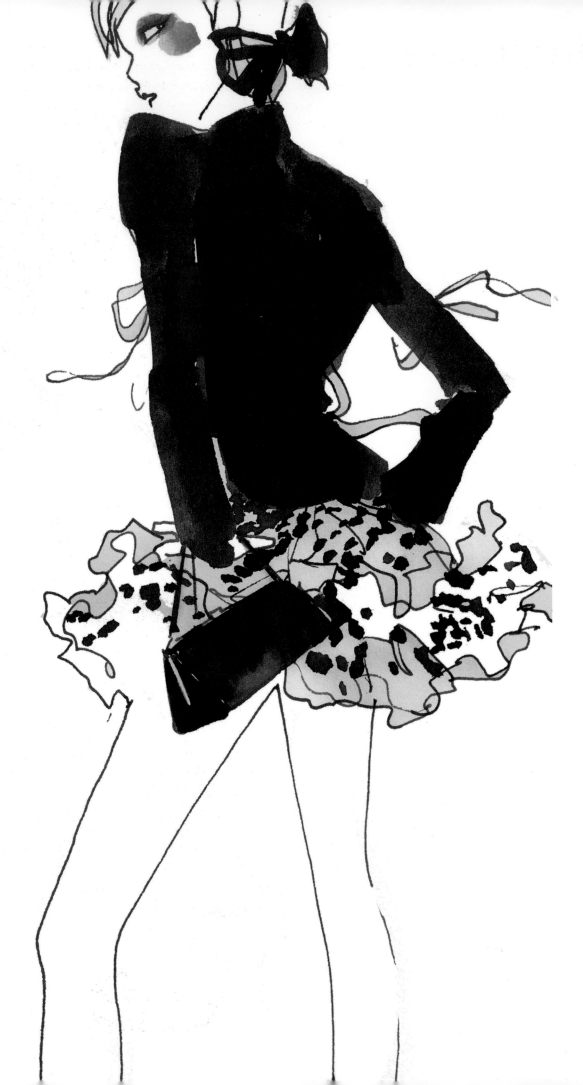

▷
Moschino
Pen and ink, Photoshop
Io Donna (Italy), 2003

▷▷
Simone
Pen and ink, Photoshop
'PIN UP' exhibition, Bond 07 by Selima,
New York, 2003

singh sara

Singh has drawn for as long as she can remember. 'My goal', she says, 'is to be able to draw what I envision.' Singh's fluid illustrations are primarily executed in watercolour and ink and she admits to being a perfectionist about anatomy: 'I'm very concerned about getting hands and feet,' she says. Her favorite source of inspiration? People-watching.

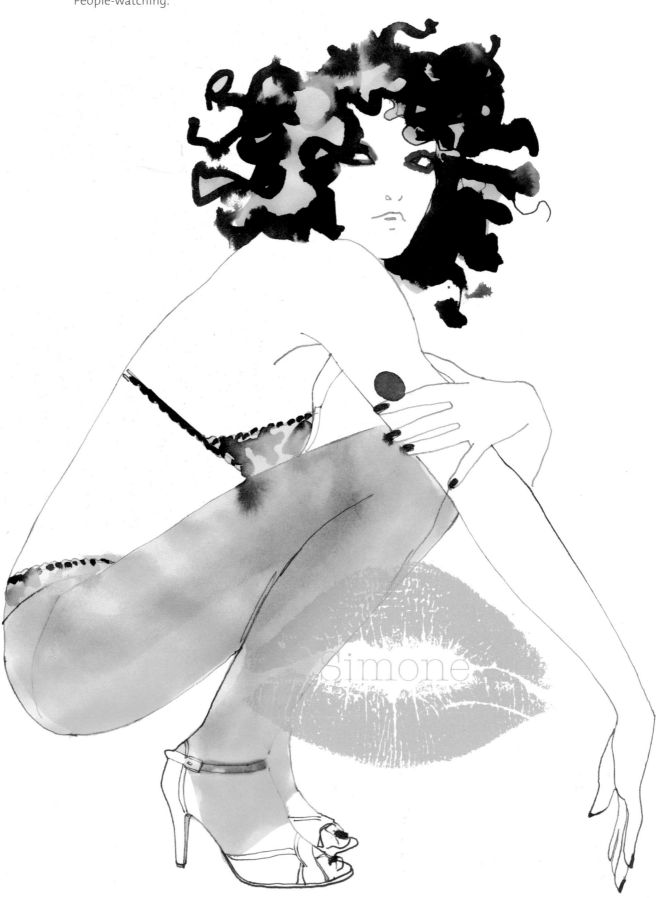

Simone

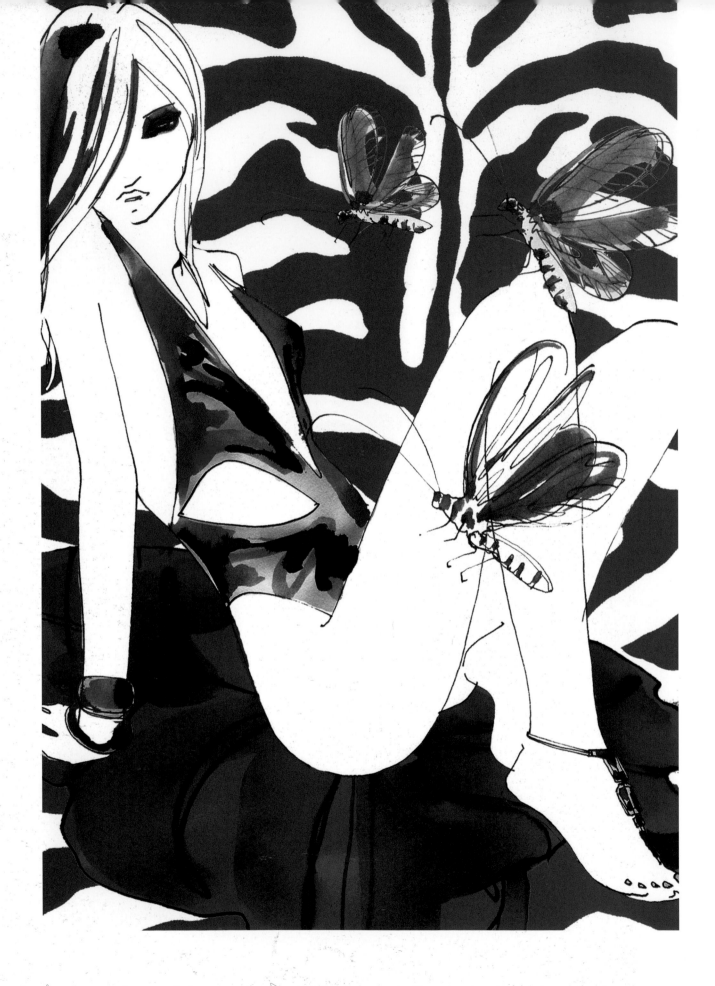

Pen and ink, Photoshop
Promotional postcard for Art Department, 2003

Pen/brush and ink, Photoshop
Wellfit Magazine (Germany), 2002

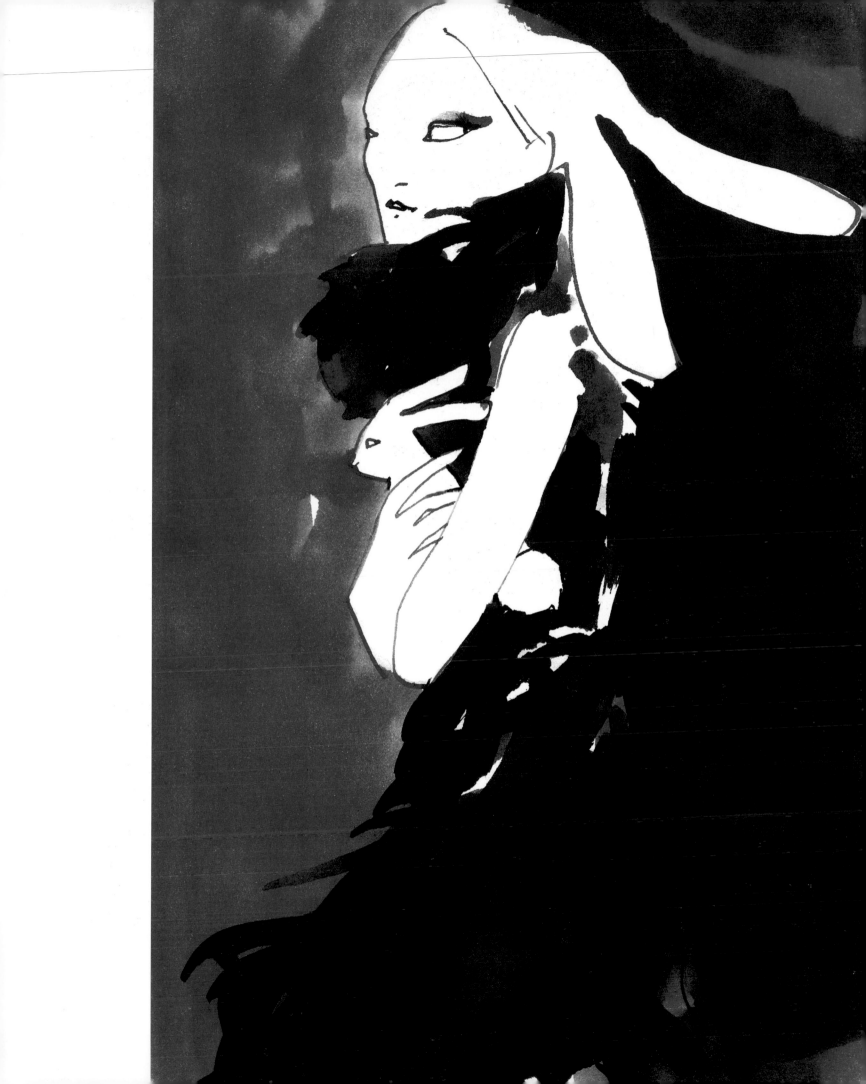

sirichai

Sirichai's focus is on the body's gestures and movements. His work is often conceived in the workroom as clothes are being fitted on the model. The result? Minimal and intuitive illustrations that illuminate 'the ambiguity between abstraction and representation'.

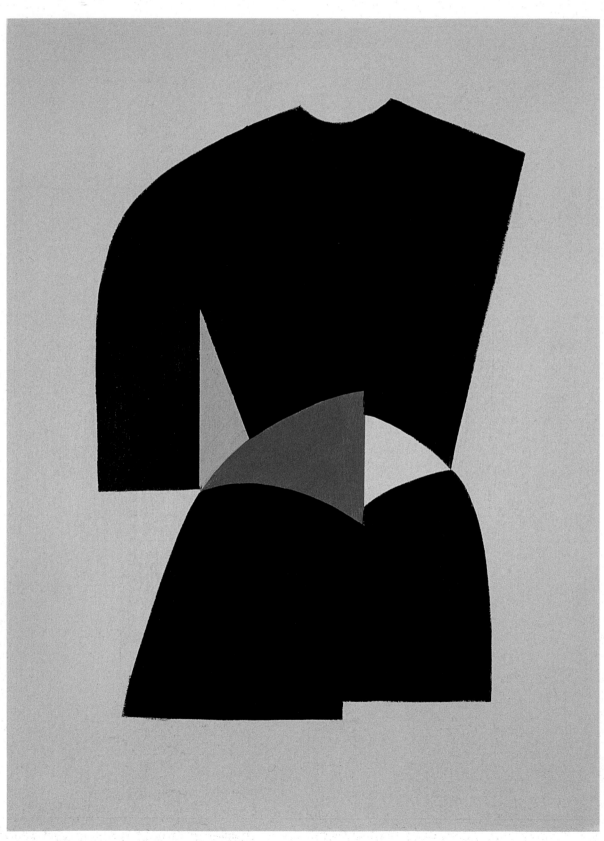

▷
Geoffrey Beene, spring 2001
Acrylic on paper
Sirichai for Geoffrey Beene, 2000

▷▷
Geoffrey Beene football jersey dress, fall 1967
Acrylic on paper
Sirichai for Geoffrey Beene, 2002

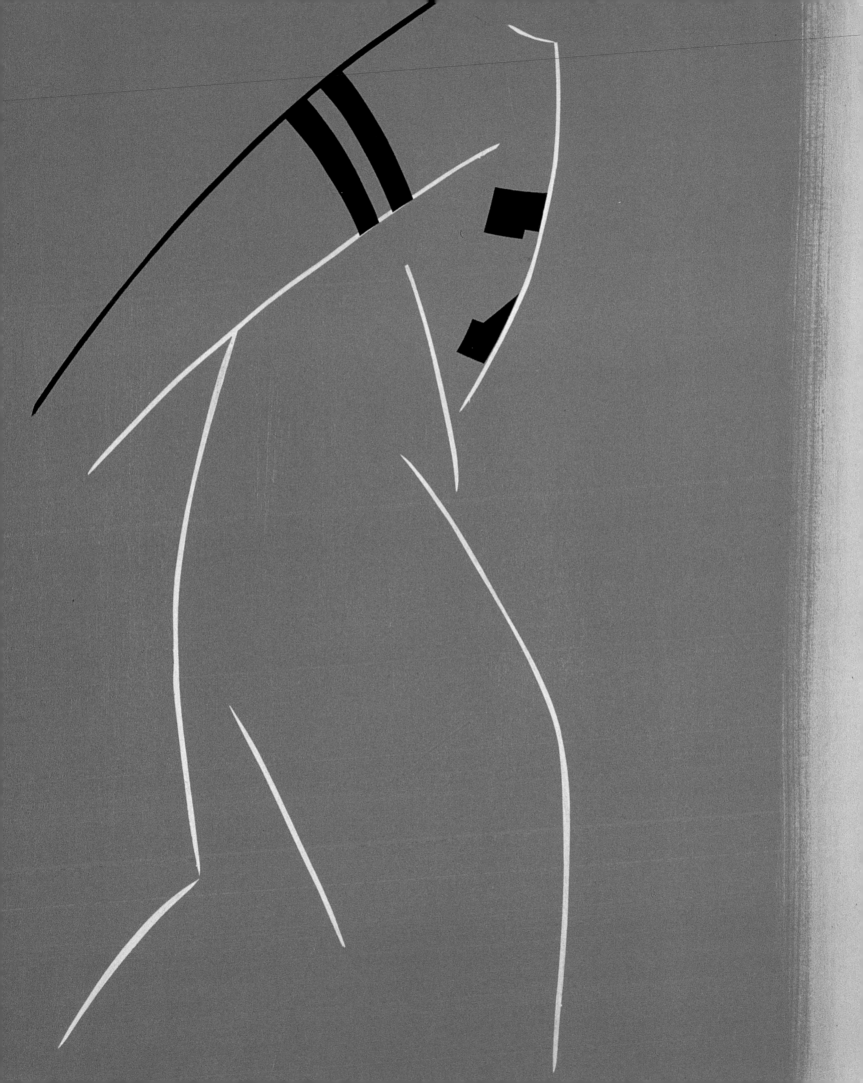

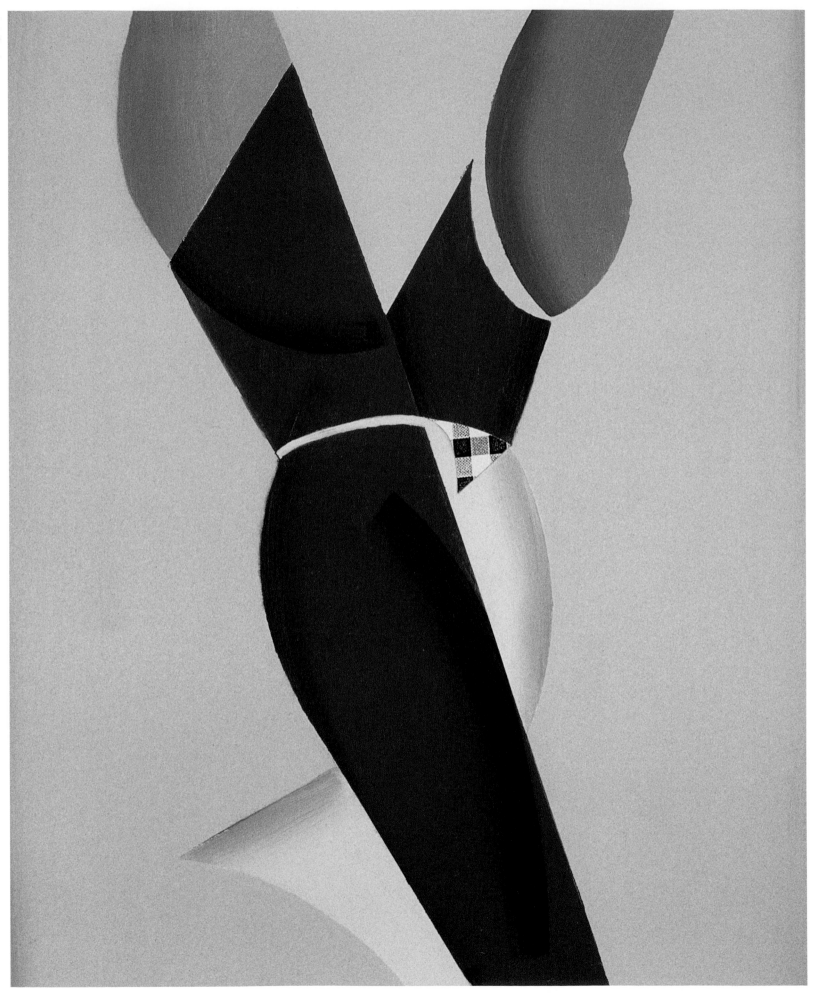

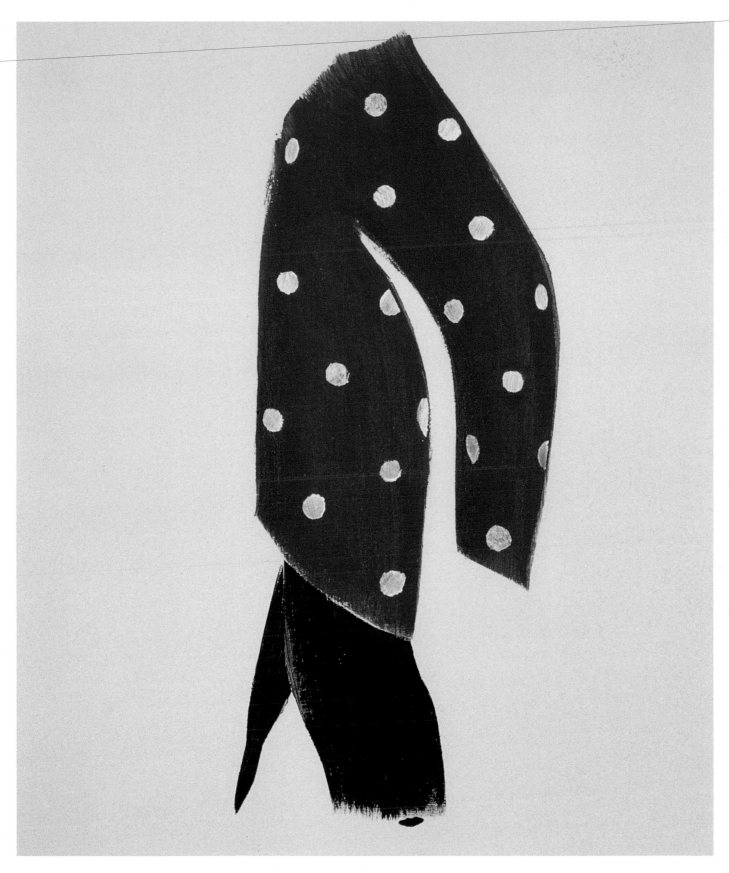

△
Geoffrey Beene, fall 1996
Acrylic on paper
Sirichai for Geoffrey Beene, 2001

◁
Geoffrey Beene, spring 2002
Acrylic on paper
Sirichai for Geoffrey Beene, 2001

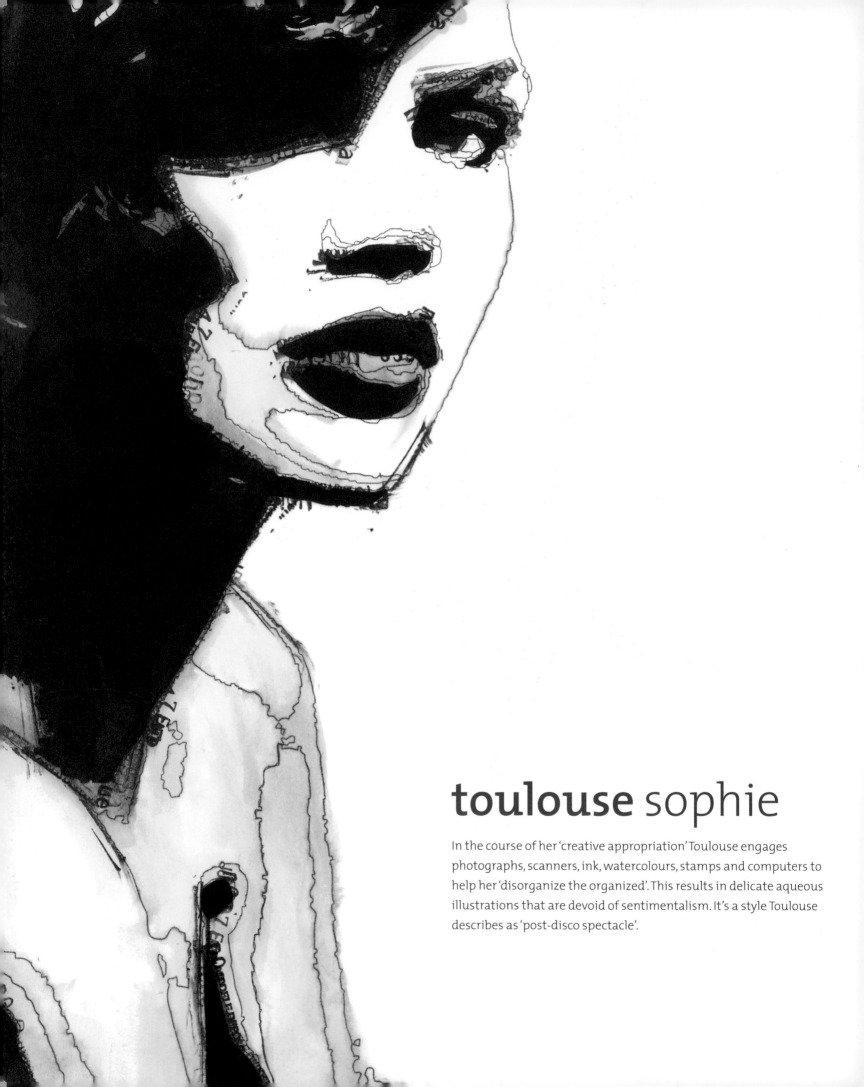

toulouse sophie

In the course of her 'creative appropriation' Toulouse engages
photographs, scanners, ink, watercolours, stamps and computers to
help her 'disorganize the organized'. This results in delicate aqueous
illustrations that are devoid of sentimentalism. It's a style Toulouse
describes as 'post-disco spectacle'.

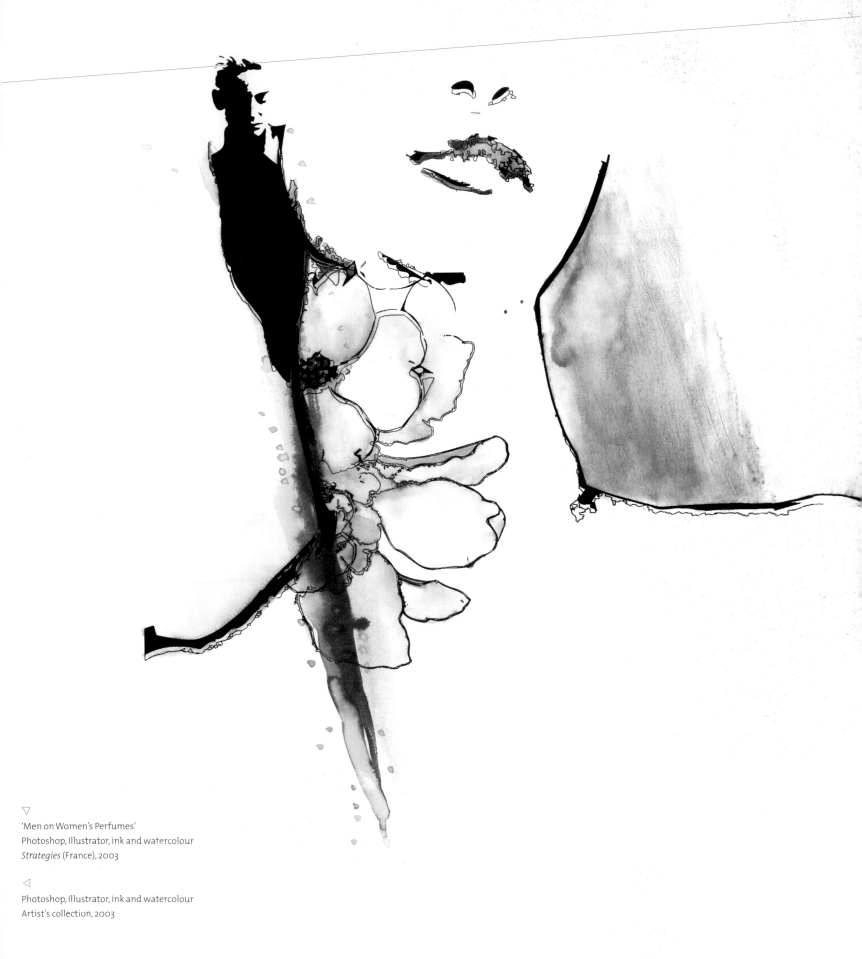

▽
'Men on Women's Perfumes'
Photoshop, Illustrator, ink and watercolour
Strategies (France), 2003

◁

Photoshop, Illustrator, ink and watercolour
Artist's collection, 2003

▽

Celine
Photoshop, Illustrator, ink and watercolour
Study for *Io Donna* (Italy), 2003

▷▷

Benôit Missolin collection
Photoshop, Illustrator, ink and watercolour
Flux Magazine (UK), 2003

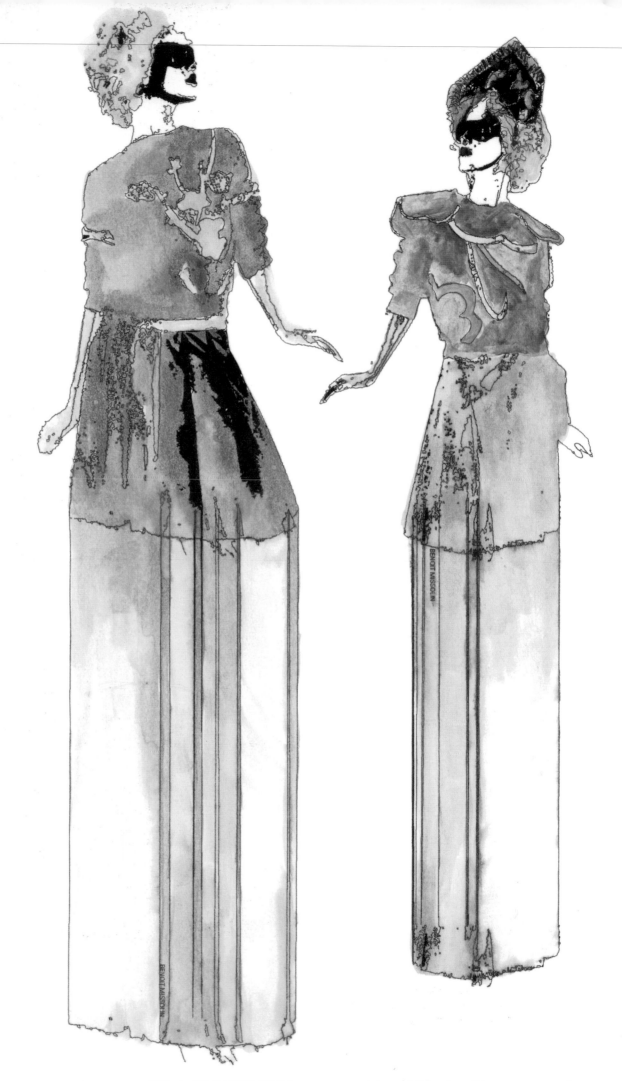

159

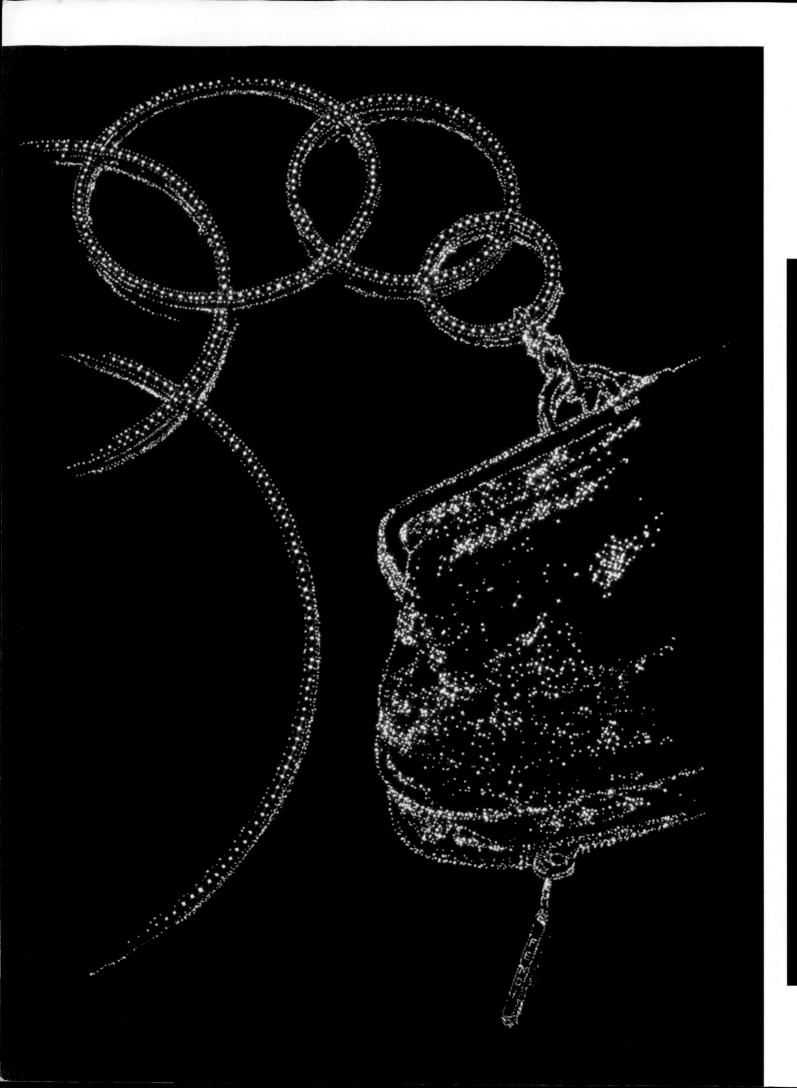

touratier maxime

'I try to collect, navigate and organize phenomena of light by playing with photographical, chemical or numerical means,' says Touratier, whose luminescent illustrations are created using photography and perforations. He creates emphasis by playing with light and the dark, blank spaces around it, aiming to 'reveal glittering, shimmering images like the universe constellated by stars'. Fashion illustration, he believes, is 'the liberation of drawing style in the service of fashion'.

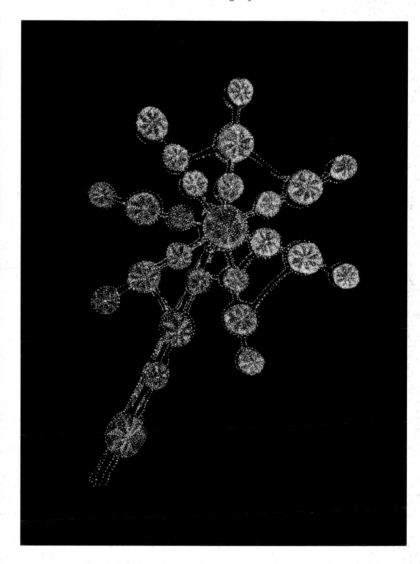

◁
'Shoe'
Mixed media, photograph and illustration
Crystal Fountain (Austria), 2002

◁◁
'C'est un sac', Fendi
Mixed media, photograph and illustration
Gloss #5 (France), 2003

△
'C'est un bijou', Chaumet
Mixed media, photograph and illustration
Gloss #5 (France), 2003

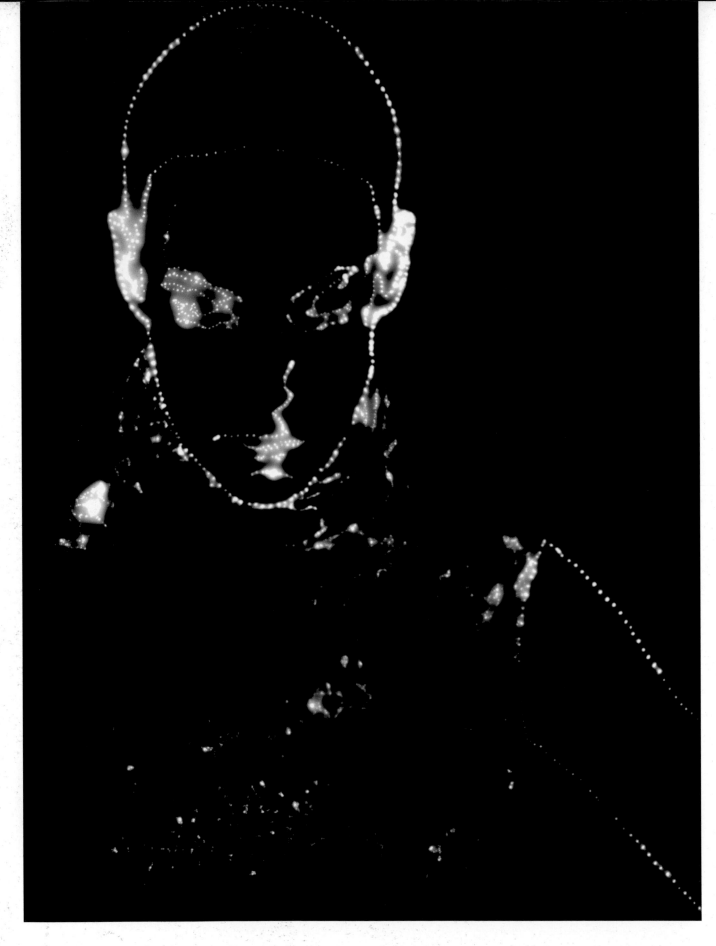

△

'Take the Pause'
Mixed media, photograph and illustration
Artist's collection, 1999

▷

'Jump', Nike
Mixed media, photograph and illustration
Study for Nike/*WAD* (France), 2000

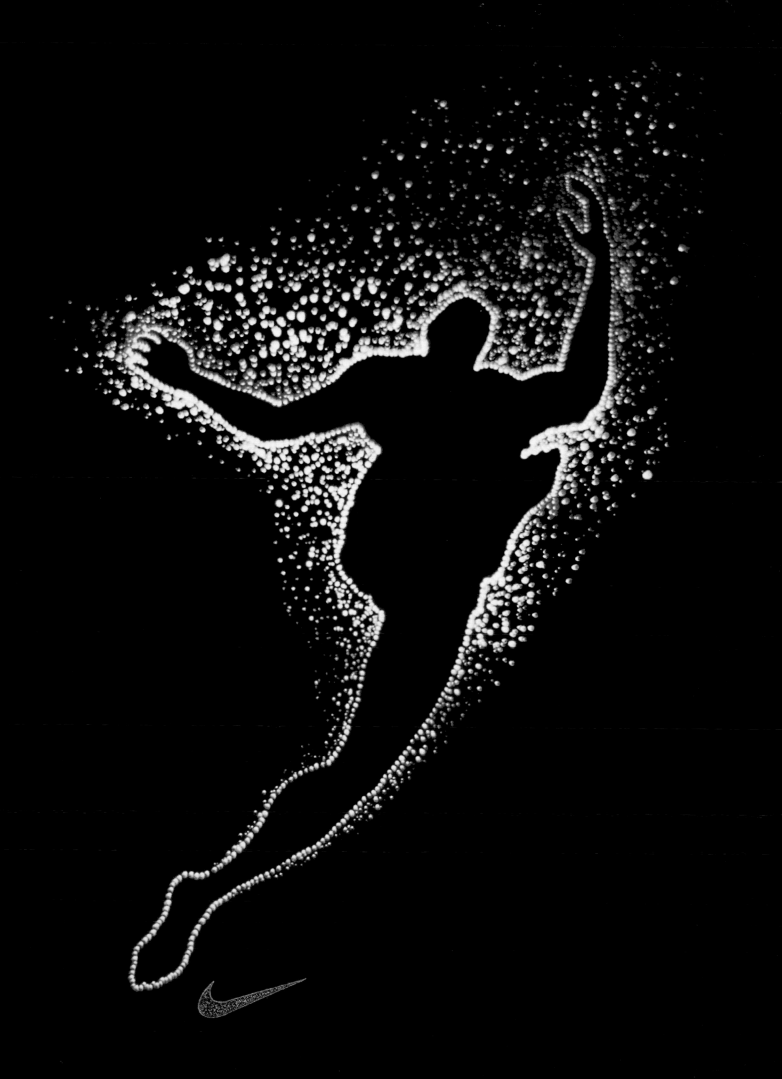

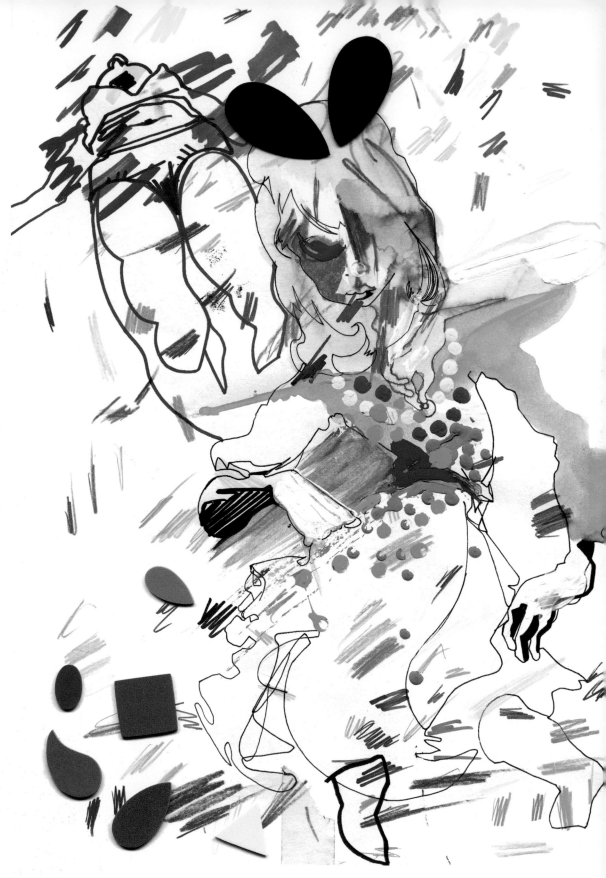

verhoeven
julie

'Miss Marple meets Monty Python' is how *Dazed & Confused*
magazine described designer/illustrator Verhoeven. Her psychedelic
and often erotic drawings are made to music: 'I listen and visualize,'
the artist says. Her description of her personal style: 'messy,
spontaneous, unpredictable and jolly', might also be applied
to her work on paper.

◁

'Fleetwood Mac: You Make Loving Fun'
Mixed media collage
Fat-Bottomed Girls (TDM Editions), 2002

▽

'Television Personalities: Part-Time Punk'
Mixed media collage
Fat-Bottomed Girls (TDM Editions), 2002

▷▷▷

'Help Yourself and God Will Help You'
Pen and ink, collage
Rebel (France), October 2001

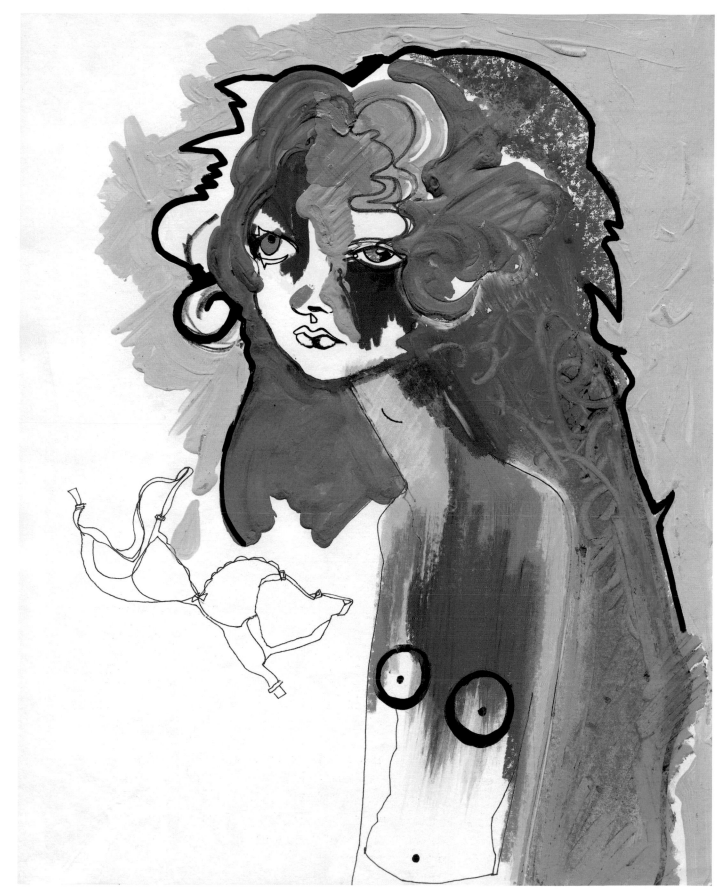

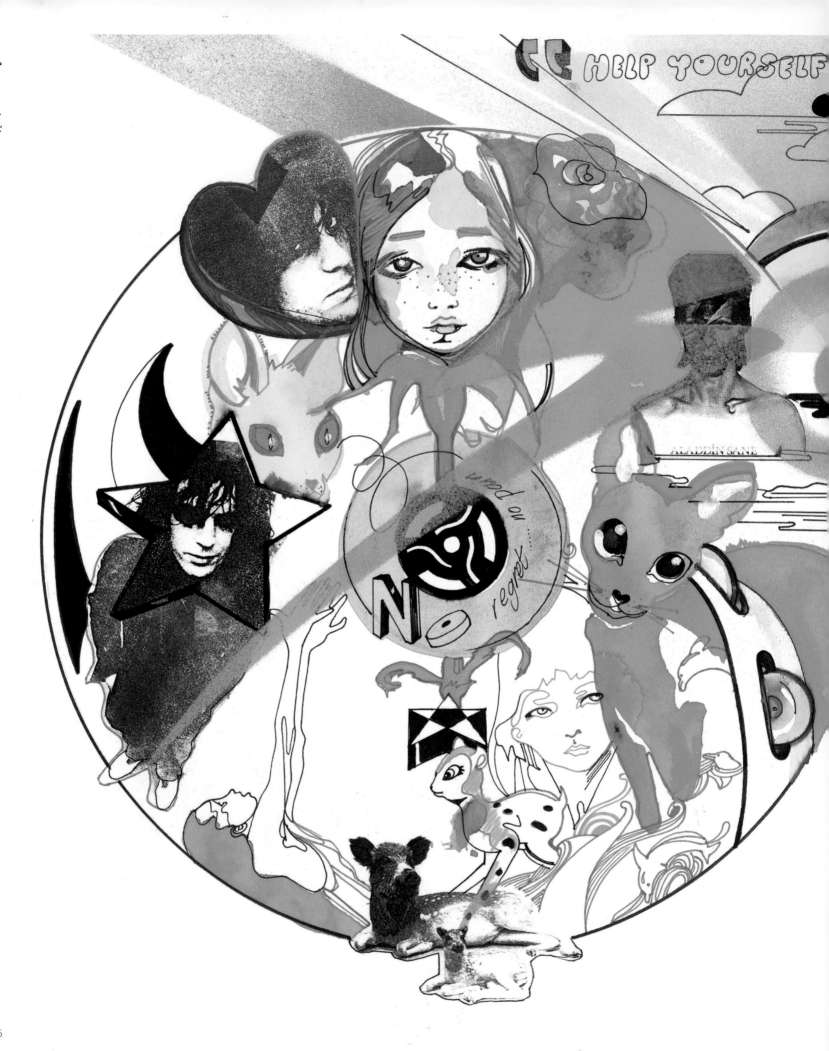

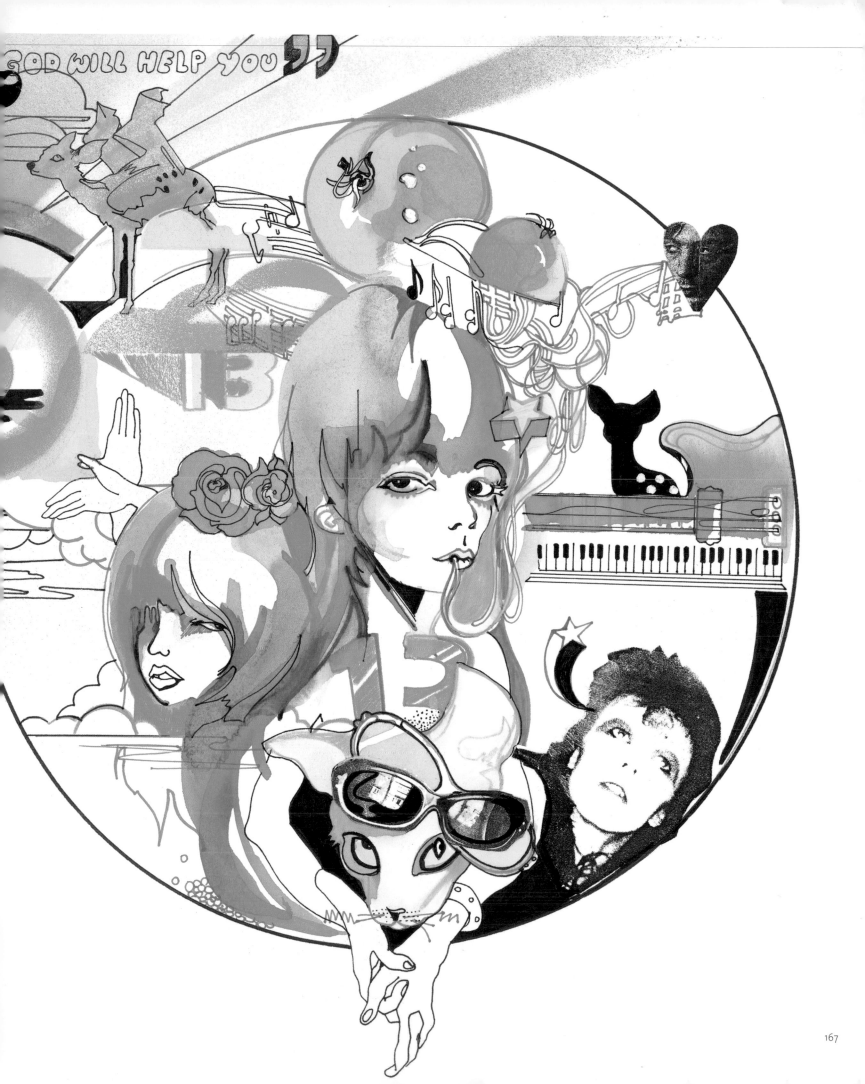

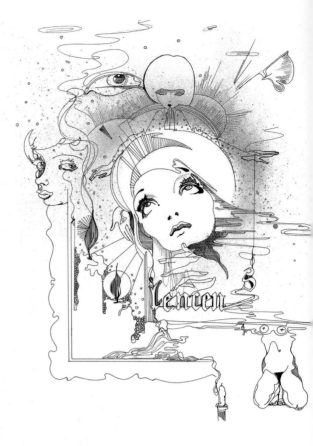

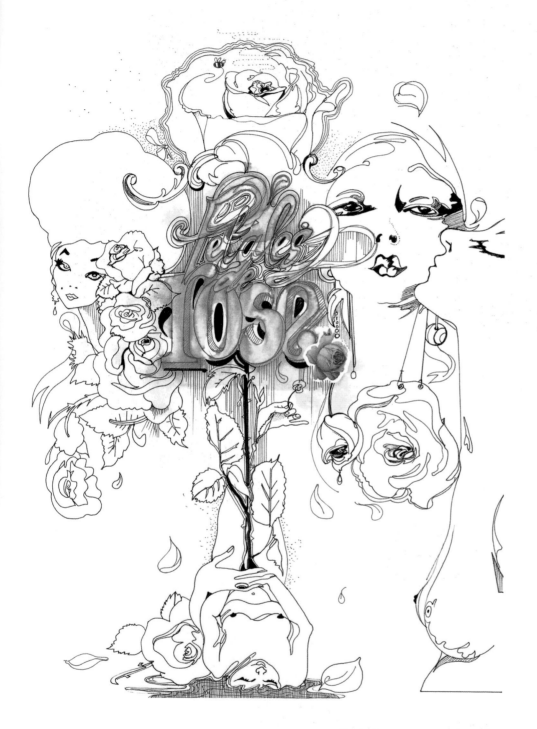

◁ △
'Les Quatre Eléments'
Pen, watercolour and aerosol
Numéro (France), May 2000

▷
'Twenties Flapper/Pearls'
Alexander McQueen, Anna Sui, Chanel,
Cacharel, Dolce & Gabbana, Chloé
Collage
The Face (UK), November 2001

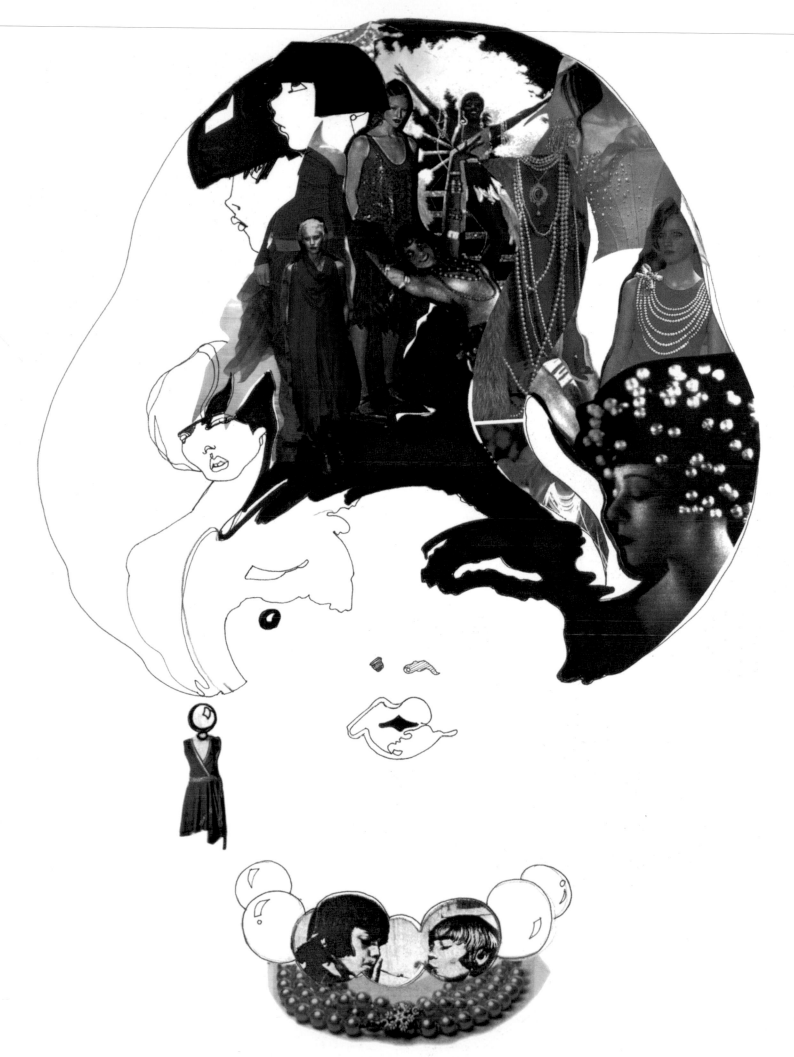

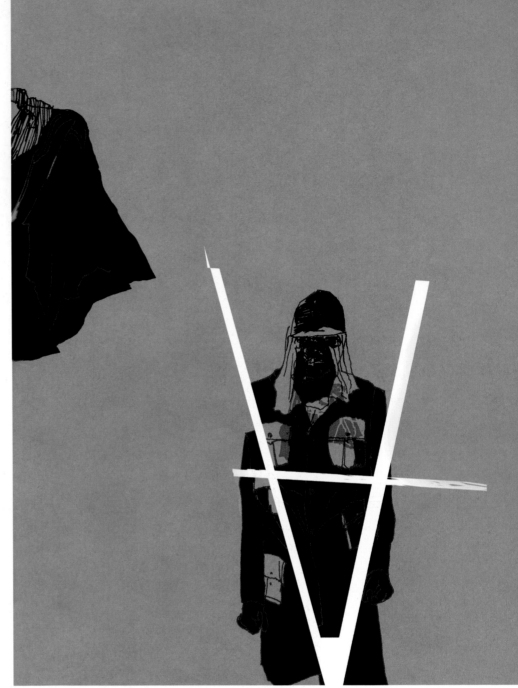

weiner clay

'My hand scratches my head. My head whispers something to my hand. My hand pleases my head.' This, then, is Weiner's description of his technique. Weiner works obsessively, creating 'emotive and brilliant' drawings with mixed media and on the computer. 'I love to draw,' he says. 'It is my second language.'

Raf Simons; Trousers, trench, nameplate
Ink and marker
Hintmag.com (USA), 2003

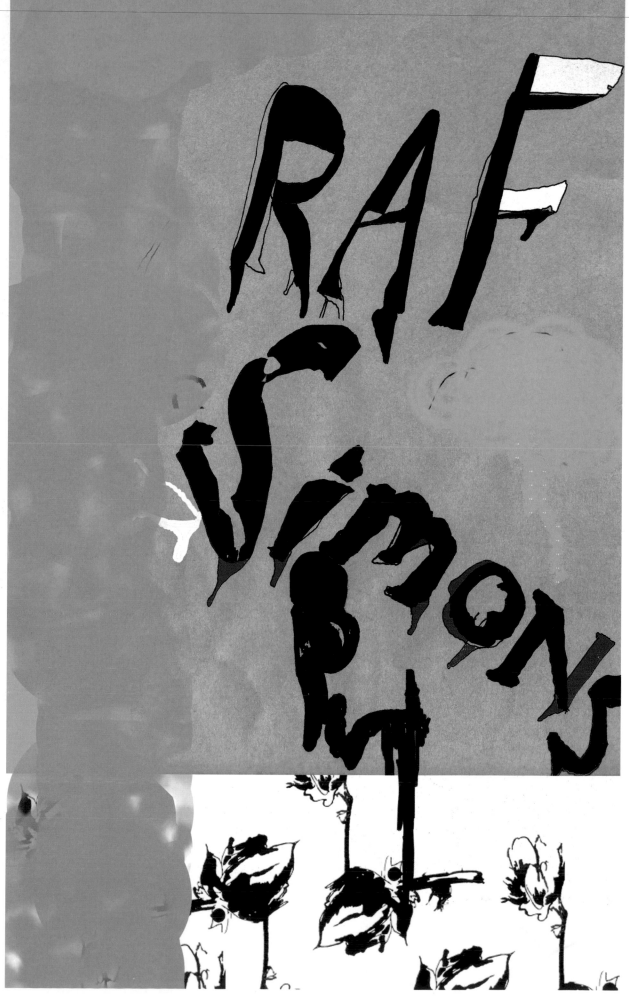

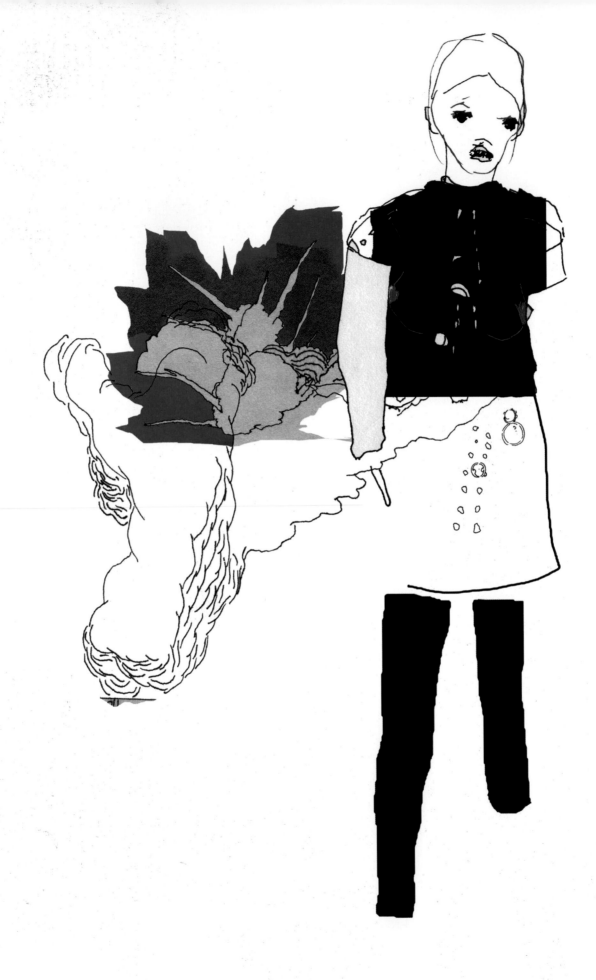

▷ ▷▷

Louis Vuitton, I & II
Gouache, paper cut-out, watercolour
Io Donna (Italy), 2003

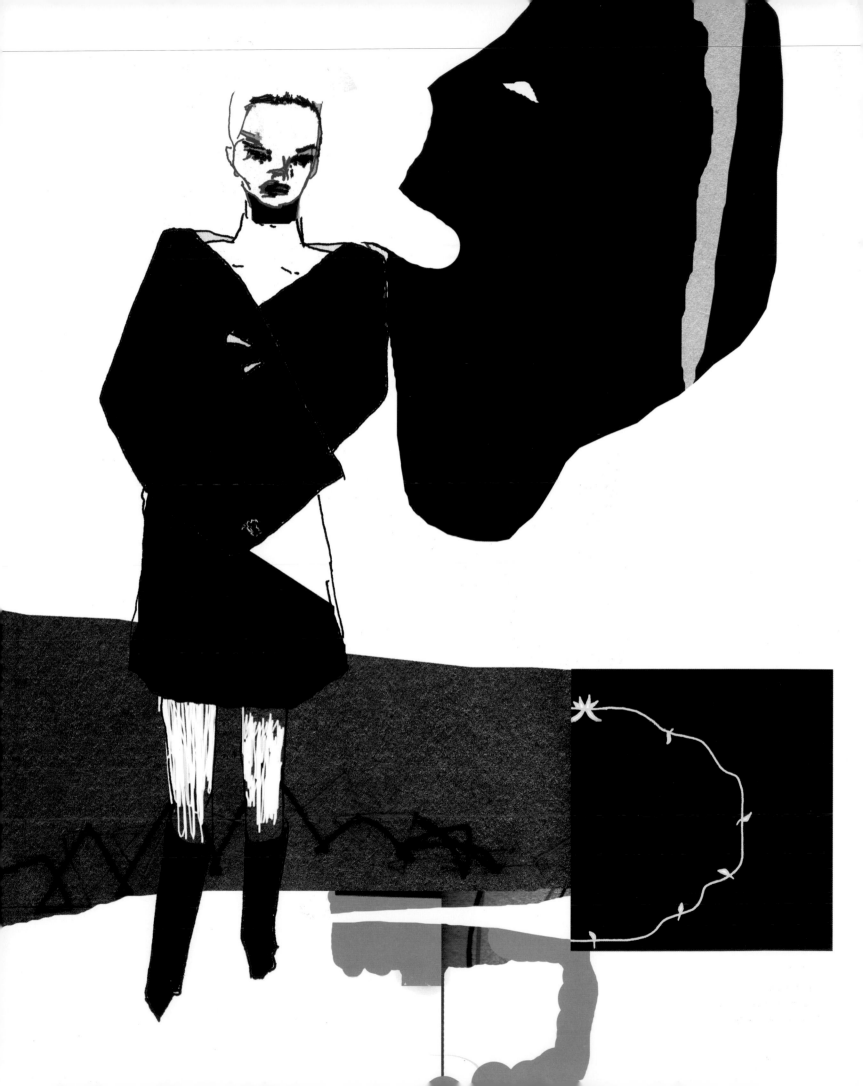

akroe

Étienne Bardelli was born in Franche-Comte, France in 1977. In 1990 he started tagging, and then began to paint in old empty factories. He studied applied arts, specializing in graphic design for two years. In 1998, he moved to Paris to work as a graphic designer, launching a freelance career soon after. He now works for music and fashion clients. His work has been published in *Summertime* and *Writing: Urban Calligraphy and Beyond* (Die Gestalten Verlag); in Christian Hundertmark's *The Art of Rebellion* (Gingko Press); and in *Worldsign* and *Clark* magazines, among others.

contact
e akroe@akroe.net
www.akroe.net

anastase charles

Charles Anastase was born in 1979 in London and now lives in Paris, where he works as a designer. In addition to working on his own line, Anastase is a consultant to various ready-to-wear labels. In 2003 A. P. C. published Anastase's monograph, also exhibiting his work in their Tokyo store. His work was shown in 2002 as part of the Fashion Documenta exhibition at the Palais de Tokyo in Paris. *Crash*, *Dazed & Confused*, *Composite*, *Doing Bird* and *Jalouse* are among the magazines that have published his work.

contact
Alban Adam
t 33/ (0)(6) 22 45 24 25
e charlesanastase@hotmail.com

antoniou rebecca

Rebecca Antoniou was born in Northamphire, England in 1971. She studied art and fashion design at Kent Institute of Art & Design. Since 1994 she has lived in New York, where she has worked for Tommy Hilfiger and Banana Republic. Among Antoniou's corporate clients are Converse, RCA, XL recordings, Virgin records and H&M. Her work has appeared in publications including *Black Book*, *Elle Decor*, *Flaunt*, *Loaded Fashion*, *Nova*, *Nylon*, *Spin* and *Spoon*.

contact
Art Department
t 1/ (212) 243-2103
f 1/ (212) 243-2104
e stephaniep@art-dept.com
www.art-dept.com

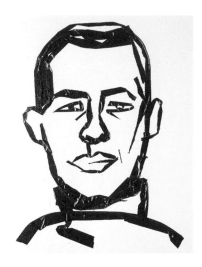

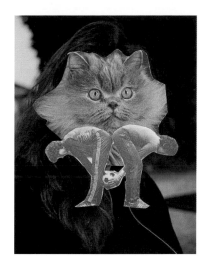

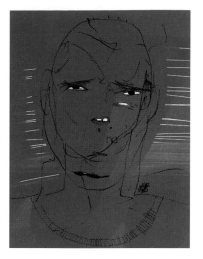

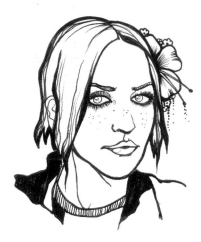

aponte carlos

Born in New York, Carlos Aponte grew up in Puerto Rico admiring the work of Antonio Lopez. Lopez later became Aponte's mentor, encouraging him to return to New York and pursue a career in illustration. Aponte studied there at the Fashion Institute of Technology and at the School of Visual Arts, and he is the recipient of the New York Independent Animation Award. Coca-Cola and Banco Popular de Puerto Rico are among Aponte's corporate clients. His editorial work has featured in publications such as *Elle*, *Fashions of the New York Times*, *The New Yorker*, *Tatler*, *Vibe* and *Visionaire*.

contact
Art Department
t 1/ (212) 243-2103
f 1/ (212) 243 2104
e stephaniep@art-dept.com
www.art-dept.com

arkhipoff elisabeth

Born in 1973 in Abidjan, on the Ivory Coast, Elisabeth Arkhipoff now lives in Paris. She holds degrees in literature and philosophy from l'Université de Paris. Arkhipoff's work has been exhibited internationally at institutions including the Musée d'Art Moderne de la Ville de Paris and the Rooseum Center for Contemporary Art, Malmo, Sweden. A monograph of her work with Laurent Fétis was published in 2003 (Design Exchange Tokyo). Her illustrations have appeared on the covers of *+81* and *Studio Voice* and in *Creative Review*, *Dazed & Confused*, *Ryuko Tsushin*, *Self-Service*, *Vogue Nippon* and *Zoo* as well as on SHOWstudio.com. Corporate clients include Karine Arabian and Virgin.

contact
t 33/ (0)(1) 43 44 51 63
e earkhipoff@noos.fr
www.romanticsurf.com

barwick thomas

Thomas Barwick hails from Beverley in Yorkshire, England. He studied fine art at Nottingham Polytechnic and has returned to Yorkshire with his young family to live in Hebden Bridge. Barwick has worked for a number of music clients, designing cover art for Duophonic 45s and acts including Madonna over Yorkshire and They Came from the Stars (I Saw Them). In addition, he has created numerous event flyers and posters. Magazines including *Spruce*, *World Architecture* and *Adrenalin* have published his work editorially. In 2003 Barwick designed a limited edition line of skateboards for FSU.

contact
t 44/ (0)(1422) 846 526
m 44/ (0) 7968 962 021
e tom.barwick@virgin.net
www.thomasbarwick.com

bercsek fábia

Fábia Bercsek lives in São Paulo, Brazil, where she was born, and designs womenswear under her own label. She attended art college and graduated from the fashion course at Santa Marcelina University. Her corporate clients include Alexandre Herchcovitch, Brazilian *Vogue* and Grafikonstruct. Bercsek's work has been featured in publications including *O Brasil na Moda* (Editora Caras) and *2Fanzine*.

contact
t + f 55/ (11) 3081 3935
e info@fabiabercsek.com.br
www.fabiabercsek.com.br

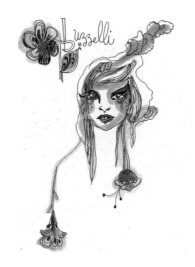

berthoud françois

François Berthoud was born in Switzerland in 1961. He studied graphic design in Switzerland, following which he moved to Milan and began working for Condé Nast, as well as publishing comic strips for Italian magazines. He was a major contributor to *Vanity* and illustrated an entire issue of *Visionaire*. A book dedicated to his work was published in 2000. Berthoud's work has been widely exhibited, most recently in Milan in collaboration with Capucci, and has appeared in all major international fashion publications. His advertising clients include Capucci, Myla, Shiseido and Incotex.

contact France
Art Partner
t 33/ (0)(1) 4201 6077
f 33/ (0)(1) 4201 6078
e info@artpartner.com
www.artpartner.com

contact USA
t 1/ (212) 645-2027
f 1/ (212) 343-9891
e info@artpartner.com
www.artpartner.com

buzzelli kime

Born in 1969 in Cleveland, Ohio, Kime Buzzelli now lives in Los Angeles, California. She studied fashion illustration at Parsons School of Design in New York and has degrees in painting and art education from Ohio State University. Buzzelli has been exhibiting her work since 1994, throughout the United States, and showed at Tokyo's Rocket Gallery in 2003. Her work has been published in magazines including *Bust* and *Paper*; her drawings have also been incorporated into clothing worn by Shakira, Jewel and Daryl Hannah. Buzzelli owns Show Pony, a boutique-cum-installation space and fashion line.

contact
Show Pony
t 1/ (213) 250-3381
e showpony@earthlink.net

cardenas alejandro

Alejandro Cardenas was born in 1977 in Santiago, Chile and now lives in Brooklyn. In addition to his work as an illustrator, Cardenas is the creative director for New York designer label Proenza Schouler. He studied at the New World School of the Arts High School, Miami and at the Cooper Union School of Art, New York. Among his corporate clients are Motorola, Kate Spade and United Bamboo. His work has been seen in *Sherman*, *Travel + Leisure*, *Seventeen*, *Big*, *Exit* and *Allure*.

contact
Art Department
t 1/ (212) 243-2103
f 1/ (212) 243-2104
e stephaniep@art-dept.com
www.art-dept.com

deygas florence

Paris-based Florence Deygas was born in Valence, France in the 1960s. She is a self-taught illustrator who studied animated film at l'Ecole des Gobelins, Paris. Deygas has illustrated the covers of *Minimix* and *Ryuko Tsushin*, and her work has appeared in *Big*, *Composite* and *Vogue Nippon* (among other publications), as well as on the web at colette.fr. Her varied corporate clients include Bourjois, Dreamworks and Lancel. In 1998 Deygas illustrated a book entitled *YSL invite Hiromix*, which was accompanied by an exhibition. Shows of her artwork, focused on her Winney figurine, have been held in France and Japan. With her partner Olivier Kuntzel, Deygas was awarded the D&AD People's Pencil in 2003 for the opening title sequence of Steven Spielberg's 2002 film *Catch Me if You Can*.

contact France
add a dog
t 33/ (0)(1) 42 55 43 94
f 33/ (0)(1) 42 55 43 96
e addadog@wanadoo.fr

contact Japan
Mizuyo Yoshida, Steady Study
t 81/ (0)(3) 3405 1238
f 81/ (0)(3) 3405 1237
e mzy@steady-study.co.jp

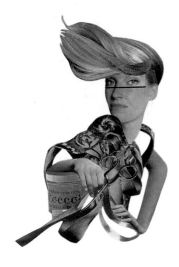

esdar maren

Maren Esdar was born in Westphalia, Germany in 1972 and now lives in Hamburg, where she completed a degree in fashion design at the University of Applied Sciences. She studied figure and fashion drawing with Howard Tangye in London, at Central St Martins from 1999 to 2000. Esdar's work has appeared in Dutch, German and Korean editions of *Vogue*, as well as *Annabelle*, *Sepp* and *Vorn*. She co-owns an art agency called Style_unique.

contact Europe
Unit CMA
t 31/ (0)(20) 530-6000
f 31/ (0)(20) 530-6001
e info@unit.nl
www.unit.nl

contact USA
t 1/ (212) 529-0400
f 1/ (212) 529-1995
e info@unitcmna.com
www.unit.nl

galdos del carpio tristan

Tristan Galdos del Carpio was born in 1969 to a Peruvian father and French mother. He lives in Paris, where he studied etching and serigraphy at l'Ecole Nationale Supérieure des Arts Décoratifs. In 1999 his work was exhibited in Tokyo at the Poetry of Sex Gallery, for whom he now creates T-shirt designs. Galdos del Carpio has contributed to a book about Pierre Huygues and illustrated an advertising campaign for the Italian company Clone. His work has been published in magazines including *Das Magazin*, *Self-Service* and Paris *Vogue*.

contact
Philippe Arnaud Agent S. A.
t 33/ (0)(1) 45 56 00 33
f 33/ (0)(1) 45 56 01 33
e apa@club-internet.fr
www.philippearnaud.com

gibb kate

Born in the Low Countries, Kate Gibb lives in London. After studying printed textiles at Middlesex University her focus shifted to silkscreen printing. She earned an MA at Central St Martins. Gibb famously collaborated with the Chemical Brothers and has worked closely with Dries Van Noten and Levi's. She has numerous publishing (Penguin, Bloomsbury) and music clients (Chrysallis, EMI, Source Records, Virgin). In 2003 she had a show in Tokyo at Parco Gallery and plans for 2004 include a one-woman show at the Pentagram Gallery in London. Publications including *Arena Homme*, *Creative Review*, *Dazed & Confused*, *The Face* and *Relax* have showcased her work.

contact
Big Active Creative Management
t 44/ (0)(20) 7702 9365
f 44/ (0)(20) 7702 9366
e info@bigactive.com
www.bigactive.com

goodall jasper

Jasper Goodall was born in Birmingham in 1973. He has a degree in illustration from the University of Brighton, where he is now based. In 2003 Goodall collaborated with Louise Middleton of Bikini on a beachwear line. His work has been exhibited in Tokyo and England and appears in *Pen and Mouse* (Laurence King). Among his corporate clients are Warner Music (The Webb Brothers), MTV, Bartle Bogle Hegarty (BBH), Wieden+Kennedy, Saatchi & Saatchi, Pentagram, Nike, Adidas, Coca-Cola and Deep Design. Goodall's editorial roster includes *Big*, *Creative Review*, *The Face*, *Graphics International*, *The Observer Magazine* and *XLR8TOR* (for whom he illustrated the cover).

contact
Big Active Creative Management
t 44/ (0)(20) 7702 9365
f 44/ (0)(20) 7702 9366
e info@bigactive.com
www.bigactive.com

gray richard

Richard Gray, who lives in London, was born in Norwich, England in 1966. He studied fashion at Middlesex University. Gray has collaborated with a number of designers including Alexander McQueen, Boudicca, Miguel Adrover and Agent Provacateur and his work has been exhibited throughout Europe and appeared in a number of books. Among the many publications to showcase Gray's work are *Madame Figaro* (including a cover), *The Observer Magazine*, *Sleek* and Italian *Vogue*.

contact
Art Department
t 1/ (212) 243-2103
f 1/ (212) 243-2104
e stephaniep@art-dept.com
www.art-dept.com

habermacher rené & tsipoulanis jannis

René Habermacher was born in Switzerland in 1969, Jannis Tsipoulanis in Athens in 1968. The pair divide their time between three cities: Hamburg, Athens and Zurich. Tsipoulanis works as a photographer, and is self-trained in the field of illustration. Habermacher studied graphic design at the Hochschule für Gestaltung und Kunst in Zurich. In 1991 he was nominated for the Sotheby's Cecil Beaton Award, and since then has won numerous awards from Art Directors' Clubs in Europe and America. Among Habermacher and Tsipoulanis's corporate clients are Mercedes Benz, Coca-Cola and Basement Jaxx (for whom they designed a sleeve). They have illustrated the covers of *Numéro*, *Harper's Bazaar* and *Composite*, and their editorial work has appeared in such magazines as *GQ*, *Nova*, *Playboy* and *RollingStone*.

contact Germany
Never Stop Movement
t 49/ (0)(40) 46 88 14 88
f 49/ (0)(40) 46 88 14 89
e info@never-stop-movement.de
www.never-stop-movement.de

contact UK and The Netherlands
Big Active Creative Management
t 44/ (0)(20) 7702 9365
f 44/ (0)(20) 7702 9366
e info@bigactive.com
www.bigactive.com

ito keiji

Award-winning illustrator, art director and graphic designer Keiji Ito was born in 1958 in Tokyo, where he lives and works today. Some of his corporate clients are Dentsu, Sony and Warner Music Japan. Ito's work has been published in *Big*, *Esquire*, *The Ganzfeld*, *Relax*, *Surface*, *Vogue Nippon* and on the cover of *Casa Brutus*. He published a monograph, *Future Days*, in 2003. Ito has exhibited in Japan and in Brazil and he is the recipient of the grand prize from the Times Asia-Pacific Advertising Awards (2001) as well as awards from the Art Directors' Clubs in New York and Tokyo. Ito teaches at many Japanese universities and is the C. E. O. of Unidentified Flying Graphics, a design firm.

contact
Foundation World Inc./Intergaia
t 1/ (212) 941-6721
f 1/(212) 941-8650
e fun@foundationworld.com
www.foundationworld.com
www.site-ufg.com

jeroense peter

Peter Jeroense was born in Rotterdam in 1966. He studied fashion there at the Willem de Kooning Academie (Academy of Modern Arts). In 1990 Jeroense was awarded the Hyères Fashion Award, one of several awarded to his ell=bell label. Currently living in Amsterdam, his artwork has been shown in a number of Dutch exhibitions and in publications such as *Blackbook*, *Flaunt*, *Jalouse USA*, *Nylon*, *Spoon* and in books including *Woman By* (Catalogue Centraal Museum Utrecht) and *Romantik* (Die Gestalten Verlag). His advertising campaign for New York-based label Sigerson Morrison appeared on taxicabs and throughout the city.

contact Europe
Unit CMA
t 31/ (0)(20) 530-6000
f 31/ (0)(20) 530-6001
e info@unit.nl
www.unit.nl

contact USA
t 1/ (212) 529-0400
f 1/ (212) 529-1995
e info@unitcmna.com
www.unit.nl

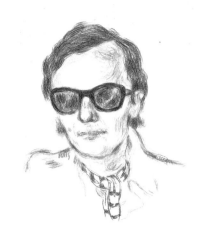

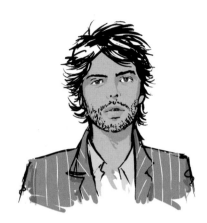

kirton ross

Ross Kirton was born in 1971 in Stourbridge. He trained as a graphic designer at Berkshire College of Art and Design and received a BA in photography from Blackpool. He now works as a fashion photographer and artist and is based in London. Among Kirton's corporate clients are Chanel and Selfridges. His work has been published in *Marmalade*, *V* and *DV Magazines* and in the British, Spanish and Japanese editions of *Vogue*. An exhibition of his work for Chanel was displayed in 2003.

contact
t 44/ (0) 7770 561 555
e ross@rosskirton.co.uk

london philidor

Philidor London (an alias) was born in 1967 in Utrecht. He studied fashion design and illustration at the Hogeschool voor der Kunsten (School of Arts) there. Now a resident of Amsterdam, London's work has appeared in *Currency*, *Fidget*, *Io Donna*, *MAN* and Korean *Vogue* magazines.

contact
f 31/ (0)(20) 626-5297
t + f 31/ (0)(20) 293-4352

manel stéphane

Stéphane Manel was born in 1971 in Epinal, Vosges, France. He studied in Paris at l'Ecoles Supérieures des Arts Graphiques et Décoratifs. Manel's clients include Dimitri From Paris, RATP, Puma, Loewe, Rocawear, Universal, X-Girl and Virgin. In 2002 his work was published in the book *Olympic de Paris* (L'Appareil Photo editeur). He has illustrated the covers of *Beikoku* and *Stratégies* and contributed to *Citizen K*, Japanese *Elle*, *Crash*, *Esquire*, *The Face*, *Flaunt*, *Jalouse*, *Neomu* and *Tokion*.

contact
t 33/ (0)(1) 48 78 79 55
e manel@wanadoo.fr
www.stephanemanel.com

contact France
Prima Linea
t 33/ (0)(1) 53 63 23 00
f 33/ (0)(2) 53 63 23 01
e agency@primalinea.com
www.primalinea.com

contact Europe
Unit CMA
t 31/ (0)(20) 530-6000
f 31/ (0)(20) 530-6001
e info@unit.nl
www.unit.nl

contact USA
t 1/ (212) 529-0400
f 1/ (212) 529-1995
e info@unitcmna.com
www.unit.nl

mascia pierre-louis

Pierre-Louis Mascia was born in 1968 in France. He studied at L'Ecole des Beaux Arts in Toulouse and has a degree from the Fondation Franco-Japonaise Sasakawa, where he learned to use traditional Japanese paper (washi). Mascia lives and works in Toulouse. In addition to his illustration work he designs accessories collaboratively under the label Pierre-Louis et Marielle. Among Mascia's corporate clients are Yohji Yamamoto, Galeries Lafayette, Neiman Marcus, Bergdorf Goodman, Absolut Vodka, British Fashion Week, Premiere Classe and Givenchy Parfums. His work has been published in *Vogue*, *Vogue Pelle*, UK *Elle*, *Surface* and *Spoon*.

contact Europe
Unit CMA
t 31/ (0)(20) 530-6000
f 31/ (0)(20) 530-6001
e info@unit.nl
www.unit.nl

contact USA
t 1/ (212) 529-0400
f 1/ (212) 529-1995
e info@unitcmna.com
www.unit.nl

contact Japan
Jeu de Paume
t 81/ (3) 3486-0532
f 81/ (3) 3486-0534
e info@paumes.com
www.paumes.com

minami kenzo

Kenzo Minami was born in 1974 in Nippon, Japan. He rode for an equestrian team before moving to the United States in 1992, where he studied industrial design at Parsons School of Design in New York. Minami's graphic design and computer skills are self-taught. He worked as an interface designer with MIT, and as a set designer for MTV and the Sci-Fi Channel before taking up a camera himself to shoot videos enhanced with graphic and 3-D animations. Currently he is an art director, designer and partner at Panoptic Inc., a creative agency. Minami's corporate clients include International Deejay Gigolo Records, Nike and the Tribeca Grand Hotel. He has illustrated the cover of *Flaunt*, and has contributed to *Addict*, *Blackbook*, *XLR8R* and the *Pour le Victoire* book (Surface to Air). Minami's work has been exhibited at Nike Reconstruct and Zakka Corp in New York.

contact USA
CWC International
t 1/ (646) 486-6586
f 1/ (646) 486-7622
e agent@cwc-i.com
www.cwc-i.com

contact Japan
t 81/ (0)(3) 3496-0745/0746
f 81/ (0)(3) 3496-0747
e agents@cwctokyo.com
www.cwctokyo.com

mode 2

Mode 2 was born in Mauritius in 1967. He now divides his time between London and Paris. A well-known graffiti artist with a social conscience, Mode 2 has championed the importance of graffiti in giving, as he says, 'many young people access to exploring shape and colour through use of our alphabet, and that giving them the confidence to go on to bigger challenges'. Mode 2's work has been widely exhibited – at Agnès B., Paris in 1995; Arc, Manchester in 1997; and OMAC, Belfast in 1999 – and published in titles such as *Spraycan Art* (Thames & Hudson), *At Down* (Attitude Press) and *Maurer United Architects: Play* (Uitgeverij 010). His clients include Sony Music, Virgin and Carhartt.

contact
t 44/ (0) 7960 585 267
t 33/ (0) 6 10 78 66 09
e mode2@mode2.org

nawel

Nawel was born in 1973. At the age of 15 she enrolled in a school of applied arts. She specialized in fashion at l'Ecole Supérieur des Arts Appliqués Duperre in Paris. Nawel has worked in the fashion industry in various capacities: as a stylist at Guy Laroche, a casting director at Hermès, a costumier for movies and musicals, and now she is concentrating on fashion illustration and photography. Nawel lives in Paris, where she works closely with the stylist Kanako B. Koga. Her work has been exhibited in Paris at l'Espace Richelieu as well as at various galleries in Japan. She has contributed to magazines including *Numéro*, *Composite*, *Spoon*, *Mixt(e)*, *L'Officiel*, *Citizen K* and *Jalouse*, as well as working with corporate clients such as Printemps du Luxe.

contact Europe
Unit CMA
t 31/ (0)(20) 530-6000
f 31/ (0)(20) 530-6001
e info@unit.nl
www.unit.nl

contact USA
t 1/ (212) 529-0400
f 1/ (212) 529-1995
e info@unitcmna.com
www.unit.nl

ota koji

Koji Ota was born in Nagasaki, Japan in 1964. He now lives in Brussels. Ota studied sociology at the University of Kumamoto and became a buyer for a Japanese boutique in Paris, teaching himself to paint in his spare time. He has worked for over ten years as an illustrator, with corporate clients including China China, Bay Brook, Prix de Beauté and the Asian Live Festival. Ota's illustrations have been published in *REF*, *Nishitetsu News Magazine* and on the cover of *Gracia*; online at thisisamagazine.com; *Fukoka Magazine* published his manga cartoon 'Le Monde du Pupu' weekly from 1988 to 2002. His work has been exhibited internationally, most recently at the Orange Gallery in Kumamoto.

contact
t 32/ (0)(2) 347 4178
e iwashi@skynet.be
www.mach-factory.co.jp/iwashi/

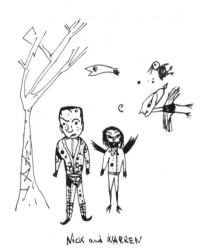

NICK and WARREN

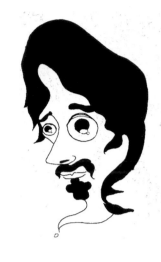

persson stina

Stina Persson was born in Lund, Sweden in 1972. She is living in Sweden after spending several years in New York, where she studied illustration at the Pratt Institute. Persson's resumé also includes a course in fine art at Italy's Istituto Europeo delle Arti Operative in Perugia and in fashion at Polimoda in Florence. Franco Sarto shoes, Lillet, Volvo Japan, Bloomingdale's and Macy's Department Store are among Stina's corporate clients. Her work has been widely published in magazines including *Amica*, *Elle*, *Grafik*, *Marie Claire*, *Res*, *Strut*, *ubersee* and thisisamagazine.com. She received the American Greeting Card Association Award in 1995 and the Society of Illustrators' Student Award in 1996 and 1997. Persson's work has been exhibited in New York and, most recently, at Parco Gallery in Tokyo.

contact USA
CWC International
t 1/ (646) 486-6586
f 1/ (646) 486-7622
e agent@cwc-i.com
www.cwc-i.com

contact Japan
t 81/ (0)(3) 3496-0745/0746
f 81/ (0)(3) 3496-0747
e agents@cwctokyo.com
www.cwctokyo.com

du preez warren & thornton jones nick

Design duo Warren du Preez and Nick Thornton Jones live and work in London. Du Preez was born in Johannesburg, South Africa in 1966 and is a self-trained artist. Thornton Jones, born in Liverpool in 1971, studied graphics and illustration at Gwent College. They have worked with Björk, Massive Attack, Unkle, Sony, Hermès, Cacharel, Issey Miyake, Levi's....Their art has appeared in periodicals including *Visionaire*, *Creative Review*, *Tate Magazine*, *Numéro*, *Dazed & Confused* and *Big*, and been published in a number of books, among them *Pen & Mouse* and *Creative Island* (Laurence King), *Mapping* (RotoVision), *Fashion: Images de Mode* (Vision On) and *Zoo* (Purplehouse). In 2003 Gas published a retrospective of their work. They have exhibited at Colette, Paris in 2002, Saatchi & Saatchi in 2003. Most recently they collaborated with Hamish Morrow at the unveiling of his spring/summer 2004 collection.

contact
Leonie Edwards Jones
Artist Representation/Management
t 44/ (0)(20) 7734-1110
f 44/ (0)(20) 7734-7774
e leonie@armanagement.org.uk

Portrait of Warren du Preez and Nick Thornton Jones by Adrian Genty

queen termite

Yuko Kawano was born in 1977 in Japan and graduated from Sokei Art School in 2000. She designs underwear and tee shirts, tattoos and club flyers. Her work has appeared in such magazines as *Common Sense*.

contact
Rocket Gallery
t 81/ (0)(3) 3499-8782
f 81/ (0)(3) 3499-8783
e mail@rocket-jp.com
www.rocket-jp.com

reid bernie

Bernie Reid was born in Scotland in 1972. He lives in Leith. Reid (who is of Anglo-Spanish descent) trained at Telford College in Edinburgh. He collaborated with Stella McCartney at Chloé and his work now decorates the interior of her eponymous New York boutique. He has also worked with Boxfresh, Liberty and Uth, and his work has been published in *Dazed & Confused*, *i-D*, *The Independent*, *Nova* and on the cover of *Studio Voice*.

contact
t 44/ (0) 7767 481 683
e bern.beca@btinternet.com

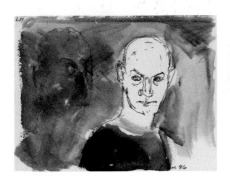

remfry david

Born in Sussex, England in 1942, David Remfry studied painting at Hull College of Art. He has exhibited professionally for thirty years and has had over fifty solo exhibitions. Since 1995 he has lived in New York City. Remfry is a Member of the Royal Watercolour Society and a Fellow of the Royal Society of Arts. In 2001 he was awarded the MBE for services to British Art in America. His work is in The British Museum, National Portrait Gallery (portraits of Sir John Gielgud and Jean Muir) and the Victoria and Albert Museum in London; Middlesbrough Museum and Art Gallery; Minneapolis Museum of Art, Minnesota, Swarthmore College, Pennsylvania and Art Gallery of Boca Raton, Florida in the USA; and Museo Rayo, Roldanillo, Colombia. His work has recently been shown at the Victoria and Albert Museum (2003) and P.S.1 Contemporary Art Center, New York City (2001).

contact
Caroline Hansberry
t 1/ (212) 242-3050
e remfrystudio@aol.com
www.davidremfry.com

shiv

Born just outside London in 1973, Shiv now lives in the north of the city. She credits the Notre Dame Convent School for Girls for having the greatest influence on her work, though she pursued foundation studies at West Surrey College of Art and Design and has a degree in graphic design from Camberwell College of Art. Shiv's corporate clients include Nike, Ninja Tune, Sony Music and Virgin, and her work has appeared editorially in *El Pais*, *Sleazenation* and on the cover of *Frieze* magazine.

contact
Big Active Creative Management
t 44/ (0)(20) 7702 9365
f 44/ (0)(20) 7702 9366
e info@bigactive.com
www.bigactive.com

singh sara

Sara Singh was born in 1967 in London and grew up in Sweden and the United States. Singh has a degree in fashion design from Beckman's School of Design in Stockholm. In 2003 her work was exhibited in Paris and Stockholm as part of the 'Catwalk: Swedish Fashion Illustrators' show and she had a solo exhibition in New York City. Estée Lauder, Furla, Le Sportsac, Mini Cooper, Neiman Marcus and Shiseido 5S have all used her work. Singh's images have appeared in *In Style*, *Marie Claire*, *Time Out*, *Vogue*, *Vogue Pelle* and the European editions of *Elle*.

contact
Art Department
t 1/ (212) 243-2103
f 1/ (212) 243-2104
e stephaniep@art-dept.com
www.art-dept.com
www.sarasingh.com

sirichai

Sirichai Tachoprasert was born in Bangkok, Thailand in 1967. He now lives in New York City where he works for Geoffrey Beene. Sirichai has degrees in architecture and interior architecture from King Mongkut Institute of Technology, Bangkok and in illustration from the Fashion Institute of Technology in New York. The Cooper Hewitt Museum and the window displays of Saks Fifth Avenue are among the places his work has been exhibited. In addition to his work for Mr Beene, which includes several advertising campaigns, Sirichai has worked with French Fragrances Inc., German *Vogue*, Editions Payot & Rivages and The Barbican Centre in London. In 2000 Sirichai illustrated *Beauty and the Beene: A Modern Legend* (Abrams), which won several awards at the 14th annual New York Book Show.

contact
t 1/ (212) 620-9169
f 1/ (212) 268-5773
e bobeye2@earthlink.net

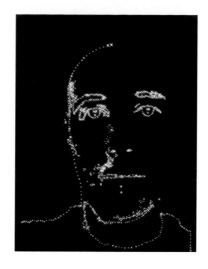

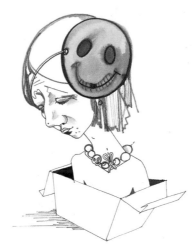

toulouse sophie

Sophie Toulouse was born in Rennes, Brittany in 1970. She studied psychology and fine arts in Jussieu and at the Sorbonne. Toulouse played bass in a punk rock band and has worked as an art director. She lives in Paris and in New York, where her work has been exhibited at the Watts Gallery and The Frying Pan and will appear at Artazart in 2004. *Cream*, *Flux* and *Oyster* are among the magazines that have published her work. Toulouse's corporate client roster includes Clinique, IFF, Lifetime TV and Interscope Records.

contact USA
CreativeAgent
t + f 1/ (646) 602-0062
m 1/ (347) 922-4680
e alex@creativeagent.com
www.creativeagent.com

contact France
Costume 3 Pièces
t 33/ (0)(1) 42 47 10 10
e costume3pieces@free.fr
http://costume3pieces.free.fr

contact Germany
Agenturfotografen
e horvatGmbH@aol.com

touratier maxime

Maxime Touratier was born in 1971 in Châteauroux, France. He studied multigraphic arts and photography at l'Ecole des Beaux Arts in Bourges and received his Master's from l'Ecole des Beaux Arts in Nantes. Currently living in Paris, Touratier works for corporate clients such as Perso, Vital, Guerlain and Swarovski. His work has appeared in *Jalouse* magazine.

contact
Chez Antoine
t 33/ (0)(1) 42 78 07 72
m 33/ (0) 6 09 88 09 44
e info@chezantoine.com
www.chezantoine.com

verhoeven julie

Born in 1969, in Kent, Julie Verhoeven lives in London where she designs for the label Gibo and lectures at Central Saint Martins College of Art and Design. Work as a design assistant at Martine Sitbon and John Galliano led to consultancies with Jasper Conran, Richard Tyler, Guy Laroche, Jean Colonna and, in 2000, with Cacharel. In 2002 she collaborated with Marc Jacobs, designing accessories at Louis Vuitton. Verhoeven's work has appeared editorially in *Dazed & Confused* (including the cover), *V*, *Self-Service*, *Tank*, *Spoon*, *The Face*, *Nylon*, *Rebel*, *Nova*, *The Fashion*, *The Sunday Times*, *IT*, *Issue*, *the Independent*, *Hanatsubaki*, *10* and *Numéro* as well as on-line for Nick Knight's SHOWstudio.com. In 2003 she illustrated the Coccopani campaign. Verhoeven has taken part in several international exhibitions. 'Fat-bottomed Girls', a solo show she hung in London in 2002, was accompanied by a book of the same name, published by TDM Editions.

contact UK
CLM
t 44/ (0)(20) 7750-2999
f 44/ (0)(20) 7792-8507
e clm@clmuk.com

contact USA
t 1/ (212) 924-6565
f 1/ (212) 242-5493
e clm@clmus.com

weiner clay

Born in 1975 in Ohio, Clay Weiner studied at Columbia University. He lives in New York City where he works as a journalist and artist. His work was exhibited at the 2003 Miami Art Fair. He collaborates regularly with Rachel Comey, a fashion designer, and was awarded the 2003 Perrier Future of Design Award. MTV is one of his corporate clients, and his work has appeared editorially in print (*Vice*, *Strut*) and on-line (thisisamagazine.com, hintmag.com).

contact
t 1/ (212) 334-0470
e yours@clayweiner.com
www.clayweiner.com

anastase pp. 12–17 All work photographer: Persephone Kessanidis; NON-FINISHED TRIBUTE TO MARTIN MARGIELA... (12) stylist: Charles Anastase; model: Julie Morin; THE HAND PEOPLE (13) stylist: Hector Castro; model: Adina Fohlin; TELEPATHY & ELECTRICITY (14 *left*, 16–17) stylist: Charles Anastase; models: Masha Orlov and Christopher Niquet; hair: Lindle Mansfield and make-up: Michelle Reiner both at Streeters; UNTITLED (14 *right*) stylist: Charles Anastase; model: Julie Morin; I NEED FREEDOM (15) stylist: Charles Anastase; model: Amandine Degrai

antoniou pp. 18–21 GUCCI (20–21) stylist: Adrian Clark; hair and make-up: Fiona Moore at Terrie Tanaka for Aveda

arkhipoff pp. 26–29 TWILIGHT FANTASY (26) stylist: Ako Tanaka; make-up: Nathalie Nobs for Brigitte Hebant; hair: Giovanni di Stefano for Propaganda; DIESEL ON TOUR (29) stylist: Ako Tanaka; make-up: Sophie Mathias for Marie-France; hair: Alexis Rocher for Marie-France

barwick pp. 30–35 *Adrenalin* (32–33, 34) concept: Muriel Zsiga; stylist: Sarah Bentley

deygas pp. 54–57 PARIS 18 (54–55) photographer: Florence Deygas; PARIS 18, PETITE CEINTURE (54) model: Julien at Next; PARIS 18, PASSE MURAILLE (55) model: Charlie at Next; Cover, *Minimix* (56) model: Athena at Next; stylist: Eko Sato

gibb pp. 4, 66–71 DRIES VAN NOTEN SPRING/SUMMER CATALOGUE 2001 (4, 66–67, 69, 70, 71) art direction and styling: Nancy Rhodes; COME WITH US (70) art direction: Mark Tappin and Kate Gibb

habermacher and tsipoulanis pp. 82–85 MOST WANTED (82) stylist: Capucine Safyourtlu; model: Linda Evangelista; make-up: Stéphane Marais; GRASPING (83) stylist: Inka Marnette; SUPERSONIQUE (84) motorcycle: BMW; stylist: Capucine Safyourtlu; KATE MOSS (85) make-up: Linda Cantello for YSL beauté

kirton pp. 94–97 All work stylist: Charlotte Stockdale

nawel pp. 7, 116–121 YSL RIVE GAUCHE (7), HERMÈS (116), ALEXANDRE MATTHIEU (117), CHANEL (118) and BALENCIAGA (119) stylist: Kanako B. Koga; CHANEL AND DIOR HAUTE COUTURE (120–121) stylist: Hortense Manga

reid pp. 136–39 All images stylist: Beca Lipscombe; GHOST (136) model: Suzanne Deacon; CHANEL (137) model: Marisol; STELLA MCCARTNEY (138–139) model: Lucy McKenzie

remfry pp. 140–143 STUDY: TETYANA BRAZHNYK (140) © David Remfry 2002, 32 x 26 cm (12.6 x 10.3 in.); TETYANA BRAZHNYK (140–141) © David Remfry 2002, 57 x 76 cm (22.5 x 29.9 in.); LULU (142) 57.2 x 35.6 cm (22.5 x 14 in.); LULU (143) 57.2 x 35.6 cm (22.5 x 14 in.)

shiv pp. 144–147 PRESTO/NIKE (145) model: Amber; GOOD TIMES (146–147) art direction: Love

singh pp. 148–151 MOSCHINO (148) model: Liselotte Watkins; SIMONE (149) stylist and model: Helena Ringvold

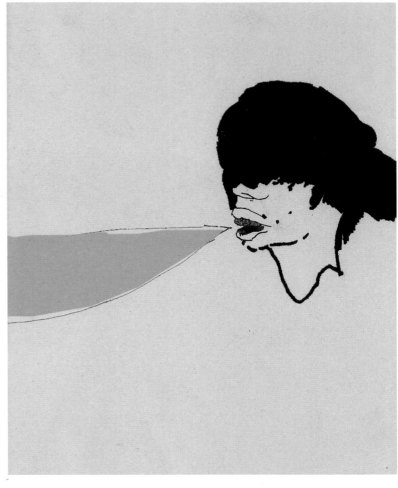

Akroe (Étienne Bardelli)

Charles Anastase, Alban Adam

Rebecca Antoniou, Stephanie Pesakoff at Art Department

Carlos Aponte

Elisabeth Arkhipoff, Laurent Fétis

Thomas Barwick

Fábia Bercsek

François Berthoud

Kime Buzzelli

Alejandro Cardenas

Florence Deygas

Maren Esdar

Tristan Galdos del Carpio, Rafael Galdos del Carpio and Philippe Arnaud

Kate Gibb, Greg Burne and Bianca at Big Active

Jasper Goodall

Richard Gray

René Habermacher and Jannis Tsipoulanis

Keiji Ito, Yoko Inoue at Intergaia

Peter Jeroense, Martine Nieuwenhuis, Pascale Fabery de Jonge and Constanza Camarga at UNIT

Ross Kirton, Eve Stoner at Pearce Stoner

Philidor London, Geerten Ten Bosch

Stéphane Manel

Pierre-Louis Mascia

Kenzo Minami

Mode 2, Sally and Sarah Edwards

Nawel

Koji Ota

Stina Persson, Koko Nakano and Junko Wong at CWC

Warren du Preez and Nick Thornton Jones, Leonie Edwards Jones at Artist Representation/Management

Queen Termite (Yuko Kawano), Mari Kawabata and Keiichi Kuzuoka at Rocket Gallery, Mayumi Kamura at Building

Bernie Reid, Beca Lipscombe

David Remfry, Caroline Hansberry

Shiv

Sara Singh

Sirichai

Sophie Toulouse, Alex at Creative Agent

Maxime Touratier, Antoine Rayssac at Chez Antoine

Julie Verhoeven, Thu Nguyen and Josh Wynn at CLM

Clay Weiner, Rachel Comey

Konstantinos Antonopoulos at *Loaded Fashion*

Mickey Boy Gibbons at *Adrenalin*

Marc Kwakman and Piet Paris

Kevin Lyons

Cédric Rivrain

Emma Wizman at *Numéro*

Michele and Valérie at Agent 002

My wonderful parents: Matthew and Andrea Borrelli; Donald and Maureen Himes and my amazing colleagues at Thames & Hudson – Helen Farr, Tamsin Perrett, Karolina Prymaka who designed a beautiful book and Jamie Camplin who believes in me.